The

BEST AMERICAN INFOGRAPHICS

2015

The
Ame
Infogr
20

MARINER BOOKS
HOUGHTON MIFFLIN HARCOURT
BOSTON | NEW YORK 2015

Best

rican

With an Introduction by **MARIA POPOVA**

GARETH COOK, *Series Editor*

aphics

15

WWW.HMHCO.COM

Library of Congress Cataloging-in-Publication Data is available.

ISBN 978-0-544-54270-9

Book design by Patrick Barry

Cover design by Mike Lemanski

Printed in Hong Kong

DHK 10 9 8 7 6 5 4 3 2 1

Permissions credits are located on page 158.

Contents

One of my favorite pieces in this year's collection is an infographic in two parts. It begins with what appears to be a still-life painting from one of the seventeenth-century Dutch masters. A wooden table overflows with a rich variety of fruits and vegetables. A wicker basket holds dates, oranges, red and green grapes, stocky leeks, and a bunch of baby fennel. Another basket features more tropical offerings: a coconut, a small pineapple, sugarcane, and bananas, both yellow and red. Some kumquats appear to have spilled out and lie at the table's edge. Half a papaya, its flesh a lurid orange, rests upright against some loosely curled radicchio. Persimmons, hanging on branches, are a lustrous orange-red set off by a handful of artichokes in a tarnished brass vessel. This "painting," though, is in fact a virtuoso photograph by New York City's Paulette Tavormina, working on a commission from *National Geographic*.

Turn the page and the idea behind the work is revealed. A key identifies each piece of food in Tavormina's photograph and then shows where it came from on a map of the world. The baby pineapple, the infographic tells us, was grown in South Africa and then travelled 8,970 miles by boat, a 12-day journey to New York City. The dates were flown in from California, for a total trip of 2,635 miles. The coconut came by ship from Costa Rica, the king oyster mushrooms from mainland China, the Bosc pear from Argentina. All told, the 60 items of produce in this one "moveable feast" traveled 223,875 miles, the equivalent of circling the planet some nine times. Your local produce aisle is probably not so lovely, but this is a reminder that every offering has come from somewhere else. It's a still life about 60 journeys — and all the journeys we take for granted.

This infographic, like many of the greats, works some of its magic by shifting our perspective. Surveying the impressive spread, we are invited to step out of our role as consumer for a moment, and imagine the world from the vantage of the people who made the presence of this exotic fruit in our lives possible. What farmer in southern Vietnam tended to it as it grew? How was it plucked from its tree? Who loaded it onto a ship, and who piloted the ship across the Pacific? All this labor to land it in a display, awaiting a city dweller craving something a little unusual.

"... YOU WILL FIND MANY INVITATIONS TO SEE THE WORLD FROM A NEW VANTAGE POINT."

It is often said that reading fiction trains the mind to feel the world as it is experienced by others, but a good infographic can also expand our circle of consideration. *Empathy*, in fact, is a word that comes to English via the translation of a German term in the psychology of art, *Einfühlung*. The word first started appearing in the late nineteenth century to describe the human capacity to place ourselves into the objects and animals that make up a visual scene. It was only later that it took on the broader meaning of seeing the world from another's perspective. So to speak of the "empathy" evoked by a still life of fruits is not so very strange at all.

Flipping through this collection, you will find many invitations to see the world from a new vantage point. How do we compensate an American soldier who volunteered to defend our country and lost a hand in the bargain? We pay him one hundred dollars a month. Or, painful as it is, take in the chirpy horror of the tweeting women of ISIS and wonder how a young woman arrives at that psychological place.

Consider what an average life looks like, week by week, and meditate on our common experience. And brace yourself for what I would argue is the most straight-up heartbreaking work in this collection: Lazaro Gamio's line drawings of children's outfits, each representing, with the emotional compression of a novella, a young soul lost in day care. Gamio's drawings made me see, but also feel.

The Best American Infographics 2015 is divided into four sections. The first, "You," draws together pieces that focus on individuals. The skater Marissa Castelli rises from the ice, spinning quickly, then nails a landing on the back outside edge of her right skate, her arms outstretched like wings. What does 2,000 calories of fast food look like? Who would you guess is older—an "Ashley" or a "Lisa"? And how can a workplace be changed so that people get sick less often?

The second part, "Us," is a portrait of the many. There are language maps of the United States, such as one showing the most common language after English and Spanish, state by state. The answers include French, Polish, Vietnamese, and Tagalog. *New York Magazine* takes you into the tangled social network of the city's restaurateurs. The second section also satisfies more rarified interests: how chess openings have changed over time, or how letters are distributed in English words, or how often particular notes are sounded in various works.

The third part, "Material World," is filled with wonders. Behold a map of the North American continent, circa 77 million years ago. There are snowflakes, in all their variety. Another work diagrams a bioluminescent tree of life, and among the glowing life forms on display is a mushroom known as the "ghost fungus." Who knew? There are drones and domes, planes and toilets, and a luge in Times Square. Yet people still figure in these stories. The *New York Times* shows the tiny changes in an automotive ignition switch that brought death to unsuspecting drivers. And another standout: the world's deadliest animals. The shark barely rates, and the top killer is a reminder of the conditions so many of our fellow humans find themselves living in. The book's final section is a thought-provoking selection of the top ten interactive infographics of the year—from China's "Great Firewall" to the star shooters of the Washington Wizards—as judged by Simon Rogers, Twitter's data editor.

All of the infographics in *The Best American Infographics 2015* were originally published for a North American audience, online or in print, during 2014. With the exception of the ten interactive infographics, I selected all of the winners, though with a lot of help from my brain trust, who have served as scouts and advisors and all-around indispensable helpers—a big thanks to them. (Their biographies are listed in the back.) To nominate infographics for the next volume, see the rules at garethcook.net, or email me at contactgarethcook@gmail.com.

I particularly want to thank Maria Popova for her lovely introductory meditation on wisdom in the information design age, as well as Mike Lemanski, whose cover made me smile the first time I saw it and continues to have that effect. And I would like to thank my assistant, Emily Kent, the designer, Patrick Barry, as well as the team at Houghton Mifflin Harcourt, particularly permissions expert Mary Dalton-Hoffman, enthusiast-in-chief Michelle Bonanno, and my editor, Deanne Urmy, who conceived of this series and who has done so much to bring so many great books into the world. Finally, I would thank all of the people whose work is featured here: your labors force us to think, and inspire us to care.

GARETH COOK

It seems unlikely that a woman born nearly two centuries ago, trained as neither a statistician nor a journalist, living in an era when the word *designer* didn't even exist, would be a pioneer of data journalism. But that's exactly what the legendary nurse and social reformer Florence Nightingale was. For her, displaying statistics in visually assertive ways wasn't a matter of eye-candy fetishism but one of political urgency — her famous "coxcombs" diagrams made visceral the counterintuitive fact that, during the Crimean War of 1854, more soldiers died from disease than in combat. In being blindingly clear and convincing in their clarity, Nightingale's visualizations gave British politicians enough uncomfortable pause to finally change legislature in favor of better sanitary conditions.

This is what information design does at its best — it gives pause, makes visible the unsuspected yet significant *invisibilia* of life, and, by astonishing us into mobilization, it catapults us toward one of the greatest feats of human courage: the act of changing one's mind. By giving us both vital new information to consider and an equally vital moment of pause in which to consider it, successful data visualization invites us to reconsider the givens with which we live, elevating us to a higher plane of knowledge and plunging us into deeper understanding of some subtle or monumental aspect of how our world works. At its best, it plants the seed for a moral inclination to do something to nudge that world a little bit closer to how it *should* work.

Therein lies the quality that sets the great and the mediocre apart: information design that merely informs or simply delights fails to move this moral dial. The most it can hope to do is to transmute information, which simply conveys some basic fact or set of facts about the world, into a modest mesh of knowledge, which hinges on an understanding of how bits of information fit together. But what hovers above information, and above knowledge, is wisdom. Wisdom applies information worth remembering and knowledge that matters to solving the larger problem of what direction we should be moving in, as individuals and as a society.

"To truly claim knowledge requires that we synthesize different bits of information into a relational framework, organizing them in a shared mesh of context . . ."

That is what Nightingale's diagrams did 150 years ago, and this is what the most effective infographics do today.

Adrienne Rich, in her magnificent 1977 commencement address, argued that an education is not something you get but something you claim. The same, I believe, is true of knowledge and wisdom. And yet we live in an age defined by a pathological impatience that makes us want to *have* the knowledge, but not want to do the work of *claiming* it. We seem to be bored with thinking itself — we want to instantly *know*. And knowing is, of course, the cessation of thinking. This is why we face an epidemic of listicles. Why think about what constitutes a great work of art — how it moves you, what it says to your soul — when you can skim the 20 most expensive paintings in history on *Buzzfeed*? We are increasingly intolerant of long articles and skim them mercilessly. And if the very phenomenon of book trailers weren't telling in and of itself, we even skip forward in these short videos that compress a 300-page tome — an author's labor of love, years in the making — into a three-minute animation.

At first glance, it might seem like information visualization contributes to this intellectual laziness. When it is done poorly, it certainly can. But when it is done well, it actually champions the opposite. To truly claim knowledge requires that we synthesize different bits of information into a relational framework, organizing them in a shared mesh of context—we need to understand how each bit relates to every other and how the individual parts illuminate one another to produce greater understanding of the whole. Knowledge lives in this relational understanding, and a great infographic accomplishes just that. Once we have this springboard, we can begin to leap toward wisdom.

There is a reason why we call disjointed bits of encyclopedic information *trivia*. The true material of wisdom is meaning—and the meaningful is the opposite of the trivial. The only thing gleaned by skimming and skipping forward is trivia, which is the reason cheap "infoporn" lives up to its derogatory name. The only way to glean wisdom is contemplation, which is what great information design both invites and makes inviting.

Indeed, *information design* is something of a misnomer—although information is the discipline's raw material, insight and wisdom are its ultimate product, at least when the work lives up to its highest potential. Where infoporn creates the illusion of instant knowledge, great information design sheds light on unclaimed wisdom and serves up an intelligent and imaginative invitation to claim it.

A U.S. and European survey of commuter patterns (Ryan Morris, "Commuter Science," page 44) reminds us that despite our vast cultural and individual differences, our mundane daily exasperations unite us into a common rhythm of the human experience.

An illuminating look at the history of scientific ideas (Accurat, "How Fast Do Ideas Move?," page 48) brings to mind the French molecular biologist Jacques Monod's famous 1970 assertion that the "abstract kingdom"—the conceptual place analogous to the biosphere, populated by ideas that propagate much like biological organisms do—obeys the same natural cycles to which all creatures are beholden. The infographic reminds us that ideas are not immutable truths but living organisms, mortal like the human minds that generated them, even if operating on longer life cycles.

A brilliantly simple chart compresses the average human lifetime into a finite-looking grid of weeks (Tim Urban, "Your Life, in Weeks," page 24) and instantly jolts us into confronting the most primal complexity of existence—the struggle to reconcile our longing for eternity and permanence with the reality of a universe driven by finitude and constant flux. We are mortal, the devastating yet enlivening chart seems to say, so we'd better bestir ourselves to live already.

Some of the best work lives at the intersection of the practical and the poetic. In her visualization of bioluminescent creatures ("A Family Tree of Glow," page 80), Eleanor Lutz crafts a scientifically accurate and brilliantly succinct taxonomy. And yet, looking at it, you find yourself possessed—at least I do—by a breath-stopping awe at the glorious mystery and beauty of our world. How can an infographic sing to the soul the way a Mary Oliver poem sings? And yet it does, as if these marvelous creatures have joined together in a chorus exhorting you to begin belonging to this world immediately, because "There is so much to admire, to weep over. / And to write music or poems about."

Information design can—and, at its best, does—do just that: it extends an invitation to belong to our world more fully, by making visible and graspable its diverse astonishments, the weep-worthy and the poem-worthy.

MARIA POPOVA

The

BEST AMERICAN INFOGRAPHICS

2015

YOU

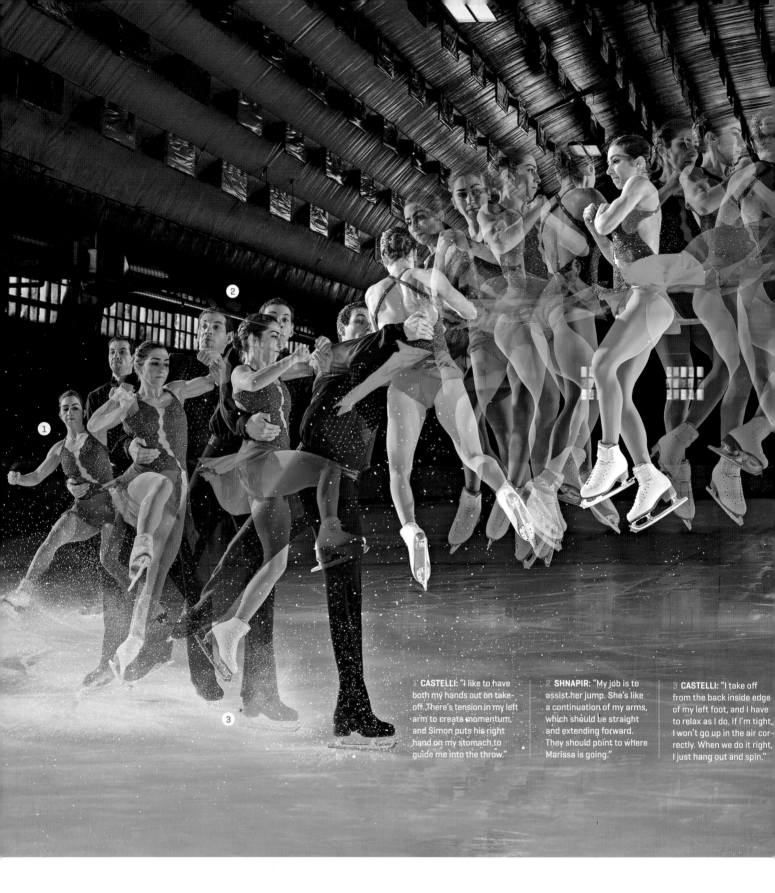

1 CASTELLI: "I like to have both my hands out on take-off. There's tension in my left arm to create momentum, and Simon puts his right hand on my stomach to guide me into the throw."

2 SHNAPIR: "My job is to assist her jump. She's like a continuation of my arms, which should be straight and extending forward. They should point to where Marissa is going."

3 CASTELLI: "I take off from the back inside edge of my left foot, and I have to relax as I do. If I'm tight, I won't go up in the air correctly. When we do it right, I just hang out and spin."

DANCING IN THE AIR

An Olympic effort, four feet off the ice.

ARTISTS John Huet, photographer, represented by Marilyn Cadenbach; Dave Nadeau, retoucher; Chin Wang, creative director; Marne Mayer, art director; Karen Frank, senior director of photography; Nick Galac, photo editor; Amy Brachmann and Rebecca Nordquist, editors; Marissa Castelli and Simon Shnapir, figure skaters.

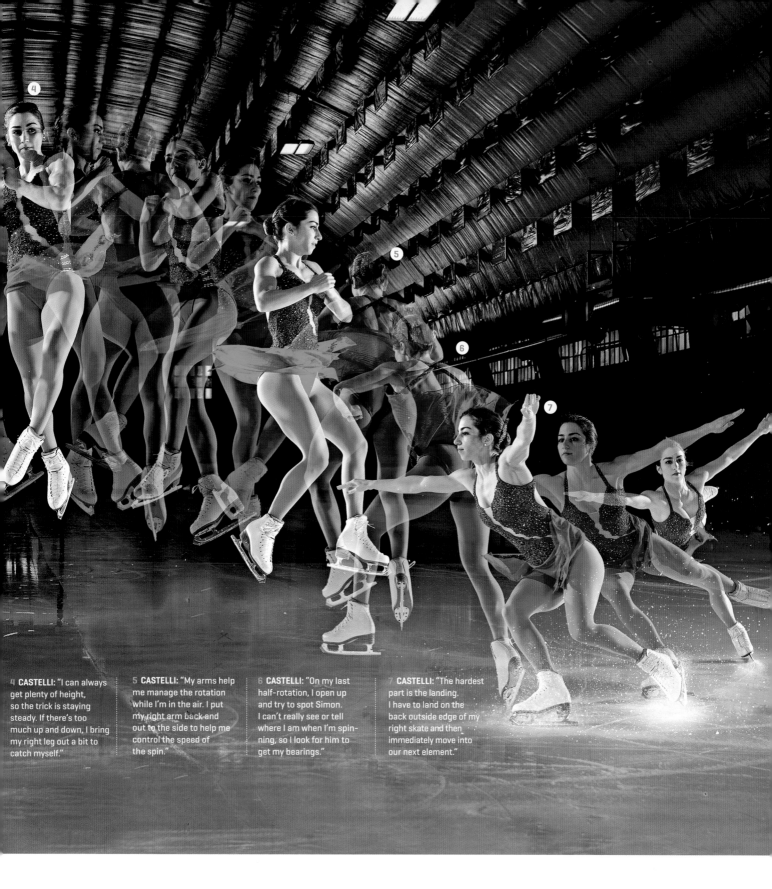

4 CASTELLI: "I can always get plenty of height, so the trick is staying steady. If there's too much up and down, I bring my right leg out a bit to catch myself."

5 CASTELLI: "My arms help me manage the rotation while I'm in the air. I put my right arm back and out to the side to help me control the speed of the spin."

6 CASTELLI: "On my last half-rotation, I open up and try to spot Simon. I can't really see or tell where I am when I'm spinning, so I look for him to get my bearings."

7 CASTELLI: "The hardest part is the landing. I have to land on the back outside edge of my right skate and then immediately move into our next element."

STATEMENT To give readers a glimpse into the level of athleticism they'd be witnessing during the 2014 Sochi Olympics, we broke down the techniques of a few gold medal hopefuls representing Team USA in Russia. One of those techniques included the play-by-play of figure-skating pair Marissa Castelli and Simon Shnapir's throw quadruple salchow jump. Figure skaters make things like this look easy, and most people would be surprised by what this move actually requires. Simon is throwing Marissa four feet into the air, and then he has to anticipate where she's going to land and be on point when she gets there. That's teamwork.

PUBLICATION *ESPN The Magazine* (February 3, 2014)

Age Distribution of American Girls Named Violet
By year of birth

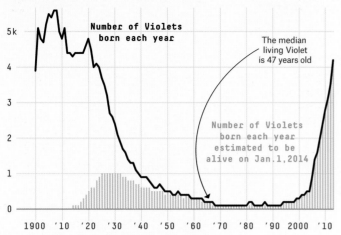

Number of Violets born each year

The median living Violet is 47 years old

Number of Violets born each year estimated to be alive on Jan. 1, 2014

Age Distribution of American Boys Named Joseph
By year of birth

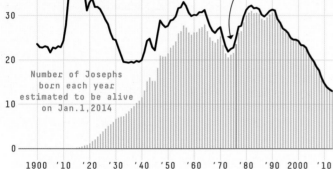

Number of Josephs born each year

The median living Joseph is 37 years old

Number of Josephs born each year estimated to be alive on Jan. 1, 2014

Age Distribution of American Girls Named Brittany
By year of birth

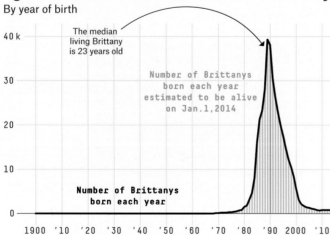

The median living Brittany is 23 years old

Number of Brittanys born each year estimated to be alive on Jan. 1, 2014

Number of Brittanys born each year

Median Ages For Females With the 25 Most Common Names
Among Americans estimated to be alive as of Jan. 1, 2014

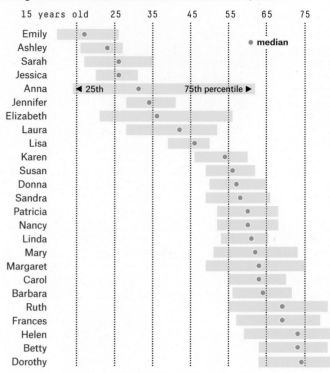

15 years old · 25 · 35 · 45 · 55 · 65 · 75

median

◄ 25th 75th percentile ►

Emily, Ashley, Sarah, Jessica, Anna, Jennifer, Elizabeth, Laura, Lisa, Karen, Susan, Donna, Sandra, Patricia, Nancy, Linda, Mary, Margaret, Carol, Barbara, Ruth, Frances, Helen, Betty, Dorothy

Youngest Female Names
By estimated median age for Americans alive as of Jan. 1, 2014

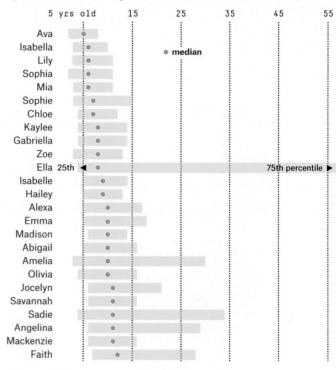

5 yrs old · 15 · 25 · 35 · 45 · 55

median

25th 75th percentile ►

Ava, Isabella, Lily, Sophia, Mia, Sophie, Chloe, Kaylee, Gabriella, Zoe, Ella, Isabelle, Hailey, Alexa, Emma, Madison, Abigail, Amelia, Olivia, Jocelyn, Savannah, Sadie, Angelina, Mackenzie, Faith

WHERE HAVE ALL THE ELMERS GONE?

How to guess someone's age.

ARTISTS Design and graphics development by Allison McCann, visual journalist; data analysis and writing by Nate Silver, founder and editor in chief, at *FiveThirtyEight*. Both are based in New York.

STATEMENT Can you determine someone's age just by knowing his or her name? In a sense this graphic is our attempt to find out. We used data from the Social Security Administration's baby names database and its actuarial tables to figure out the age distribution

Median Ages For Males With the 25 Most Common Names

Among Americans estimated to be alive as of Jan. 1, 2014

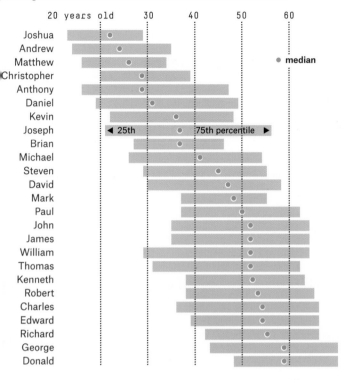

Names With the Widest Age Spreads

Estimated interquartile range of ages for Americans alive as of Jan. 1, 2014

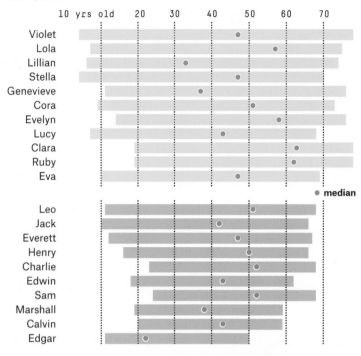

Youngest Male Names

By estimated median age for Americans alive as of Jan. 1, 2014

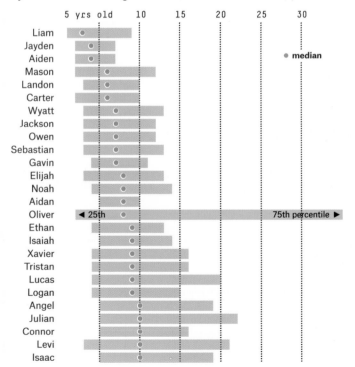

Deadest Names

Estimated percentage of Americans with a given name born since 1900 who were dead as of Jan. 1, 2014

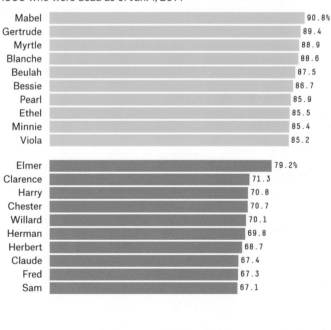

Name	%
Mabel	90.8%
Gertrude	89.4
Myrtle	88.9
Blanche	88.6
Beulah	87.5
Bessie	86.7
Pearl	85.9
Ethel	85.5
Minnie	85.4
Viola	85.2
Elmer	79.2%
Clarence	71.3
Harry	70.8
Chester	70.7
Willard	70.1
Herman	69.8
Herbert	68.7
Claude	67.4
Fred	67.3
Sam	67.1

and median ages for some of the most common American names since 1900. We wanted to do this piece because we hadn't seen anyone ask the age of living Americans with a given name, even though there are numerous websites devoted to tracking the popularity of baby names. We found that peak "Brittany" occurred in 1990, and that the number of Annas born each year was steadily decreasing until a late '90s resurgence. We liked the idea of readers seeing these name distributions and trying to remember if they still knew anyone named Elmer or Gertrude, or laughing because they'd just named their newborn Ava or Liam.

PUBLICATION *FiveThirtyEight.com* (May 29, 2014)

Costs per state for...

Dress(es)
- $1,000-$1,100
- $1,101-$1,200
- $1,201-$1,300
- $1,301-$1,400
- $1,401-$1,500
- $1,501-$1,600

Bridal bouquet
- $110-$121
- $122-$133
- $134-$145
- $146-$157
- $158-169
- $170-$180

Invitations and reply cards
- $205-$219
- $220-$233
- $234-$247
- $248-$261
- $262-$275
- $276-285

Wedding bands
- $1,000-$1,100
- $1,101-$1,200
- $1,201-$1,300
- $1,301-$1,400
- $1,401-$1,500
- $1,501-$1,600

Wedding photographer
- $1,400-$1,550
- $1,551-$1,700
- $1,701-$1,850
- $1,851-$2,000
- $2,001-$2,150
- $2,151-$2,300

Event location
- $3,200-$3,450
- $3,451-$3,700
- $3,701-$3,950
- $3,951-$4,100
- $4,101-$4,350
- $4,351-$4,700

Wedding cake or dessert
- $370-$400
- $401-$430
- $431-$460
- $461-$490
- $491-$520
- $521-$550

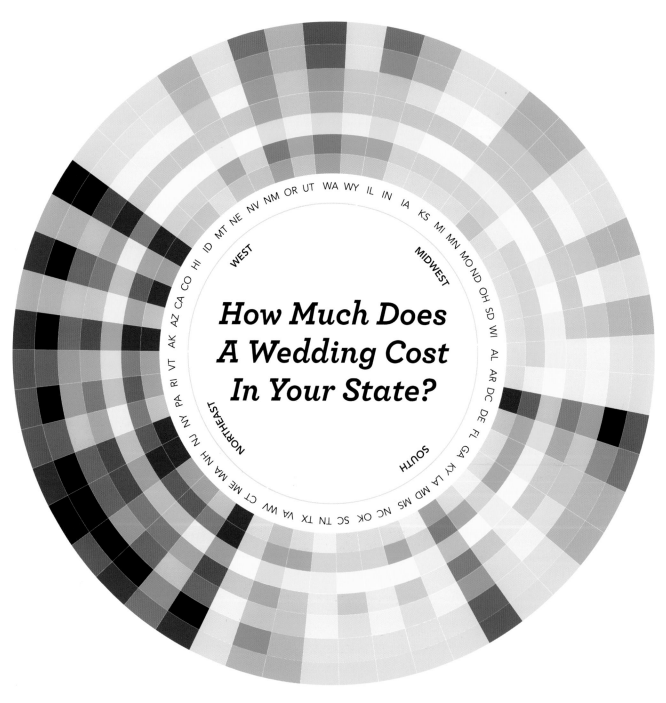

How Much Does A Wedding Cost In Your State?

WEDDING COSTS, STATE BY STATE

Hawaiian weddings are expensive; Missouri, not so much.

ARTISTS Infographic art and text by Alissa Scheller, associate infographics editor; editing by Ashley Reich, senior editor, weddings and divorce, and Katy Hall, former senior multimedia editor, at the *Huffington Post*.

STATEMENT Americans spend a lot of money on weddings, but just how much varies a great deal by state. People love looking for regional trends, but I didn't feel like a map showing total wedding costs would adequately depict all the expenses that could conceivably go into a wedding, or account for the fact that not everyone's wedding includes the same things. So I decided to separate costs for individual items, and took a cue from a great gay-rights graphic at the *Guardian* for presentation. I like that this allows you to see costs for individual categories, but also get an idea of bigger-picture costs just by seeing which states have an overall darker tone. The data is from The Wedding Report, Inc., a market research company.

PUBLICATION *Huffington Post* (March 5, 2014)

THE UNHEALTHY OFFICE

A self-portrait of what can be wrong about a workplace.

Are you in an unhealthy office relationship?

If you spend more waking hours in your office building than with your significant other, you and your workspace had better be a good match. Studies have shown that office buildings aren't benign containers but active contributors to good — or poor — health, mood and productivity. Your office can do you right or wrong in many ways, till demolition do you part.

By Bonnie Berkowitz and Laura Stanton

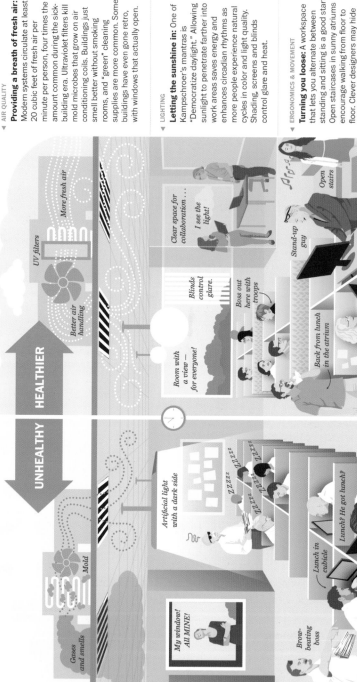

▶ AIR QUALITY

Leaving you gasping: "Sick building syndrome" is largely a relic of the 1970s and '80s, when office buildings were sealed for energy efficiency without adequate filtration and ventilation. But even now, paint, furniture, carpet, pesticides and cleaning products can emit gases that affect air quality. A 2012 report found that 9 percent of asthma cases among adults who had ever been employed were work-related.

▶ LIGHTING

Putting you in a bad light: In many buildings, natural light gets no farther than the executive offices that monopolize the windows. Fluorescent tubes put out light that doesn't match the natural spectrum, reducing alertness, darkening mood and impairing nighttime sleep, said Kevin Kampschroer, an innovator in sustainable federal office design.

▶ ERGONOMICS & MOVEMENT

Holding you back: Constant sitting is just one problem. A building's design can encourage people to move, or not, said environmental psychologist Judith Heerwagen. If your only options are laps around the cube farm or climbing the dank stairwell with the

▶ AIR QUALITY

Providing a breath of fresh air: Modern systems circulate at least 20 cubic feet of fresh air per minute per person, four times the amount common during the sick-building era. Ultraviolet filters kill mold microbes that grow on air conditioning coils. Buildings just smell better without smoking rooms, and "green" cleaning supplies are more common. Some buildings have even gone retro, with windows that actually open.

▶ LIGHTING

Letting the sunshine in: One of Kampschroer's mantras is "Democratize daylight." Allowing sunlight to penetrate farther into work areas saves energy and enhances circadian rhythms as more people experience natural cycles in color and light quality. Shading, screens and blinds control glare and heat.

▶ ERGONOMICS & MOVEMENT

Turning you loose: A workspace that lets you alternate between standing and sitting is a good start. Open staircases in sunny atriums encourage walking from floor to floor. Clever designers may hide the elevators, or program some to disallow short trips, Kampschroer

are passed through the air, a downside to those low partitions. Telecommuting can reduce this problem by letting people stay home when they're just a little ill, experts said. Common sense applies, too. Wash your hands often and reconsider that dip into the communal candy dish.

▼ TEMPERATURE
Staying just right: Cutting-edge offices are finding ways to allow every person to control the microclimate at his or her desk. Solutions can be simple, such as air diffusers that mitigate drafts and tiny fans and heaters, or as complex as wiring climate controls into every workspace.

▼ ACOUSTICS
Keeping quiet: Kampschroer said good office design allows people to escape noise while also giving them space to collaborate. Closed rooms should be available for private phone calls or meetings, and laptops let people pick up and move together — or apart. Offices with low partitions tend to be quieter, because people know they can be heard. But those wide-open plans that provide great light and airflow need ways to dampen noise.

▼ VISUAL
Coloring your world: Some variety in color, pattern and texture is ideal, without descending into chaos. Heerwagen advocates biophilic design, using colors and patterns that are found in nature to reduce stress.

THE WASHINGTON POST

study found that people who worked in open spaces took 62 percent more sick days than those in offices or high-walled cubicles. Additional studies have shown that people who show up to work ill drain company resources because they are less productive and pass along germs to others.

◀ TEMPERATURE
Running hot or cold: Heerwagen said that in tests of ambient temperature, half of all workers said they were too hot and the other half said they were too cold. Personal preference varies too much for a one-temperature-fits-all approach, especially in Washington, where some people still wear wool suits in summer.

◀ ACOUSTICS
Bringing in the noise: If a co-worker's phone rant or the copier's whir puts you on edge, you are not alone. A 2010 study of white-collar workers found that background noise contributed to a measurable rise in stress as shown by heart rates, cortisol levels and an impaired ability to concentrate. Some of the most distracting sounds can come from high-walled cubicles that give inhabitants a false sense of privacy.

◀ VISUAL
Stuck in shades of gray: Monotone is bad decor. Even worse is a jarring jumble that rises to visual toxicity. (Yep, that's a thing.) One building Heerwagen visited had so many clashing colors and abstract patterns that workers became physically ill.

Sources: Kevin Kampschroer, director of federal high-performance green buildings for the General Services Administration; environmental psychologist Judith Heerwagen of the GSA; National Institute of Building Sciences' Whole Building Design Guide; Center for the Built Environment at Berkeley; Centers for Disease Control and Prevention; Scandinavian Journal of Work, Environment and Health; Environmental Protection Agency; "Effects of the physical work environment on physiological measures of stress" by Julian F. Thayer, et al., for the GSA and National Institutes of Health

ARTISTS Laura Stanton, graphics editor, and Bonnie Berkowitz, graphics reporter, at the *Washington Post*.

STATEMENT Is your building killing you? Maybe not, but many office buildings contribute to our being sedentary, uncomfortable, sleep-deprived, and foggy-brained. We collected a list of common-but-detrimental features of workplaces, and realized our own building would be a good way to depict dated — and unhealthy—workplace design. This loosely depicts our office, with everyone who worked in the *Post*'s infographics department at the time represented, plus a few editors from Health and Science. The *Post* is scheduled to move into a new building within the next couple of years. The mouse isn't coming.

PUBLICATION *Washington Post* (June 8, 2014)

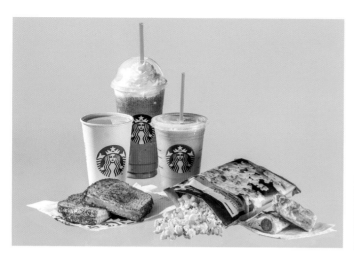

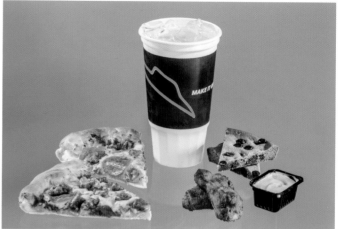

STARBUCKS Java Chip Frappucino (460), latte (190), orange mango smoothie (270), grilled cheese (580), popcorn (125), sausage croissant (410).

PIZZA HUT Meat Lover's Stuffed Crust pizza (880), baked wings with blue cheese (340), Mountain Dew (440), two cookies (360).

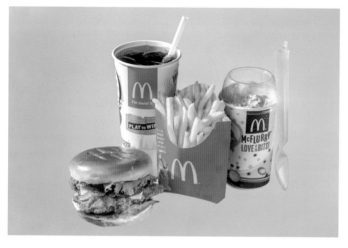

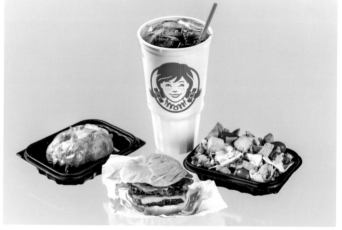

MCDONALD'S Crispy Chicken sandwich with bacon (750), fries (340), Coke (200), McFlurry with Oreos (690).

WENDY'S Baconator Cheeseburger (940), Potato with bacon and cheese (520), Caesar salad (250), Coke (320).

2,000 CALORIES

A day's worth of food, restaurant by restaurant.

P.F. CHANG'S Spinach (120), dumplings (195), orange beef (565), pad thai (580), caramel cake (430), wine (125).

OLIVE GARDEN Salad (150), breadstick (140), Tour of Italy sampler (1,500), quartino of wine (230).

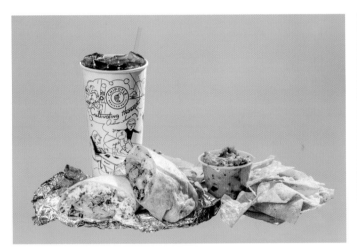
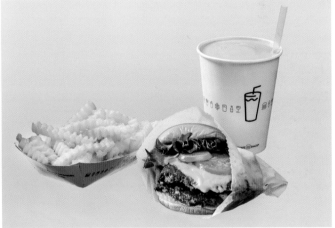

CHIPOTLE Carnitas burrito (945), chips and guacamole (770), Coke (276).

SHAKE SHACK Double ShackBurger (770), fries (470), Black and White shake (760).

ARTISTS Produced by Darcy Eveleigh, Upshot photo editor, and Troy Griggs; photography by Tony Cenicola; reporting by Josh Barro, Troy Griggs, David Leonhardt, and Claire Cain Miller, at the *New York Times*.

STATEMENT Depending on age and gender, most adults should eat between 1,600 and 2,400 calories a day. But what does 2,000 calories really look like? This shows the answer at a range of chain restaurants. Upshot photo editor Darcy Eveleigh wanted a clean graphic look for the food on different pastel-colored backgrounds; Tony Cenicola decided to shoot on clear Plexiglas to eliminate surface shadows and to make it easier to change colors.

PUBLICATION *nytimes.com* (December 22, 2014)

THE TRUTH ABOUT STARTUPS

Who succeeds? How much money do you need?

ARTISTS Graphic by Kristin Lenz, art director; text and reporting by Kris Frieswick, senior editor. Data from the Kauffman Foundation, analyzed by Susan Coleman, Carmen Cotei, and Joseph Farhat, University of Hartford.

STATEMENT Many people—and the media—pay great attention to companies started by young white male entrepreneurs. And there are a lot of assumptions about what resources give new companies a leg up. But when you look at the data,

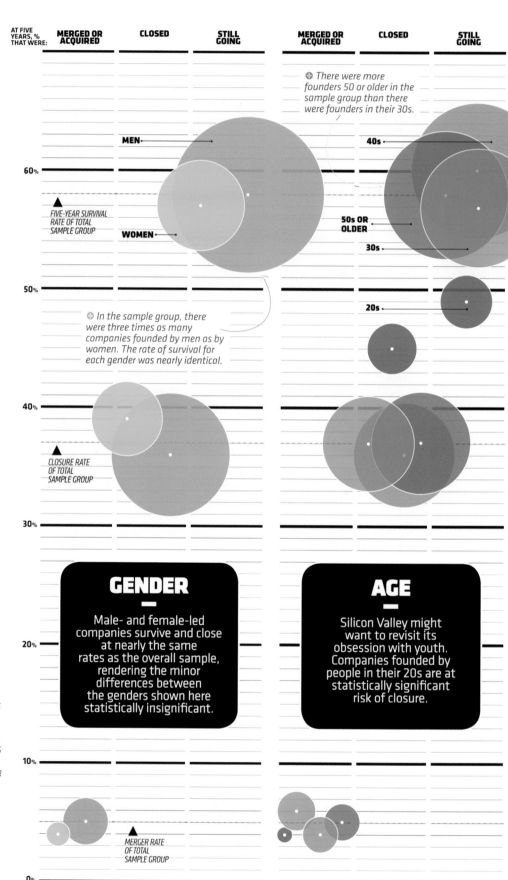

AT FIVE YEARS, % THAT WERE:

MERGED OR ACQUIRED · CLOSED · STILL GOING

MERGED OR ACQUIRED · CLOSED · STILL GOING

⊕ *There were more founders 50 or older in the sample group than there were founders in their 30s.*

MEN

40s

60%

FIVE-YEAR SURVIVAL RATE OF TOTAL SAMPLE GROUP

WOMEN

50s OR OLDER

30s

50%

20s

⊕ *In the sample group, there were three times as many companies founded by men as by women. The rate of survival for each gender was nearly identical.*

40%

CLOSURE RATE OF TOTAL SAMPLE GROUP

30%

GENDER
—
Male- and female-led companies survive and close at nearly the same rates as the overall sample, rendering the minor differences between the genders shown here statistically insignificant.

AGE
—
Silicon Valley might want to revisit its obsession with youth. Companies founded by people in their 20s are at statistically significant risk of closure.

20%

10%

2,000 COMPANIES

1,200

400

SIZE OF CIRCLES REPRESENTS NUMBER OF COMPANIES

CENTER DOT REPRESENTS RATE OF MERGER, CLOSURE, OR SURVIVAL

MERGER RATE OF TOTAL SAMPLE GROUP

0%

you realize many of them are myths. These graphics show that people in their twenties are among the *least* successful company founders. People in their thirties, forties, and fifties had about a 10 percent higher success rate than the younger crowd.

Funding levels and ownership of intellectual property had little impact on five-year company survival rates.

Whites start the most companies, but those with Asian founders are more likely to survive. And though men start far more companies than women, there's only a 1 percent difference in their five-year survival rate—a statistically insignificant margin.

PUBLICATION *Inc. Magazine* (October 2014)

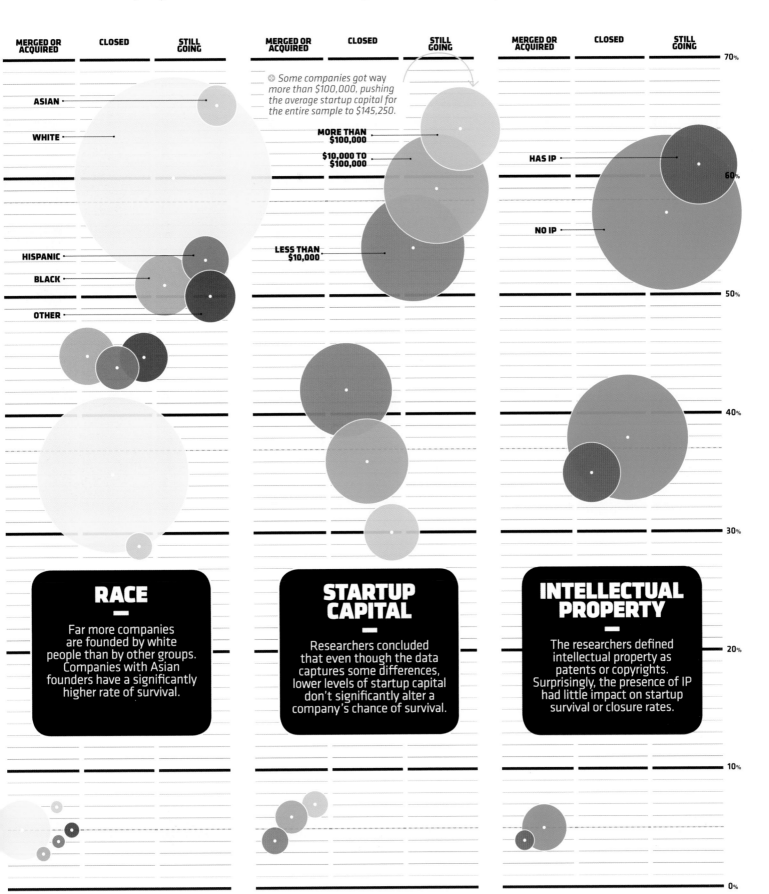

MERGED OR ACQUIRED | CLOSED | STILL GOING

ASIAN
WHITE
HISPANIC
BLACK
OTHER

⊗ Some companies got way more than $100,000, pushing the average startup capital for the entire sample to $145,250.

MORE THAN $100,000
$10,000 TO $100,000
LESS THAN $10,000

HAS IP
NO IP

70%
60%
50%
40%
30%
20%
10%
0%

RACE
—
Far more companies are founded by white people than by other groups. Companies with Asian founders have a significantly higher rate of survival.

STARTUP CAPITAL
—
Researchers concluded that even though the data captures some differences, lower levels of startup capital don't significantly alter a company's chance of survival.

INTELLECTUAL PROPERTY
—
The researchers defined intellectual property as patents or copyrights. Surprisingly, the presence of IP had little impact on startup survival or closure rates.

Who roots for which ball clubs?
A map of fandom.

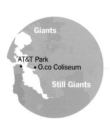

**San Francisco Giants
vs. Oakland Athletics**
Like the Mets, the Athletics
are the less-popular team
in a two-team region —
less popular everywhere in
that region, based on the
data from Facebook. Again,
winning the World Series
matters. The Giants have
won two of the last four.
The A's have won none of
the last 24.

Southern California
Highway 1 Passport
San Luis Obispo is often
considered a halfway
point between the Giants
and the Dodgers but it is
Dodgers territory,
according to Facebook
users. The Padres' plight
is personified by Adrian
Gonzalez, who was born
in San Diego, spent five
years as a Padres slugger,
but now is the Dodgers
main power source.

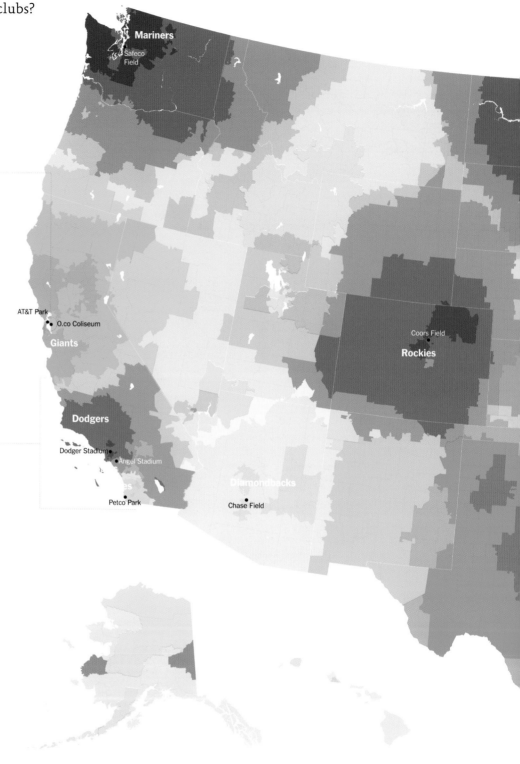

ARTIST Tom Giratikanon, Josh Katz,
and Kevin Quealy, graphics editors at the
New York Times, and David Leonhardt,
editor of The Upshot.

STATEMENT Many baseball fans have
wondered for decades where the borders
of fandom begin and end. Where in
Illinois does Cub country turn into Car-

**Chicago Cubs
vs. Chicago White Sox**

The Red Line Red Line

Helped by the charm of their field and by WGN's national broadcast reach, the Cubs have always been the better-loved of Chicago's two teams. Interstate 90 (the Dwight D. Eisenhower Express-way) is a rough guide to the border: Know whether you're north or south of it before you put on your hat.

Cubs
Wrigley Field
U.S. Cellular Field
White Sox

Yankees
Yankee Stadium
Citi Field
Also Yankees

Red Sox
Hartford
Yankees

Mets vs. Yankees

The We'd-Draw-a-Line-If-We-Could Line

The Yankees are preferred everywhere in New York City. A small Mets bright spot is the area surrounding Citi Field where Facebook users preferred the Yankees at a slightly reduced rate. The Mets did come in a strong second there, though.

**Yankees vs.
Boston Red Sox**

Munson-Nixon Redux

A new take on the Munson-Nixon line shows that Hartford has declared for the Yankees. It's still a border town, but in the way El Paso is — clearly on the Yankees' side. Red Sox Nation seems to have conquered some new territory since 2012; winning another World Series will do that.

Twins
Target Field

Brewers
Miller Park

Tigers
Comerica Park

Progressive Field

Wrigley Field
U.S. Cellular Field

Indians
PNC Park

Cubs
White Sox
Pirates

Reds
Great American Ball Park

Yankees
Yankee Stadium
Citi Field

Phillies
Citizens Bank Park

Orioles
Oriole Park at Camden Yards
Nationals Park

Nationals

Red Sox
Fenway Park

PEOPLE SAY "SUB" OR "HERO" **EAST** OF THIS LINE

PEOPLE SAY "HOAGIE" **WEST** OF THIS LINE

Trenton

METS FANS WHO EAT HOAGIES

Phillies
Mets

Mets vs. Philadelphia Phillies

The Sub-Hoagie Line

Last year's New York Times analysis of American dialects discovered the geographic line between people who call long sandwiches hoagies or subs. That line is remarkably similar to the dividing between Mets and Phillies fans.

yals
Kauffman Stadium

Busch Stadium

Cardinals

gers
Life Park

Astros
Minute Maid Park

Turner Field

Braves

Tropicana Field
Rays

Marlins Park
arlins

**Houston Astros
vs. Texas Rangers**

The Nolan Ryan Line

The state of Texas belongs to the Rangers, and why not? The team claims to represent the whole state, whereas the Astros belong merely to Houston, at least going by their name. It doesn't hurt that the Rangers have made the postseason three times in four years.

**St. Louis Cardinals
vs. Kansas City Royals**

The Denkinger Line

The Show Me State has mostly thrown in with the Cardinals, who have been as good for the last two decades as the Royals have been bad. The line is well west of the halfway point between the two cities — Columbia, Mo. — and instead runs through Sedalia and Pittsburg.

For this more detailed national version, we looked to a data source that catalogues millions of fan allegiances: Facebook. The company shared aggregate data for fandom in every ZIP code it had data for. We then applied an algorithm to smooth the data and fill in gaps. The result was a national map showing the geography of baseball fandom across the United States, with borders named in homage to the "Munson-Nixon line," the nickname coined by Steve Rushin of *Sports Illustrated* for the imaginary line running through Connecticut that separates Yankee and Red Sox fans.

PUBLICATION *New York Times*
(April 24, 2014)

dinal country? Where in Connecticut does Red Sox Nation give way to Yankee nation? (Sorry, Mets.) In 2006, John Branch, a sports reporter for the *Times*,

drove around Connecticut and asked people who they rooted for, eventually producing a crude fandom map of the two teams.

Inside the assault of a ferocious virus.

The virus can lurk in the body for more than a week before it begins a cascading meltdown of the immune system, blood vessels and vital organs.

DESCENT INTO HEMORRHAGIC FEVER

DAYS* 1 5 10 15

* Numbered from onset of symptoms

● EXPOSURE

Virus enters the body.

○ INCUBATION

Lasts two to 21 days, but most often four to 10 days before symptoms suddenly appear.

● EARLY SYMPTOMS

Usually, a little over a week after exposure to the Ebola virus, people begin having symptoms: fever, chills, muscle pain, sore throat, weakness and general discomfort. In its early stages, Ebola can resemble malaria, typhoid fever or bacterial respiratory infections.

● ADVANCED SYMPTOMS

After five or more days, patients often develop signature signs of an Ebola infection:

- Bumpy red rash on the face, neck, torso and arms; skin can flake off
- Severe diarrhea, nausea and vomiting
- Chest pain, shortness of breath, headache, confusion, bloodshot eyes, hiccups or seizures
- Spontaneous bruises, skin hemorrhages
- Bleeding from the eyes, ears, nose, mouth, mucus membranes and rectum
- Spontaneous miscarriage

● DEATH

Patients who die from the disease usually develop severe symptoms early on and die between days six and 16. The death rate can be as high as 90 percent.

○ SURVIVAL

In non-fatal cases, patients might have a fever for several days and improve, usually between days six and 11, but full recovery can be a long process involving inflamed nerves, recurrent hepatitis, bloodshot eyes and psychosis. Those who survive tend to have an early, strong and temporary inflammation response. Many survivors seem to have red blood cells that are able to release proteins that can fix damaged blood vessels.

❶ Finding a way in

Ebola virus particles occupy an infected person's blood and other bodily fluids, which can enter another person through the **eyes, mucus membranes, scratches** on the skin or from a **hypodermic needle** — but not from the air or from insects. The bodies of people who have died of Ebola are highly infectious.

Without protective equipment, shaking hands with an Ebola patient or being within three feet of a patient for long periods of time is less risky, but not advisable.

Cell-invasion strategy

Ebola is a filovirus, a tiny filament of proteins covering a single strand of genetic material, RNA, which carries only seven genes that code for viral reproduction and defense against the host's immune system.

Ebola virus

Host cell

Cell membrane

❷ Initial attack

- The virus attacks **immune cells** in the bloodstream, which carry the infection to the **liver, spleen** and **lymph nodes.** Ebola blocks the release of interferon, a protein made by immune cells to fight viruses.

- Infected immune cells migrate out of the spleen and lymph nodes, through the bloodstream or lymph ducts to other tissues

Lymph nodes

❷

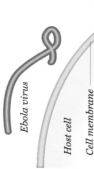

❸ Bloodstream trouble

- Proteins released by immune cells create widespread **inflammation,** which can damage the tissue lining blood vessels, causing them to leak.

 Macrophages, a type of immune cell that Ebola infects, release proteins that cause **clots in the bloodstream,** blocking blood flow to organs such as the liver and kidneys.

 Red blood cells break apart when moving through small vessels filled with clots. The spleen becomes overwhelmed with broken blood vessels.

 As cells in the liver are destroyed, the **blood loses its normal ability to clot,** exacerbating any internal or external hemorrhaging. Massive blood loss is not a frequent result of

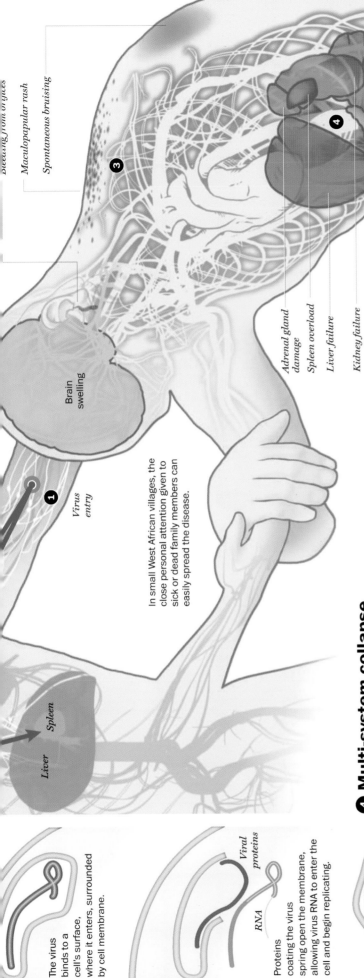

Bleeding from orifices

Maculopapular rash

Spontaneous bruising

3

Brain swelling

1

Virus entry

Liver *Spleen*

In small West African villages, the close personal attention given to sick or dead family members can easily spread the disease.

4

Adrenal gland damage

Spleen overload

Liver failure

Kidney failure

An infected pancreas can cause severe abdominal pain.

Intestinal damage causes diarrhea and dehydration.

④ Multi-system collapse

Ebola damages many kinds of tissue in the body, either by direct infection of cells by the virus or by the body's extreme inflammatory response.

• A breakdown of the **adrenal glands** leads to dangerously low blood pressure and a decreased ability to produce steroid hormones.

• The body's **connective tissues** are attacked, as are the cells that line body cavities and surfaces.

• Fluid accumulates in the **brain**. Convulsions can cause patients to spread infectious blood and bodily fluids.

• People who die from Ebola succumb to very **low blood pressure, multiple organ failure** and the **shock** of severe infection.

Sources: CDC, New England Journal of Medicine, NIH, Science, The Lancet, Nature

PATTERSON CLARK/THE WASHINGTON POST

The virus binds to a cell's surface, where it enters, surrounded by cell membrane.

Viral proteins

RNA

Proteins coating the virus spring open the membrane, allowing virus RNA to enter the cell and begin replicating.

Exit from the cell isn't fully understood, but virus particles seem to collect at the cell surface and protrude, exiting with perhaps a host envelope.

PUBLICATION *Washington Post*
(October 3, 2014)

ARTIST Patterson Clark, graphics editor at the *Washington Post.*

STATEMENT The goal was to demystify Ebola by explaining how the virus is transmitted and how it affects the body. The primary sources for information were peer-reviewed medical research papers, which helped steer the graphic past popular misconceptions about the disease, particularly the widely held belief that Ebola often leads to massive external bleeding, which it does not in most cases. Organ systems were exported in layers from a fully rigged 3D anatomy model in Maya, and reworked in Photoshop.

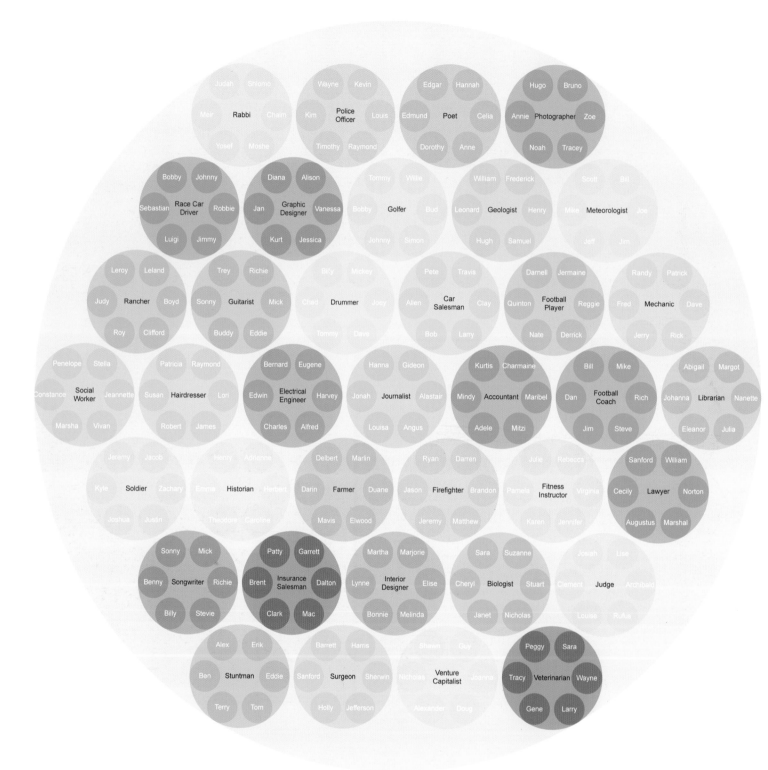

NAMES BY PROFESSION

Race-car drivers really are named Bobby.

ARTIST Mark Edmond, app developer at Seattle-based Verdant Labs.

STATEMENT While buried under baby name books in search of a name for my daughter, I wondered: What are people with these names actually *like*? If you looked at enough data, would you uncover differences between, say, the career paths of Isabelles and Alexandras? To my surprise, the answer was a resounding yes. The chart here shows names that are disproportionately common in various professions. Many of the results seem fitting — it's not hard to picture Abigail as a librarian, Roy as a rancher, or Theodore as a historian. For computer scientists, the top names are Alec, Dustin, Garrett, Nigel, Evan, and Stephan, which carried a personal surprise: we had named our son Alec, unaware at the time that his is the top name in my profession.

PUBLICATION *verdantlabs.com* (December 30, 2014)

FOLLOW THE SPOT

A map of Jean Harlow's wandering beauty mark.

PAINTED BEAUTY SPOTS IN:

1 THE SECRET SIX (1931),
in the first two-thirds of the movie
1b THE SECRET SIX (1931),
in the final third of the movie
2 THE PUBLIC ENEMY (1931)
3 IRON MAN (1931)
WIFE VS. SECRETARY (1936)
4 PLATINUM BLONDE (1931)
5 THREE WISE GIRLS (1932)
6 THE BEAST OF THE CITY (1932)
7 RED-HEADED WOMAN (1932)
8 RED DUST (1932)
HOLD YOUR MAN (1933)
BOMBSHELL (1933)
THE GIRL FROM MISSOURI (1934)
SUZY (1936)
9 DINNER AT EIGHT (1933)
LIBELED LADY (1936)
10 RECKLESS (1935)
11 CHINA SEAS (1935)
12 RIFFRAFF (1936)
13 PERSONAL PROPERTY (1937)

F during photo sessions

NO BEAUTY SPOTS IN:

HELL'S ANGELS (1930)
CITY LIGHTS (1931)
GOLDIE (1931)
SARATOGA (1937)

ARTISTS Robert Nippoldt, idea, research, illustration, design; Christine Goppel, illustration, design; David Ehlert, research.

STATEMENT The classic film actress Jean Harlow loved the look of a beauty mark, and often had one painted on — but during my book research, I noticed that in every movie and almost every photograph her beauty spot had moved to a different location. Sometimes it even wandered from one cheek to another during the same movie. By watching all her films and looking at hundreds of photographs, I started to make a face map of her moving beauty spot — one of those flirtatious little details that made her the screen's first blond sex goddess.

PUBLICATION *Hollywood in the 30s* (Winter 2014)

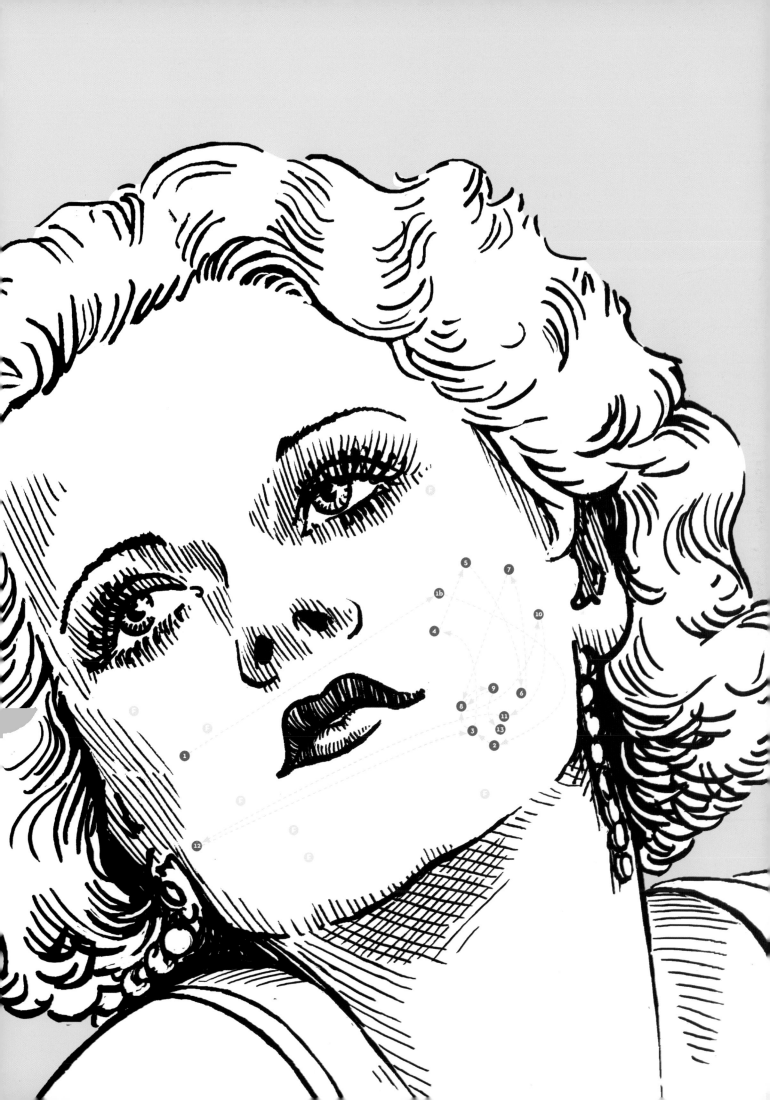

BEER ON TWITTER

A new way to map America's drinking preferences.

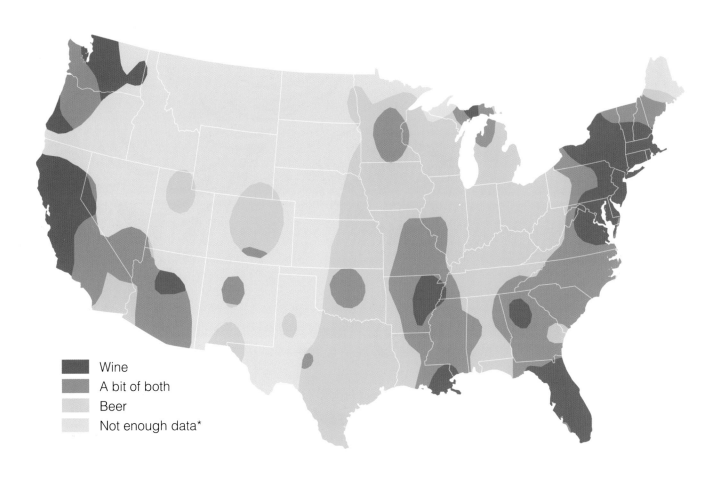

Wine
A bit of both
Beer
Not enough data*

ARTISTS Ate Poorthuis, PhD candidate, and Matthew Zook, department of geography, University of Kentucky. Both are part of the larger FloatingSheep collective from which this work emerged.

STATEMENT The daily practices of our lives are increasingly visible via social media, which records not only what we do, but where. In this case we took ad-

vantage of an ongoing research project at the University of Kentucky that collects every geotagged tweet in the world. We found there were close to 1 million geocoded tweets about beer in 2012, and by comparing subsets of the data, we could start to map differences in the preference for wine versus beer, which light beers were more discussed, and regional brand preferences. Visualizations like

this are a new kind of hybrid geography that weaves together the physical and the digital. You can think of it as "beer space."

PUBLICATION *The Geography of Beer: Regions, Environment, and Societies* (Spring 2014)

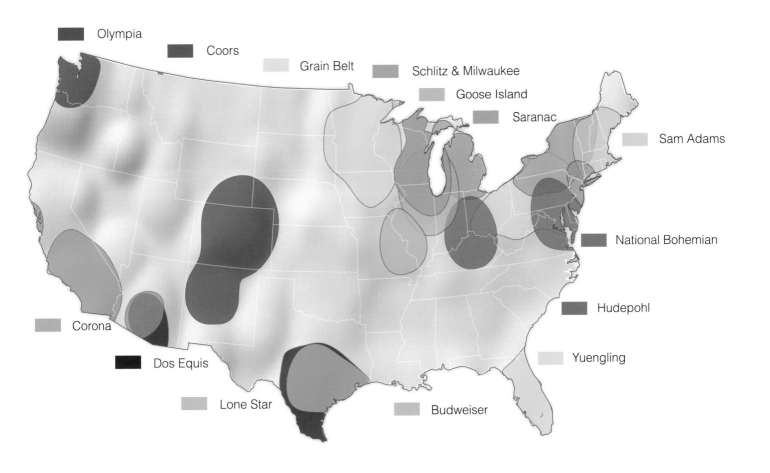

Olympia
Coors
Grain Belt
Schlitz & Milwaukee
Goose Island
Saranac
Sam Adams
National Bohemian
Hudepohl
Yuengling
Corona
Dos Equis
Lone Star
Budweiser

Coors Light
Busch Light
Busch/Miller Lite
Bud Light
Not enough data*

YOUR LIFE, IN WEEKS

If you stack them up, it's not as many as you think.

ARTIST Tim Urban, writer/illustrator and cofounder of *Wait But Why*.

STATEMENT We don't have that many weeks on this Earth, but it's very hard to internalize and remember just how finite that number is. When you look at this graphic, a count of your remaining weeks stares you in the face. It reminds you to use them wisely, and also that each week is a new opportunity—a fresh slate to work with. Ideally, it should cause both a feeling of urgency and inspiration.

PUBLICATION *waitbutwhy.com* (May 7, 2014)

The Life of a Typical American

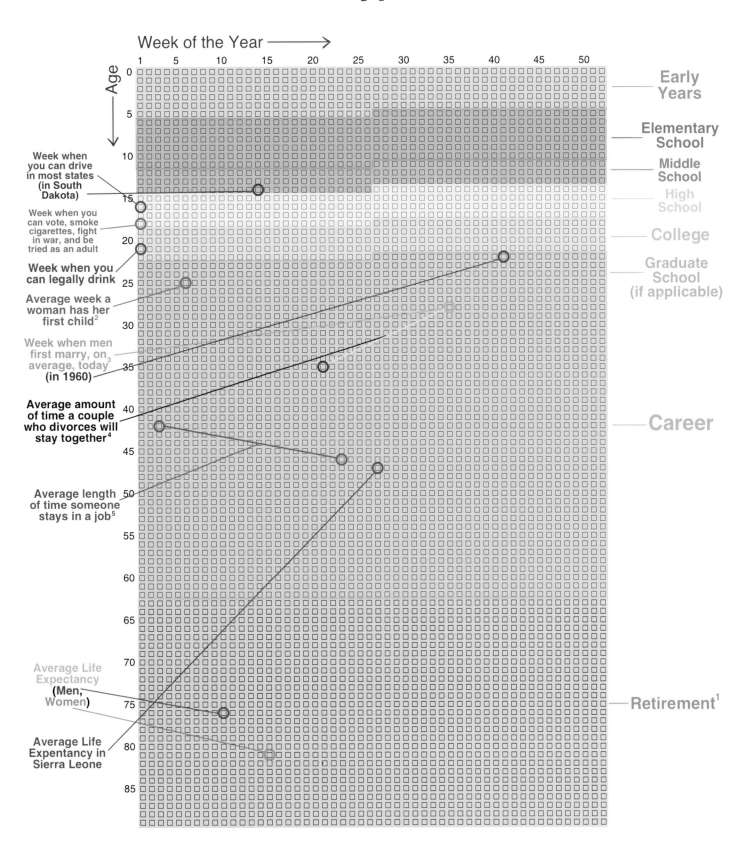

Week of the Year ——→

Age

| | 1 | 5 | 10 | 15 | 20 | 25 | 30 | 35 | 40 | 45 | 50 |

Early Years

Elementary School

Middle School

High School

College

Graduate School (if applicable)

Week when you can drive in most states (in South Dakota)

Week when you can vote, smoke cigarettes, fight in war, and be tried as an adult

Week when you can legally drink

Average week a woman has her first child[2]

Week when men first marry, on average, today[3] **(in 1960)**

Average amount of time a couple who divorces will stay together[4]

Career

Average length of time someone stays in a job[5]

Average Life Expectancy **(Men, Women)**

Retirement[1]

Average Life Expentancy in Sierra Leone

US

FOOD

The Future of Food
natgeofood.com

A Moveable Feast

This isn't a still life from 17th-century Europe. It's fresh produce from four upscale markets in Manhattan. Eating locally and reducing carbon footprints may be in, but these fruits and vegetables made big trips to the Big Apple—in some cases covering nearly 9,000 miles. In fact, in the United States, produce imports have increased significantly since 1980. Amit Ratanshi, a seller at a Bronx distributor, says New York chefs and shoppers "want to know where their food is coming from." That can mean a farm down the road, across the country, or—if it's exotic goods—half a world away.

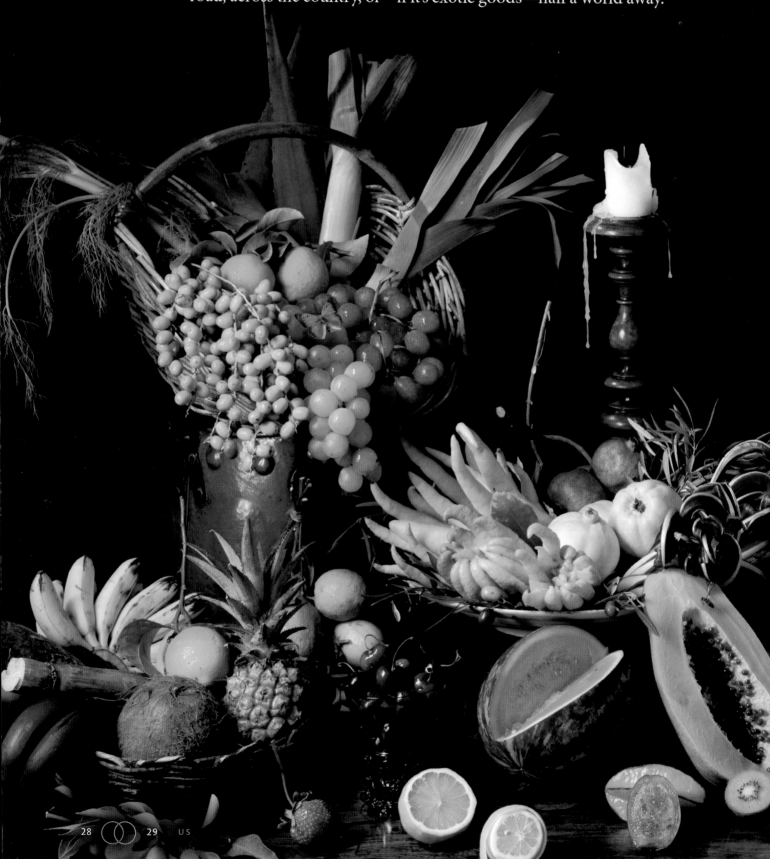

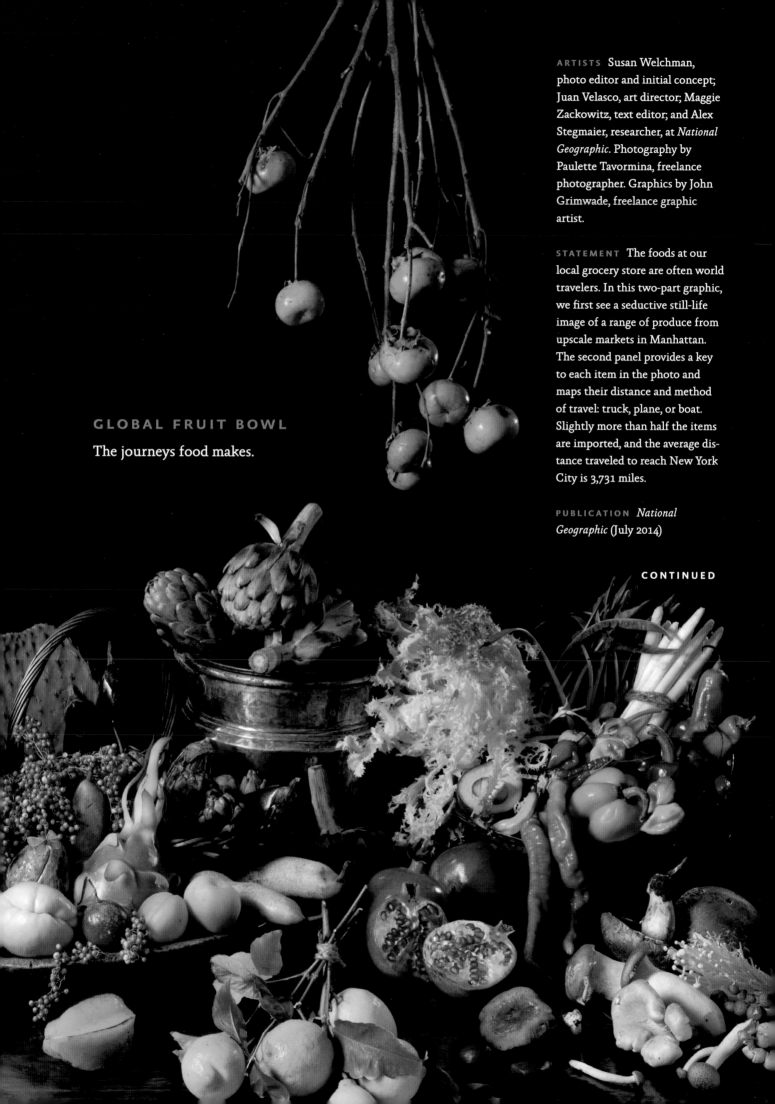

ARTISTS Susan Welchman, photo editor and initial concept; Juan Velasco, art director; Maggie Zackowitz, text editor; and Alex Stegmaier, researcher, at *National Geographic*. Photography by Paulette Tavormina, freelance photographer. Graphics by John Grimwade, freelance graphic artist.

STATEMENT The foods at our local grocery store are often world travelers. In this two-part graphic, we first see a seductive still-life image of a range of produce from upscale markets in Manhattan. The second panel provides a key to each item in the photo and maps their distance and method of travel: truck, plane, or boat. Slightly more than half the items are imported, and the average distance traveled to reach New York City is 3,731 miles.

PUBLICATION *National Geographic* (July 2014)

GLOBAL FRUIT BOWL

The journeys food makes.

CONTINUED

 (FOOD) **Behind the Moveable Feast**

DISTANCE (MILES) AND
TIME TO NEW YORK CITY

1. Dragon fruit
8,970, 1-2 days

2. King oyster mushrooms
7,420, 1-2 days

3. Enoki mushrooms
6,920, 1-2 days

4. White hon-shimejis
6,760, 1-2 days

5. Apricots
8,845, 1-2 days

6. Kiwi
8,845, 1-2 days

7. Papaya
5,330, 7-10 days

8. Chanterelles
2,465, 1-2 days

9. Buddha's hands
2,665, 2 days

10. Passion fruit
2,890, 3-4 days

Fresh produce shown in preceding pages

Big-city produce comes from near and far. Dartmouth geographer
Susanne Freidberg says that's nothing new. In the 19th century,
before cold storage, New Yorkers got Christmas citrus
from Italy. Modern global trade grew as vehicles and
cargo did. Today food moves quickly, thanks to
improved transport logistics.

PRODUCE MILEAGE*

The total distance traveled by all
the food items combined is about
223,875 miles. That's enough to
travel around the Earth roughly
nine times.

Average distance traveled
for all of the items: **3,731 miles**

Average time: **4-5 days**

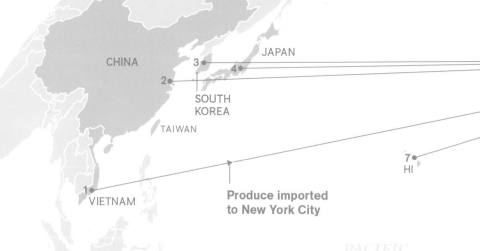

Produce imported
to New York City

HOW THEY TRAVELED

 22 by truck

 21 by plane

 17 by boat

ORIGINS

 32 international

28 domestic

*Distances, routes, and locations are estimates;
only primary forms of transportation shown

ART BY JOHN GRIMWADE AND HAISAM HUSSEIN; ALEXANDER STEGMAIER,
NGM STAFF; MEG ROOSEVELT

SOURCES: EATALY/BALDOR SPECIALTY FOODS; MANHATTAN FRUIT EXCHANGE;
WHOLE FOODS; G. PAGE WHOLESALE FLOWERS

11. Persimmons
2,665, 2 days

12. Pomegranates
2,665, 2 days

13. Olive
2,660, 2 days

14. Italian hot peppers
2,940, 5 days

15. Red grapes
2,815, 5 days

16. Quinces
2,915, 3-4 days

17. Dates
2,635, 2 days

18. Kumquats
2,635, 2 days

19. Lemons
2,635, 2 days

20. Pink variegated lemon
2,940, 5 days

21. Limes
2,635, 2 days

22. Oranges
2,635, 2 days

23. Strawberry
2,940, 4 days

24. Artichokes
2,995, 3-4 days

25. Pepperberries
2,740, 2 days

26. Green pepper
2,800, 3-4 days

27. Star fruit
2,760, 3-4 days

28. Artichokes
2,995, 5-6 days

29. Baby fennel
2,800, 3-4 days

30. Cipollini onions
2,050, 3-4 days

31. Aloe vera
2,685, 3-4 days

32. Cactus
2,685, 3-4 days

33. Chili peppers
2,685, 3-4 days

34. Watermelon
3,470, 5-7 days

35. Avocado
3,670, 5-6 days

36. Chayotes
4,000, 3-4 days

37. Shiitake mushrooms
135, 1 day

38. Portobello mushrooms
135, 1 day

39. Guava
1,220, 2-3 days

40. Sugarcane
1,220, 2-3 days

41. Yucca
2,590, 7 days

42. Coconut
2,590, 7 days

43. Red bananas
2,460, 7 days

44. Indian eggplant
2,040, 5-7 days

45. Graffiti eggplant
2,040, 5-7 days

46. Baby bananas
3,135, 7 days

47. White asparagus
3,645, 1-2 days

48. Dried chilies
5,740, 7-10 days

49. Cherries
5,740, 7-10 days

50. Bosc pear
6,775, 10 days

51. Prickly pear
5,300, 10 days

52. Leeks
3,820, 10-14 days

53. Orange pepper
3,820, 10-14 days

54. Chestnuts
4,815, 10-14 days

55. Frisée
4,055, 1-2 days

56. Green grapes
4,815, 10-14 days

57. Abate Fetel pears
4,825, 10-12 days

58. Puntarella
4,415, 1-2 days

59. Treviso radicchio
4,415, 1-2 days

60. Baby pineapple
8,970, 12 days

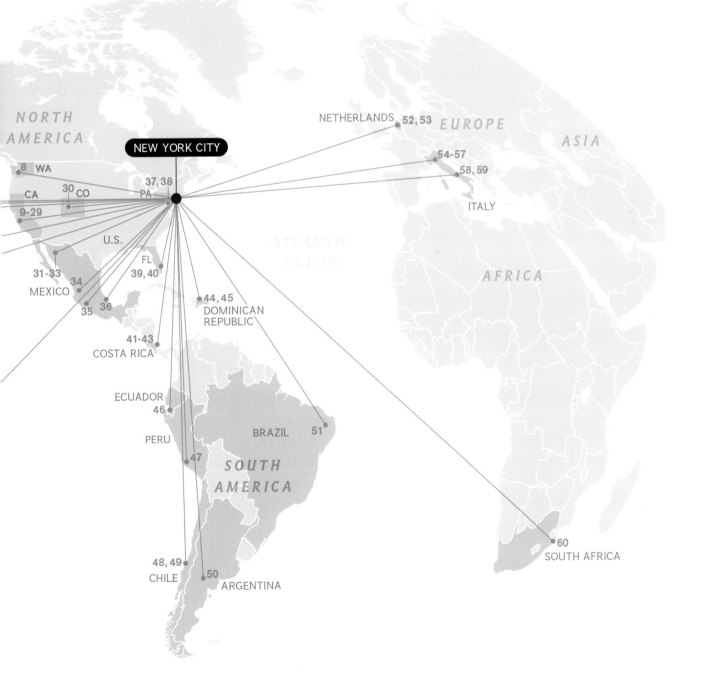

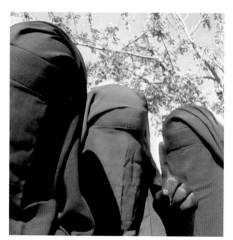

A photo, posted to Twitter, believed to be of Umm Ubaydah's friends in Syria.

WOMEN OF ISIS

Tweets from terrorist supporters.

ARTISTS Karishma Sheth, designer, and Thomas Alberty, design director, at *New York Magazine*.

STATEMENT After a number of young Muslim women from European countries left home to join ISIS fighters in Syria, several of them began tweeting. This graphic annotates one Twitter user's stream, which incorporates both ordinary Western teen stuff (pictures of cats) and less ordinary terrorist propaganda (excitement over beheadings).

PUBLICATION *New York Magazine* (September 8, 2014)

"Glory be to God" — **12:44 PM 1/14/14** SubhanaAllah these w

A conservative **head covering** worn by some Muslim women that exposes only the eyes. — me to get rid of my niqaab

In January, ISIS captured the Iraqi city of **Fallujah**. Umm Ubaydah tweeted gleefully about the takeover. — **1:29 AM 1/28/14** The lions of Fallujah

Used to connect with radicals abroad and occasionally to find husbands. — Twitter is such a dangero
mixing on here. **6:18 AM 1/29/14** PD

Pro-jihadist documents frequently circulate online. — afghans gave a hard time
-sheikh Tameem Al adnan

"party" — guys I demand a hafla **12:4 2/2**

Umm Ubaydah was offline for two weeks soon after this tweet, when she is presumed to have **made her way to Syria.** — my own house ☹ **2:20 AM 4/7/14** Bu
here and being a mujah

Through Tumblr, Kik, and Twitter, Umm Ubaydah **encouraged other women to join ISIS.** Twitter has stepped up efforts to block ISIS-linked users. — **4:10 AM 4/18/14** Sisters who are kik'ing
write hot stuff, not for

The ISIS government. — for sisters by dawlah in Mar

The day ISIS seized the Iraqi city of **Tikrit.** — etc **3:51 PM 6/11/14** Celebrations in M
banners waiving everywher
those in the west chilling in t

"prayer" — for salah, there is one on you

"a religious migration" — wanting to go back while

Umm Ubayadah **chats often with the other English-speaking expat wives,** including Umm Layth from Glasgow. — guides whom he wills **7:33 PM 7/23/14**
strongest types of women

Another **immigrant to ISIS.** — **3:59 AM 8/17/14** @UmmKhattab_ I'm

"a martyr, God willing" — **5:27 PM 8/17/14** Confusion over takes
because of bombs #shahe

The ISIS video showing the **beheading of journalist James Foley.** — America' made me so proud

Posted soon after *New York* **contacted her through Kik.** A few hours later, ISIS released a video of the beheading of a second journalist, Steven Sotloff. — me questions about why
killing their colleagues **8:42 9/4/**

"martyrdom" — us shahada together & unit

have gathered in my house and are trying to convince

'm going to miss this weather… **5:34 PM 1/18/14** Iraq 👌 🖤

y Allah grant them victory. **2:45 PM 1/28/14** Poetry 👌 **2:31 AM 1/29/14**

form tbh… I seriously advise to be cautious of free

e become my new best friends tbh **1:51 PM 1/31/14** "The

ssia, what will they do to Israel? They will eat them"

OOOOOL 😂 😩 **4:06 PM 2/19/14** 🎉 *hits a 100 followers*

od: **10:17 AM 2/25/14** … And I'm labelled as an extremist in

e honest, Wallahi there is so much khayr being

e, I wish I could describe the feeling, it's beautiful

can't emphasize enough on this, don't send me or

ty but for yours **4:19 PM 5/1/14** New Islamic clothing store

h reminders inside of ahadeeth, nullifiers of Islam

all day—gun shots ringing through the city, black

brothers handing out sweets #ISIS **9:41 AM 7/2/14** To all

omes. Know that just like there is a fardh upon you

ah. **5:16 AM 6/26/14** SubhanaAllaah many sisters are now

in the west would give anything to be here. Allaah

UmmLayth_: The wives of the Shaheed are the

come across. Epitome of independent women :D"

ng pancakes, and there's Nutella, come up in a bit

when you're almost sleep and the house shakes

nshaAllah #lol **9:57 PM 8/20/14** Wallah dawlahs 'Message to

qiyah! **5:59 AM 9/2/14** Lol I have American journalists asking

irahs like nutella while dawla is capturing and

sisters. We made hijrah together, May Allah grant

Jannah @UmmLayth_ @bintladen1

WHAT A SOLDIER'S ARM IS WORTH

VA benefits charted on the body.

ARTIST Alberto Cuadra, graphics editor at the *Washington Post*.

STATEMENT The hardships and problems disabled veterans can face with their health coverage are well-documented, but at the root of it is something hard for many of us to wrap our minds around: that there is actually a monetary value attached to the loss of an arm, or any other disability. This is a very simple daily piece that, to this day, still appalls me in terms of the brutal reality that lies beneath the data.

PUBLICATION *Washington Post* (March 20, 2014)

The price of getting wounded

The Department of Veterans Affairs method of compensating severely wounded veterans uses a grading system based on the person's injuries. The higher the grade, the larger the amount per month. Some rough examples:

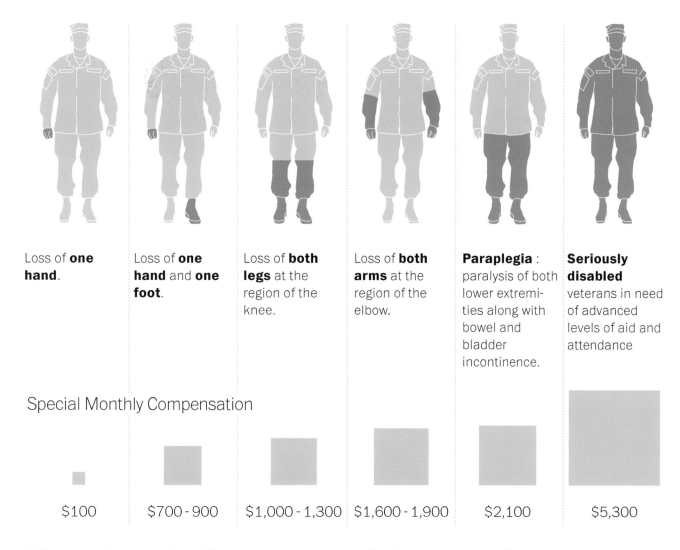

Loss of **one hand**.

Loss of **one hand** and **one foot**.

Loss of **both legs** at the region of the knee.

Loss of **both arms** at the region of the elbow.

Paraplegia : paralysis of both lower extremities along with bowel and bladder incontinence.

Seriously disabled veterans in need of advanced levels of aid and attendance

Special Monthly Compensation

| $100 | $700 - 900 | $1,000 - 1,300 | $1,600 - 1,900 | $2,100 | $5,300 |

* All numbers for veterans alone without spouses or dependents. Special monthly compensation rates are added to monthy disability payments. A veteran with a 100% rating is paid $2,858.24 a month.

Sources: U.S. Department of Veterans Affairs, Code of federal Regulations.

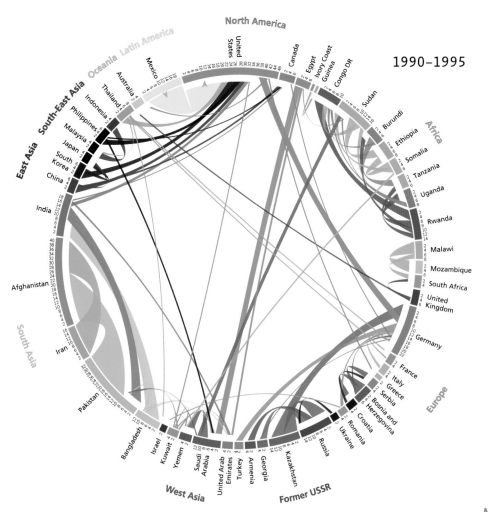

1990–1995

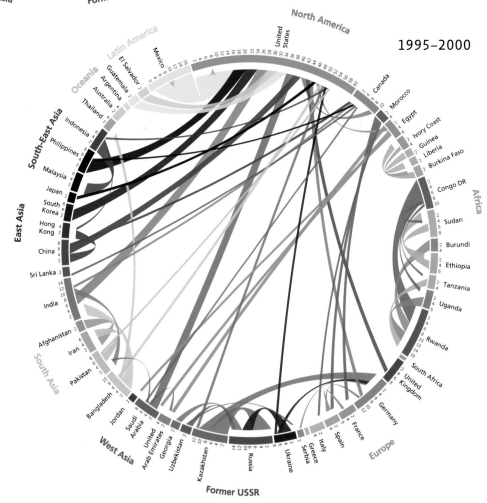

1995–2000

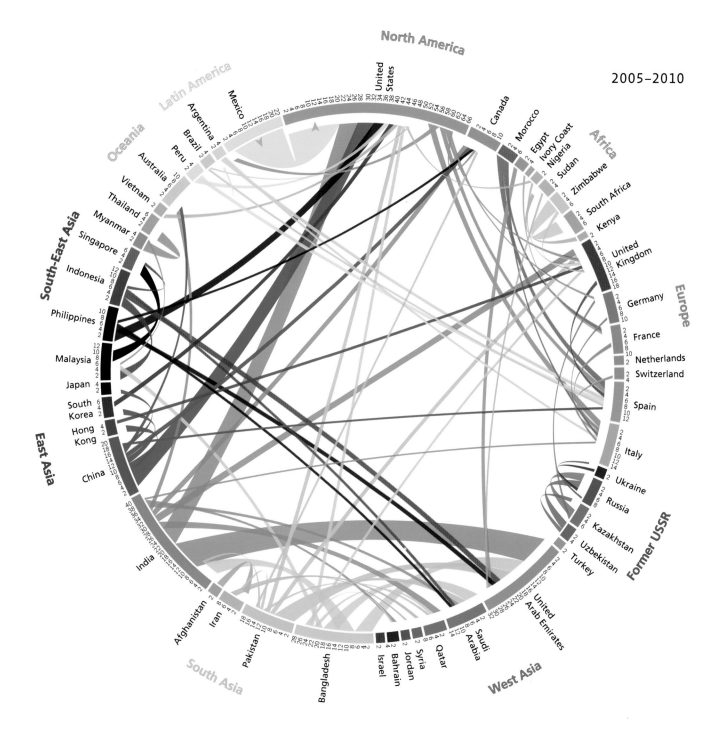

THE GLOBAL FLOW OF PEOPLE

A new way to see who migrates where.

ARTISTS Nikola Sander, Guy J. Abel, and Ramon Bauer, researchers, Vienna Institute of Demography, Austria.

STATEMENT International migration has become a hotly debated issue, but has long been very difficult to chart in a clear way. Traditional flow maps are constrained by the global geography of nation states. Our goal was to visualize the global system of migration flows in one easy-to-read graphic that could depict the relative size and direction of migration streams. The circular layout was inspired by visualizations of genomic data. Our new data set of migration between 196 countries presents estimates that are fully comparable, although it is highly complex; we reduced its complexity by focusing on migration between the 50 countries with the largest volume. The numbers on the outside of the circle indicate the total volume of movement to and from each country, in increments of 100,000. We also developed an interactive version.

PUBLICATION
Science (March 28, 2014)

Just how many E-flats are in "Für Elise"?

The Etudes o

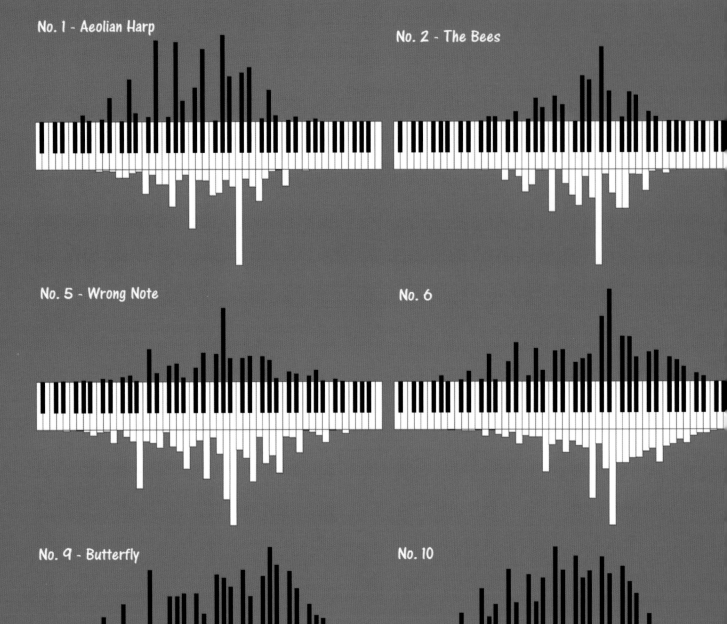

No. 1 - Aeolian Harp

No. 2 - The Bees

No. 5 - Wrong Note

No. 6

No. 9 - Butterfly

No. 10

ARTIST Joseph Yuen, creator of joey-cloud.net and a cyber-security scientist in Australia's Defence Science and Technology Organisation (DSTO).

STATEMENT The idea for this graphic came during piano practice, when I wondered how often each key gets played in each piece of music. I took out a notepad and tallied up by hand the

note frequencies for Beethoven's famous "Für Elise." The resulting sketch motivated me to build an app that counts the notes in any piano work uploaded in MIDI format; it displays them as a bar

hopin (Op. 25)

3 - The Horseman

No. 4 - Agitato

7 - Cello

No. 8

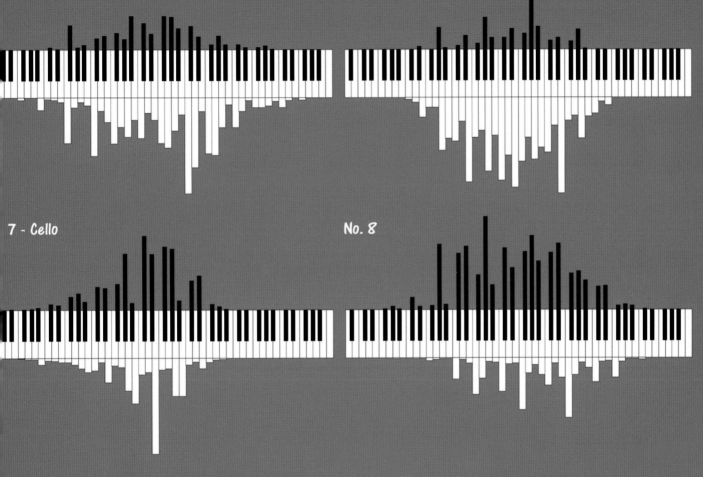

. 11 - Winter Wind

No. 12 - The Last One

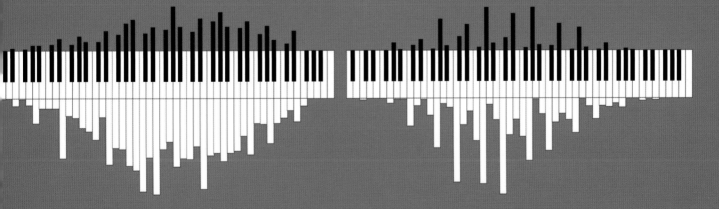

chart styled to look like a keyboard. The length of each key indicates how often it is played. It was fun visualizing various classical piano works and seeing patterns or shapes that are unique to specific composers—especially Chopin's etudes, of which I made and shared posters that have been well received by both music lovers and visualization practitioners.

PUBLICATION *JoeyCloud.net*
(September 18, 2014)

AMERICA'S GDP, SPLIT

Portrait of a lopsided economy.

UNITED STATES ECONOM

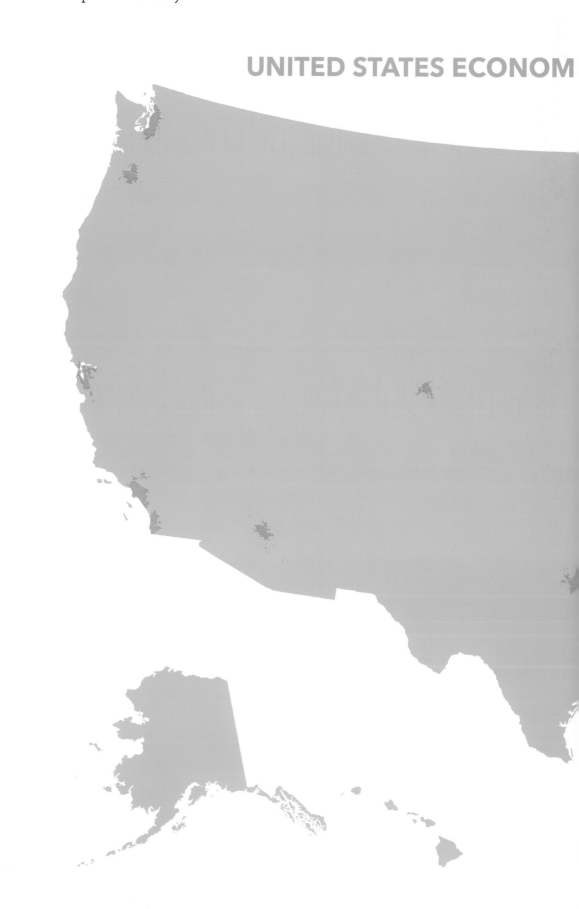

40 41 US

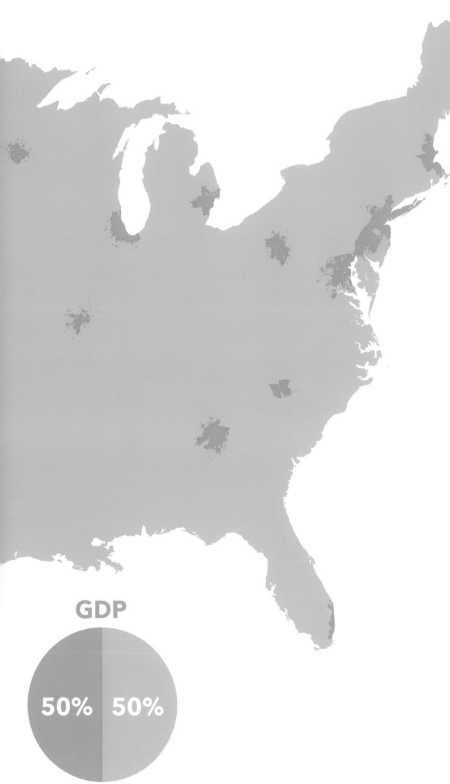

GDP

50% 50%

ARTIST Alexandr "Sasha" Trubetskoy, Washington, DC–based geographer.

STATEMENT This map shows how geographically concentrated America's economic resources are: the GDP of the blue area is equal to the GDP of the combined orange areas. I wanted to visualize the country's economic divide in a way that was visually striking, and in searching for the most lopsided possible split, I sifted through GDP data and realized that the top six metro areas account for a quarter of GDP. That got me curious on what the half-and-half version would look like. The orange areas are the 23 largest metro areas by GDP. When added together, their figure equals that of the rest of the country.

PUBLICATION *ispol.com/sasha*
(February 16, 2014)

The intricate network of
high-powered New York
restaurateurs.

ARTISTS Christopher Cristiano,
designer; Mary Jane Weedman, writer;
Kate Copeland, portrait illustrator;
Rob Patronite and Robin Raisfeld, ed-
itors; Thomas Alberty, design director;
and Adam Moss, editor in chief, at
New York Magazine.

STATEMENT The New York restau-
rant business is famously demand-
ing—and highly dependent on who
you know. "How the Restaurant
Game Is Played" makes visible the
interconnected nature of the industry.
Name-brand eateries and their chefs
are the hubs in a complex network
that shows who's who in the food
world, and who used to work for
whom.

PUBLICATION *New York Magazine*
(December 29, 2014)

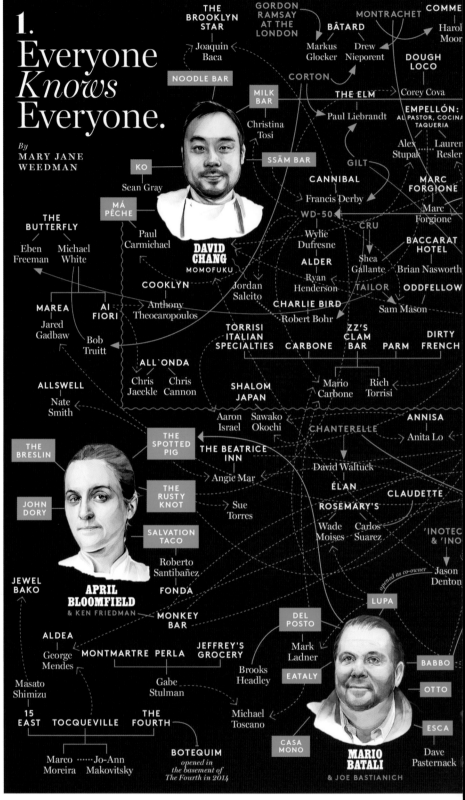

1.
Everyone *Knows* Everyone.

By
MARY JANE
WEEDMAN

IT'S UNCANNY HOW MANY CHEFS and restaurateurs have worked with the same handful of people. It's also a clue into how much relationships matter. A good mentor can be as important to a young chef's career as any amount of prep-kitchen wizardry. Take Rich Torrisi, who

LE BERNARDIN — Eric Ripert

EUGENE & CO. — Savannah Jordan

NOM WAH TEA PARLOR — Wilson Tang

FUNG TU — Jonathan Wu

FRANNY'S — Johnathan Adler

RUNNER & STONE — Peter Endriss

HOT BREAD KITCHEN — Ben Hershberger

UNCLE BOONS — Ann Redding Matt Danzer

THE MODERN — Abram Bissell

SHAKE SHACK — *opened as offshoot 2004*

O SOHM E BAR — ldo ohm

FRANÇOIS PAYARD BAKERY — François Payard

MU RAMEN — Joshua Smookler

PER SE — Thomas Keller / Eli Kaimeh

DANIEL — DANIEL BOULUD

CAFÉ BOULUD — Aaron Bludorn

AN AMERICAN PLACE — Larry Forgione

ESTELA — Ignacio Mattos

SEMILLA — José Ramírez-Ruiz

BOUCHON BAKERY

GOTHAM BAR & GRILL — Alfred Portale

TELEPAN — Bill Telepan

THE POLO LOUNGE

LINCOLN — Jonathan Benno

MAIALINO — Nick Anderer

MARTA

GRAMERCY TAVERN — Michael Anthony

sold in 2011

ELEVEN MADISON PARK — Daniel Humm

BETONY — Bryce Shuman

THE NOMAD

PIG AND KHAO — Leah Cohen

DO OR DINE — Justin Warner

DANNY MEYER

FREEMANS — Taavo Somer

ISA — Preston Madsen — Ginger Pierce

CHEF'S TABLE AT BROOKLYN FARE — Cesar Ramirez

HEARTH — Marco Canora

CRAFT — Tom Colicchio

IL BUCO — Justin Smillie

BOULEY — David Bouley

BARBUTO — Jonathan Waxman

KAREN DeMasco

LIZ Chapman

Damon Wise

LE CIRQUE — Sirio Maccioni

LAFAYETTE — James Belisle

BATTERSBY — Joe Ogrodnek / Walker Stern

DOVER

BLUE HILL AT STONE BARNS — Dan Barber

BLUE HILL

KING NOODLE — Nick Subic

ORLEANS — Oliver Vonderahe

MAYSVILLE — Kyle Knall

PECK'S — Theo Peck

ROBERTA'S — Carlo Mirarchi — BLANCA

FRITZL'S LUNCH BOX — Dan Ross-Leutwyler

PRUNE — Gabrielle Hamilton

Brian Leth

JAMS

LOCANDA VERDE

ANDREW CARMELLINI

THE DUTCH

BAR PRIMI

TXIKITO

LA VARA

EL QUINTO PINO — Alex Raij

VINEGAR HILL HOUSE — Jean Adamson

WALLSÉ — Kurt Gutenbrunner

Colin Alevras

THE COMMODORE — Stephen Tanner

PIES-N-THIGHS — Sarah Sanneh / Erika Williams / Carolyn Bane

EGG — Evan Hanczor

AL DI LÀ

PACIFICO'S — Shanna Pacifico

Gina DePalma

Jordan Frosolone

THE TASTING ROOM

hosted pop-ups

MISSION CHINESE FOOD — Danny Bowien

Sara Kramer

GLASSERIE — Amelia Telc

DINER

MARLOW & SONS — Tom Mylan *owns the Meat Hook*

REYNARD — Sean Rembold

ANDREW TARLOW

MORGENSTERN'S FINEST ICE CREAM

GG'S

SAVOY — Peter Hoffman

AUGUST — Josh Eden

Gabriel Kreuther

Frank Castronovo and Frank Falcinelli

JEAN GEORGES — JEAN-GEORGES VONGERICHTEN

ABC KITCHEN & COCINA

William Brasile

MORANDI

MINETTA TAVERN — Keith McNally — THE ODEON

EL QUIJOTE — Riad Nasr / Lee Hanson

BALTHAZAR

Nick Morgenstern

BACK FORTY WEST

BLENHEIM — Ryan Tate

MERCER KITCHEN

PERRY ST. — Cédric Vongerichten

NO. 7 — Tyler Kord

CO. — Jim Lahey

JACK'S WIFE FREDA — Dean and Maya Jankelowitz

BUVETTE — Jody Williams

VIA CAROTA — Rita Sodi

Hillary Sterling

VIC'S

FIVE POINTS

COOKSHOP

HUNDRED ACRES

Vicki Freeman Marc Meyer

worked with Andrew Carmellini in 2002 and now has an empire of his own, or Christina Tosi, who worked for Wylie Dufresne after graduating from cooking school in 2004 and is now chef-owner of Momofuku Milk Bar. Above, a partial sketch of a very interconnected world.

KEY
— CHEF/RESTAURATEUR
--→ WORKED AT
······ BAKER
→ INVESTOR
······ MARRIED
∿ FRONT OF HOUSE
— PASTRY CHEF
➡ NOW CLOSED
— FAMILY

Average hours spent in traffic
per driver, in selected regions (2012)

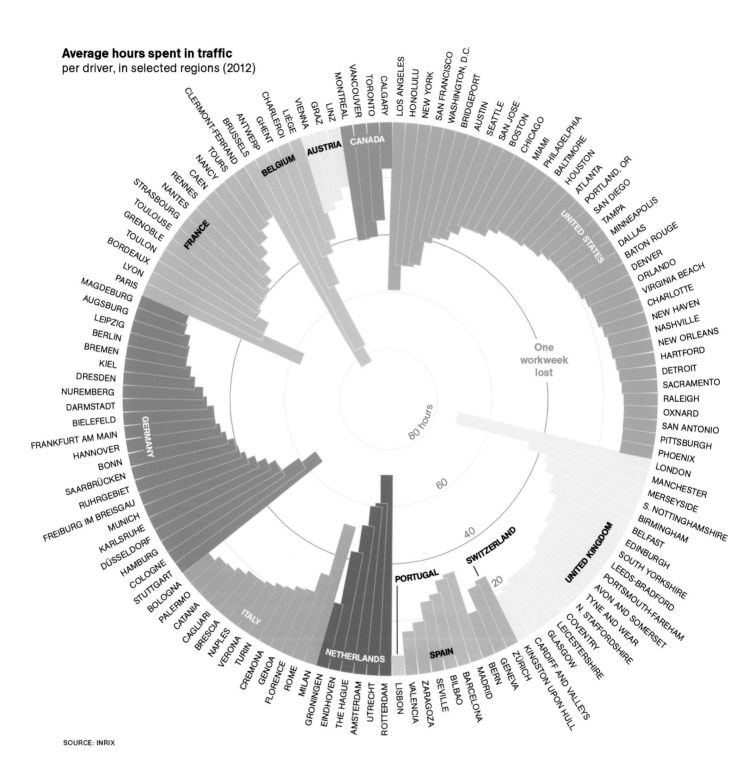

SOURCE: INRIX

COMMUTER SCIENCE

The lost hours of the daily rush.

ARTISTS Graphic by Ryan Morris, text by Catherine Zuckerman, art direction by Juan Velasco, at *National Geographic*.

STATEMENT Every driver complains about traffic, but just how much of your life do you lose to it? This graphic shows average time drivers spent in traffic congestion for large metro areas in North America and Europe in the year 2012. In many cities, annual delays per driver totaled more than a full 40-hour workweek. Delays were estimated by comparing real-time traffic observations with data for a typical commute. You can see here that some European cities are even more congested than American ones.

PUBLICATION *National Geographic* (April 2014)

LETTERS IN A WORD

J likes to begin, and Y prefers the end.

ARTIST David Taylor, data scientist at dtdata.io and creator of *prooffreader.com* blog.

STATEMENT We know that not all letters of the alphabet are equally common, but you might not have considered that they aren't distributed equally through words, either. This graphic shows how frequently each letter appears at the beginning, the middle, or the end of English words. (The charts are weighted for word frequency, so for example the *T* in *the* contributes more than the *T* in *thee*.) I have always found the success of an infographic lies in a good balance between the familiar and the unfamiliar. In this case, we've all used words and letters all of our lives, so when we see that *F* appears more often toward the end of words—or that *B* begins far more words than it finishes—it's both a revelation and something we could have easily figured out for ourselves.

PUBLICATION *prooffreader.com* (May 27, 2014)

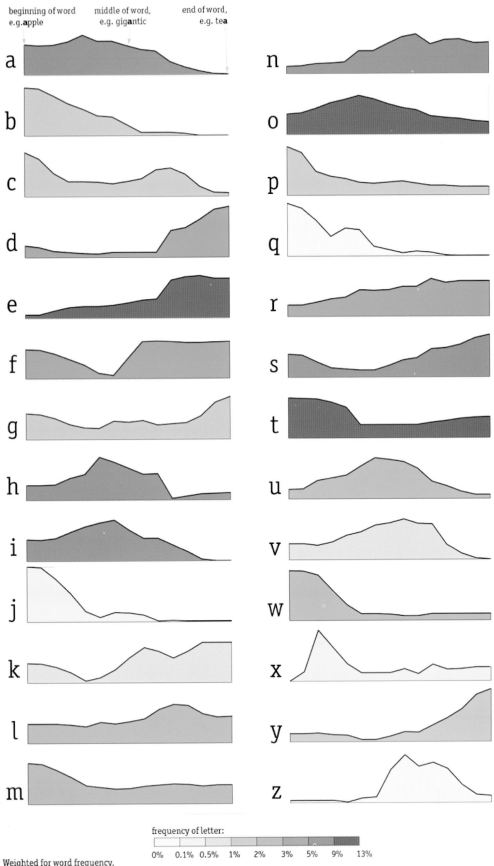

beginning of word
e.g. **a**pple

middle of word,
e.g. gig**a**ntic

end of word,
e.g. te**a**

a n

b o

c p

d q

e r

f s

g t

h u

i v

j w

k x

l y

m z

frequency of letter:

0% 0.1% 0.5% 1% 2% 3% 5% 9% 13%

Weighted for word frequency,
e.g. the t in "the" contributes
more than the t in "thee".

Source: Brown corpus
Methodology: www.prooffreader.com/explain.html

HOW FAST DO IDEAS MOVE?

The world is speeding up, but each branch of science has its own rhythm.

Life sciences tend to have a flatter citations trend [shaded portion], perhaps because ideas in the field are easier for other experts to grasp—in contrast to fields like mathematics—so it takes less time for them to catch on.

ARTISTS Giorgia Lupi, Simone Quadri, Gabriele Rossi, Glauco Mantegari, Pietro Guinea Montalvo, Davide Ciuffi, artists (Accurat). Katie Peek, art direction and writer at *Popular Science*.

STATEMENT In science, every new idea has a life cycle—it is born, catches on, and then either falls out of favor or becomes part of accepted knowledge. These graphs depict life cycles in a variety of fields by showing how often academic papers are cited, a useful shorthand for influence. This shows the 50-year citations record of the 20 largest fields of science, each represented as a wide ring, colored according to discipline.

Visually, we were inspired by musical notation, building circular "scores" for each discipline. We included both broader trends (the wide rings of color) and specific articles (individual music notes). The wider the ring, the longer papers published in that year were discussed in other academic articles before falling out of favor or becoming canon. We found that in most scientific disciplines—as in much of the broader culture—the life cycle of ideas is speeding up.

PUBLICATION *Popular Science*
(April 15, 2014)

Neurosciences

Biology

Biophysics

Genetics and heredity

HOW TO READ THE VISUALIZATION

Using the Thomson Reuters Web of Science database, we considered the 20 scientific fields with the most published articles. Within those fields, we measured the average time for the 50 most-referenced papers published each year to reach peak citations—how long it took the discipline's 50 biggest ideas to be adopted or disproved.

● **Shaded portion** is how long it takes the top 50 papers published each year to collectively reach the citations peak.

● **Darkest ring** marks the average time-to-peak over the period.

● **Dots** show the number of authors per paper.

● **Music notes** show the field's 20 leading articles over the 50-year span. Length of the note represents that paper's time to peak.

Years since publication ↑
35

1998, the last year analyzed
0

Date of publication
1948 or first year of discipline

Arcs connect the same author on multiple articles.

Length of the bar inside the circle represents the paper's total number of citations, including those that came after the peak.

Among the authors who wrote multiple top papers [arcs that link dots] are five Nobel laureates. John Pople, a theoretical chemist who won in 1998, appears twice in multidisciplinary chemistry and three times in physical chemistry.

Microbiology

Cell biology

Biochemistry and molecular biology

LIFE SCIENCES

DATA PROVIDED BY THOMSON REUTERS WEB OF SCIENCE; CONSULTATION BY JEVIN WEST, UNIVERSITY OF WASHINGTON

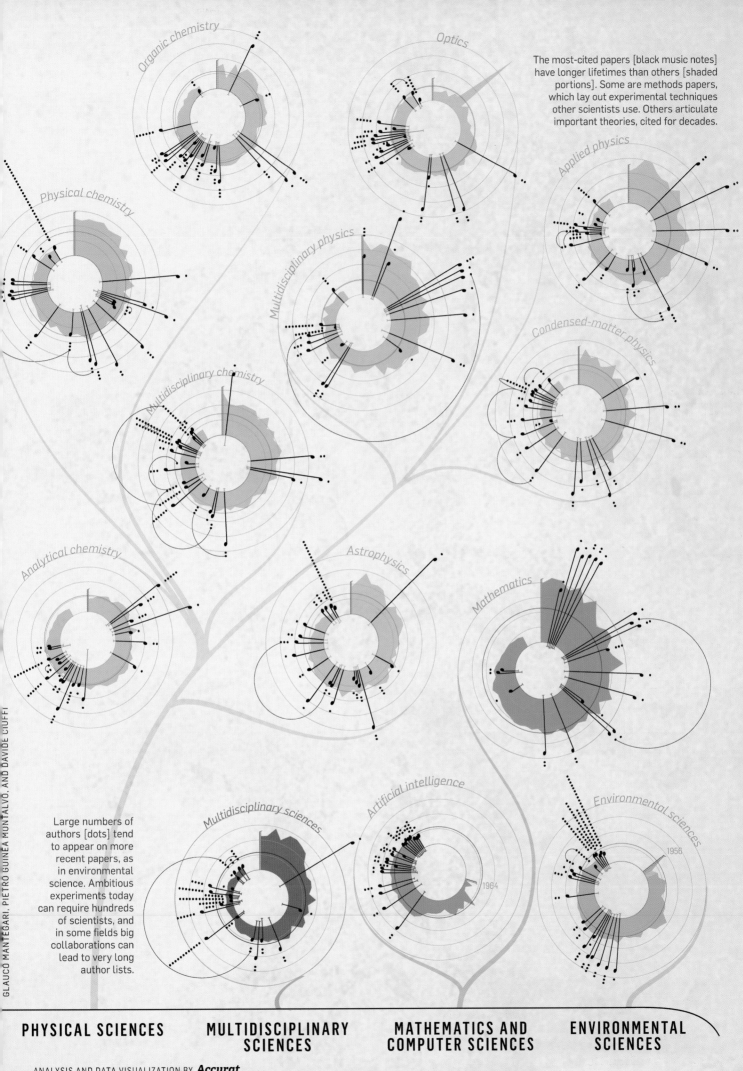

Organic chemistry

Optics

The most-cited papers [black music notes] have longer lifetimes than others [shaded portions]. Some are methods papers, which lay out experimental techniques other scientists use. Others articulate important theories, cited for decades.

Applied physics

Physical chemistry

Multidisciplinary physics

Condensed-matter physics

Multidisciplinary chemistry

Analytical chemistry

Astrophysics

Mathematics

Large numbers of authors [dots] tend to appear on more recent papers, as in environmental science. Ambitious experiments today can require hundreds of scientists, and in some fields big collaborations can lead to very long author lists.

Multidisciplinary sciences

Artificial intelligence

1964

Environmental sciences

1956

GLAUCO MANTEGARI, PIETRO GUINEA MONTALVO, AND DAVIDE CIUFFI

PHYSICAL SCIENCES

MULTIDISCIPLINARY SCIENCES

MATHEMATICS AND COMPUTER SCIENCES

ENVIRONMENTAL SCIENCES

ANALYSIS AND DATA VISUALIZATION BY *Accurat*

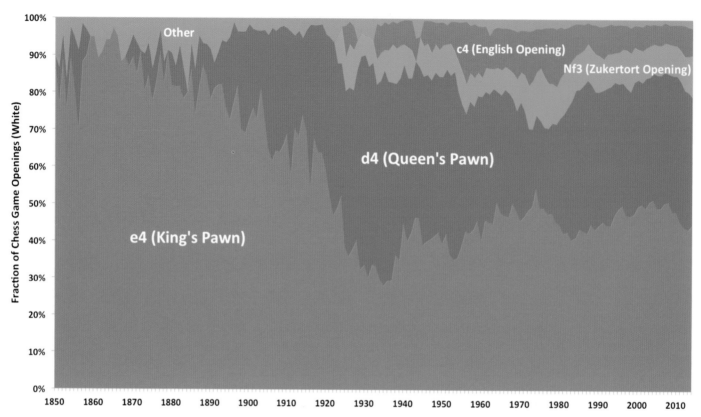

Fraction of Chess Game Openings (White)

100%
90%
80%
70%
60%
50%
40%
30%
20%
10%
0%

1850 1860 1870 1880 1890 1900 1910 1920 1930 1940 1950 1960 1970 1980 1990 2000 2010

Other

c4 (English Opening)

Nf3 (Zukertort Opening)

d4 (Queen's Pawn)

e4 (King's Pawn)

Data source: www.ChessGames.com | Author: Randy Olson (randalolson.com / @randal_olson)

CHESS TRENDS

How opening moves have changed
over time — or not.

ARTIST Randy Olson, computer science graduate research
assistant at Michigan State University.

STATEMENT These graphics reveal an untold history of
expert chess play over the past 164 years. The more popular
an opening move was in a given year, the larger the area that
move takes up on the chart. To the best of my knowledge,
no researcher had previously thought to look at the shifting
popularity of various chess openings over time. Perhaps the
most surprising finding from this project was how predicta-
ble opening play was in the nineteenth century: the first two
moves in the 1800s were almost always the same (in chess
notation: White moves its pawn to e4, Black then moves its
pawn to e5). By the early twentieth century, we finally saw a
"Cambrian explosion" of openings as chess experts began to
formally analyze chess openings and publish their strategies
in widely shared books. Still, despite there being thousands of
possible openings in chess, most expert chess games follow the
predictable pattern of a mere dozen openings that have been
meticulously analyzed and proven optimal.

PUBLICATION *randalolson.com* (May 26, 2014)

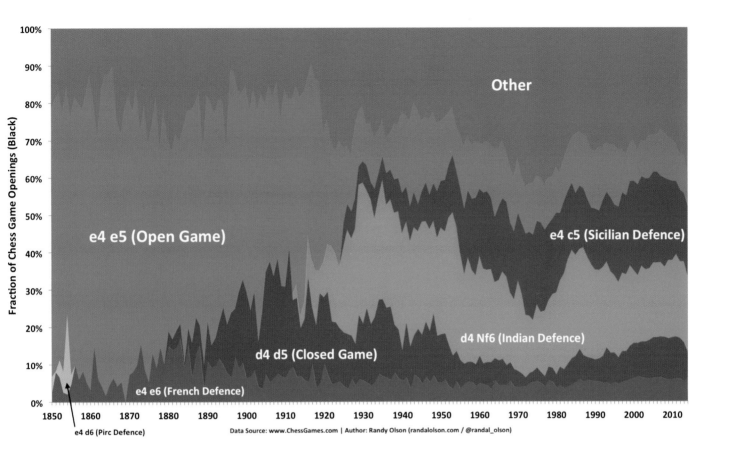

e4 e5 (Open Game)

Other

e4 c5 (Sicilian Defence)

d4 d5 (Closed Game)

d4 Nf6 (Indian Defence)

e4 e6 (French Defence)

e4 d6 (Pirc Defence)

Data Source: www.ChessGames.com | Author: Randy Olson (randalolson.com / @randal_olson)

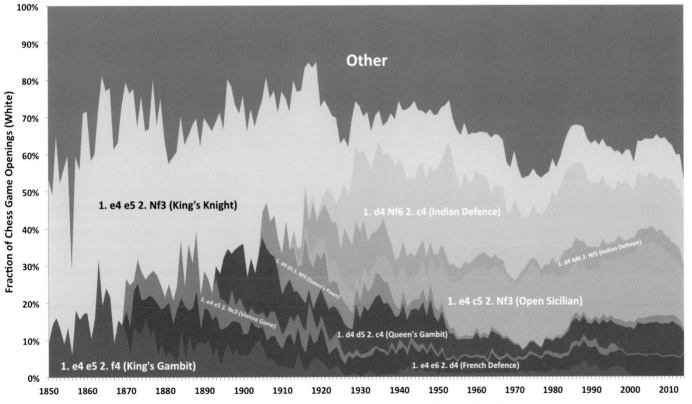

Other

1. e4 e5 2. Nf3 (King's Knight)

1. d4 Nf6 2. c4 (Indian Defence)

1. d4 d5 2. Nf3 (Queen's Pawn)

1. d4 Nf6 2. Nf3 (Indian Defence)

1. e4 e5 2. Nc3 (Vienna Game)

1. e4 c5 2. Nf3 (Open Sicilian)

1. d4 d5 2. c4 (Queen's Gambit)

1. e4 e5 2. f4 (King's Gambit)

1. e4 e6 2. d4 (French Defence)

Data source: www.ChessGames.com | Author: Randy Olson (randalolson.com / @randal_olson)

Global Ph.D.s by Gender

Doctoral Degrees Awarded From 1 · to 19,238

- ● Science and engineering (S&E)*
- ○ Other (not S&E)

- ■ Male
- ■ Female

*S&E data do not include health fields

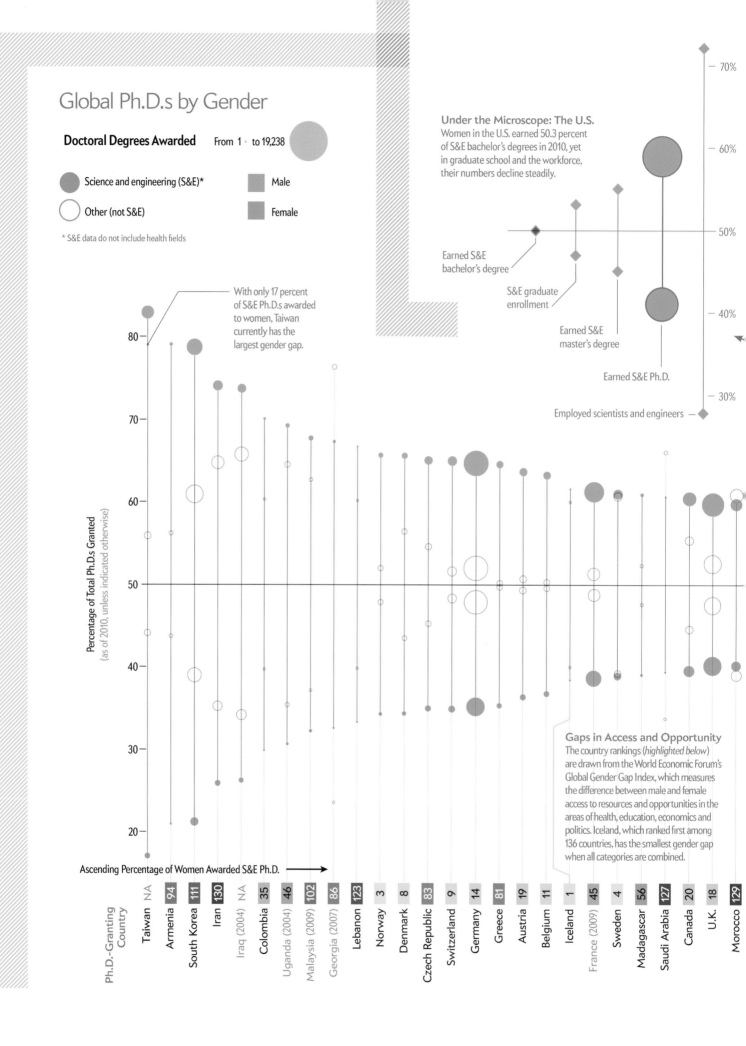

With only 17 percent of S&E Ph.D.s awarded to women, Taiwan currently has the largest gender gap.

Under the Microscope: The U.S.
Women in the U.S. earned 50.3 percent of S&E bachelor's degrees in 2010, yet in graduate school and the workforce, their numbers decline steadily.

Earned S&E bachelor's degree

S&E graduate enrollment

Earned S&E master's degree

Earned S&E Ph.D.

Employed scientists and engineers

Percentage of Total Ph.D.s Granted (as of 2010, unless indicated otherwise)

Ascending Percentage of Women Awarded S&E Ph.D. ⟶

Gaps in Access and Opportunity
The country rankings (*highlighted below*) are drawn from the World Economic Forum's Global Gender Gap Index, which measures the difference between male and female access to resources and opportunities in the areas of health, education, economics and politics. Iceland, which ranked first among 136 countries, has the smallest gender gap when all categories are combined.

Ph.D.-Granting Country

Country	Rank
Taiwan	NA
Armenia	94
South Korea	111
Iran	130
Iraq (2004)	NA
Colombia	35
Uganda (2004)	46
Malaysia (2009)	102
Georgia (2007)	86
Lebanon	123
Norway	3
Denmark	8
Czech Republic	83
Switzerland	9
Germany	14
Greece	81
Austria	19
Belgium	11
Iceland	1
France (2009)	45
Sweden	4
Madagascar	56
Saudi Arabia	127
Canada	20
U.K.	18
Morocco	129

THE SCIENCE GENDER GAP

Who gets PhDs?

ARTISTS Central graphic design by Melissa Lewis, data scientist; Kay Watson, visual designer; and Katie Hill, project and strategic design, at Periscopic, Portland, OR. Art direction and supplementary graphic by Jen Christiansen, art director of information graphics; and text by Seth Fletcher, senior editor, at *Scientific American*. Research by Amanda Hobbs, ATH Creative.

STATEMENT For a special magazine section on diversity in the field of science, we depicted the gender gap in science and engineering PhDs awarded around the world. Larger circles represent more PhDs awarded—the United States awards the most—and the distance between them is the gender gap in each country. Degrees in fields other than science and engineering are shown as hollow circles. An interactive version for the website allowed the reader to explore and sort PhDs awarded by gender, discipline, and geographic region.

PUBLICATION *Scientific American* (October 2014)

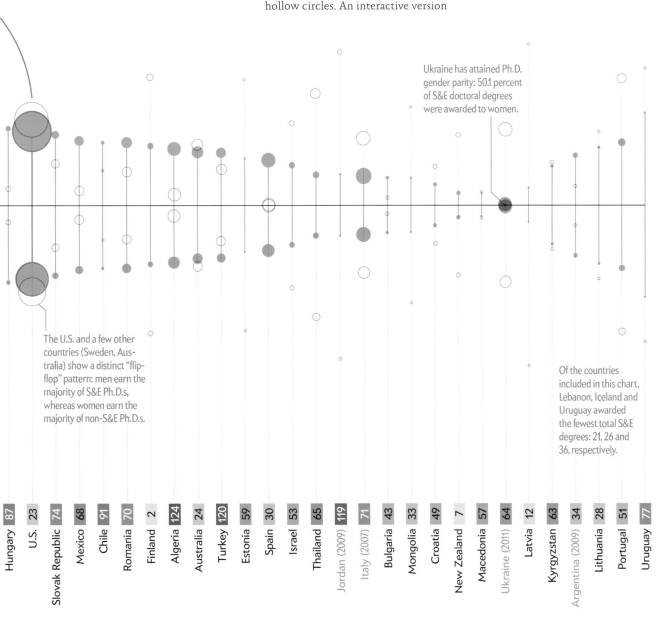

Ukraine has attained Ph.D. gender parity: 50.1 percent of S&E doctoral degrees were awarded to women.

The U.S. and a few other countries (Sweden, Australia) show a distinct "flip-flop" pattern: men earn the majority of S&E Ph.D.s, whereas women earn the majority of non-S&E Ph.D.s.

Of the countries included in this chart, Lebanon, Iceland and Uruguay awarded the fewest total S&E degrees: 21, 26 and 36, respectively.

Hungary 87 | U.S. 23 | Slovak Republic 74 | Mexico 68 | Chile 91 | Romania 70 | Finland 2 | Algeria 124 | Australia 24 | Turkey 120 | Estonia 59 | Spain 30 | Israel 53 | Thailand 65 | Jordan (2009) 119 | Italy (2007) 71 | Bulgaria 43 | Mongolia 33 | Croatia 49 | New Zealand 7 | Macedonia 57 | Ukraine (2011) 64 | Latvia 12 | Kyrgyzstan 63 | Argentina (2009) 34 | Lithuania 28 | Portugal 51 | Uruguay 77

SOURCES: *SCIENCE AND ENGINEERING INDICATORS 2014*, BY NATIONAL SCIENCE BOARD, NATIONAL SCIENCE FOUNDATION, 2014 (education data); *THE GLOBAL GENDER GAP REPORT 2013*, WORLD ECONOMIC FORUM, 2013 (WEF index)

Data relationships that only *look* true.

ARTIST Tyler Vigen, student at Harvard Law School.

STATEMENT I once saw an image where the murder rate in New York was correlated against the rising and falling slope of a theoretical mountain. The caption asked, "Is this mountain range affecting the murder rate?" The answer was obviously no, but it made a very visual point about how easy it is to see parallel trends and assume that they're somehow related. With the sheer number of statistics available, I realized that there must be a lot of unexpected and downright absurd actual correlations in the world.

I used data dredging to uncover strong annual correlations that almost certainly had nothing to do with one another, and illustrate the danger of expecting that correlation implies causation.

PUBLICATION *tylervigen.com* (May 2014)

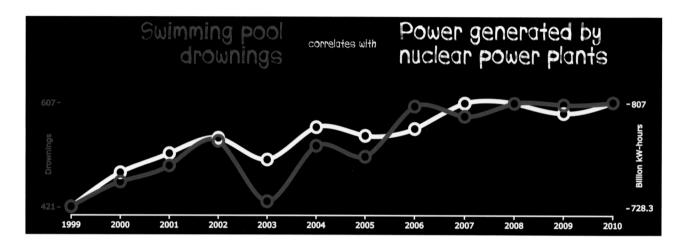

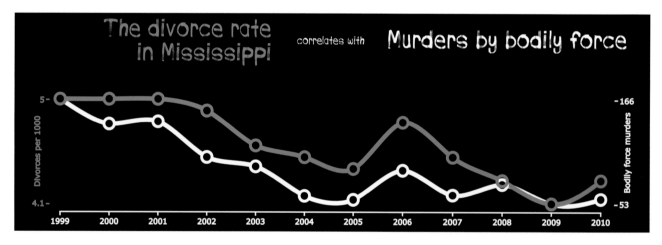

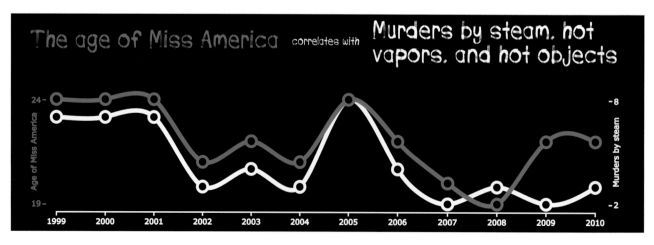

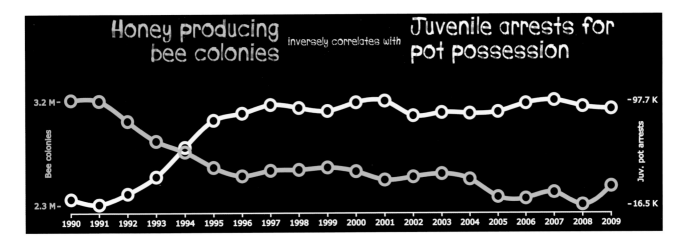

Honey producing bee colonies

inversely correlates with

Juvenile arrests for pot possession

Bee colonies: 3.2 M – 2.3 M
Juv. pot arrests: 97.7 K – 16.5 K

1990 1991 1992 1993 1994 1995 1996 1997 1998 1999 2000 2001 2002 2003 2004 2005 2006 2007 2008 2009

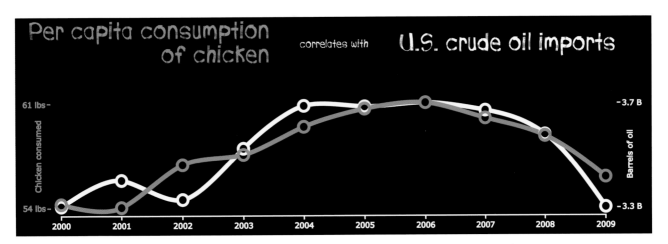

Per capita consumption of chicken

correlates with

U.S. crude oil imports

Chicken consumed: 61 lbs – 54 lbs
Barrels of oil: 3.7 B – 3.3 B

2000 2001 2002 2003 2004 2005 2006 2007 2008 2009

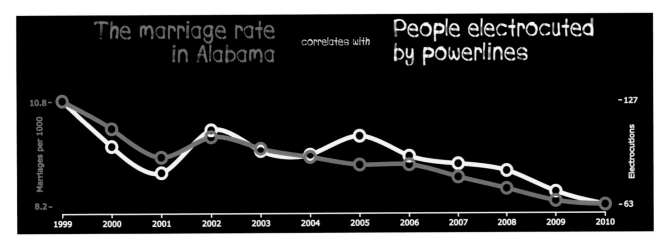

The marriage rate in Alabama

correlates with

People electrocuted by powerlines

Marriages per 1000: 10.8 – 8.2
Electrocutions: 127 – 63

1999 2000 2001 2002 2003 2004 2005 2006 2007 2008 2009 2010

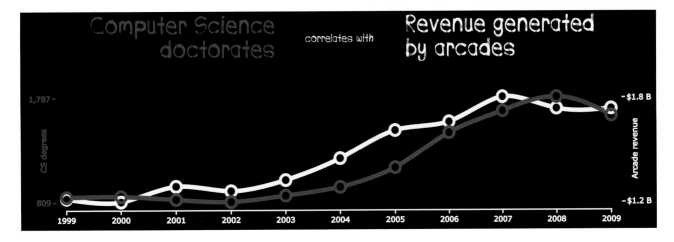

Computer Science doctorates

correlates with

Revenue generated by arcades

CS degrees: 1,787 – 809
Arcade revenue: $1.8 B – $1.2 B

1999 2000 2001 2002 2003 2004 2005 2006 2007 2008 2009

WHERE MILITANTS COME FROM

The flow of fighters to Syria.

ARTIST Gene Thorp, foreign graphics editor
and cartographer at the *Washington Post*.

STATEMENT Fighters from around the
globe have gone to Syria to join the battle to
overthrow President Bashar al-Assad's regime;
many are believed to now have joined the
Islamic State. This map shows where they
came from. We used an orthographic map
projection because it easily communicates the
immense distances these fighters have trave-
led; proportional lines combined into regional
flow arrows allowed us to convey multiple
levels of information seamlessly. Determin-
ing the best flow line routes and adjusting
their thickness was the most time-consuming
aspect of creating this graphic.

PUBLICATION *Washington Post*
(October 12, 2014)

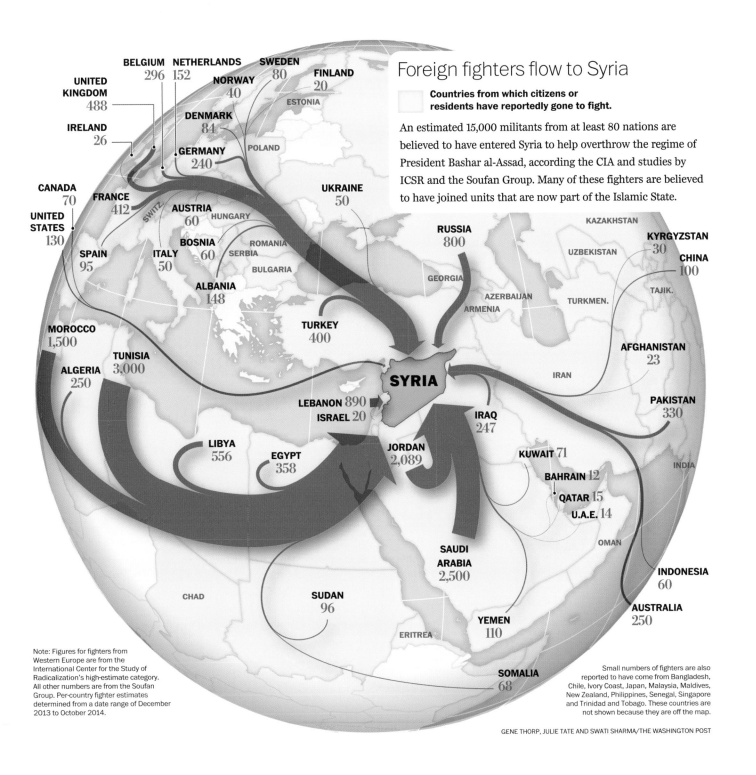

Foreign fighters flow to Syria

Countries from which citizens or residents have reportedly gone to fight.

An estimated 15,000 militants from at least 80 nations are believed to have entered Syria to help overthrow the regime of President Bashar al-Assad, according the CIA and studies by ICSR and the Soufan Group. Many of these fighters are believed to have joined units that are now part of the Islamic State.

UNITED KINGDOM 488

BELGIUM 296

NETHERLANDS 152

SWEDEN 80

FINLAND 20

NORWAY 40

ESTONIA

IRELAND 26

DENMARK 84

POLAND

GERMANY 240

UKRAINE 50

CANADA 70

FRANCE 412

SWITZ.

AUSTRIA 60

HUNGARY

RUSSIA 800

KAZAKHSTAN

UZBEKISTAN

KYRGYZSTAN 30

CHINA 100

UNITED STATES 130

SPAIN 95

BOSNIA 60

ITALY 50

ROMANIA

SERBIA

BULGARIA

GEORGIA

AZERBAIJAN

ARMENIA

TURKMEN.

TAJIK.

ALBANIA 148

MOROCCO 1,500

TURKEY 400

AFGHANISTAN 23

TUNISIA 3,000

IRAN

ALGERIA 250

SYRIA

LEBANON 890

ISRAEL 20

IRAQ 247

PAKISTAN 330

INDIA

LIBYA 556

EGYPT 358

JORDAN 2,089

KUWAIT 71

BAHRAIN 12

QATAR 15

U.A.E. 14

OMAN

SAUDI ARABIA 2,500

INDONESIA 60

CHAD

SUDAN 96

AUSTRALIA 250

ERITREA

YEMEN 110

SOMALIA 68

Note: Figures for fighters from Western Europe are from the International Center for the Study of Radicalization's high-estimate category. All other numbers are from the Soufan Group. Per-country fighter estimates determined from a date range of December 2013 to October 2014.

Small numbers of fighters are also reported to have come from Bangladesh, Chile, Ivory Coast, Japan, Malaysia, Maldives, New Zealand, Philippines, Senegal, Singapore and Trinidad and Tobago. These countries are not shown because they are off the map.

GENE THORP, JULIE TATE AND SWATI SHARMA/THE WASHINGTON POST

DEATHS IN DAY CARE

60 tragedies, personalized.

ARTIST Lazaro Gamio, graphics editor at the *Washington Post*.

STATEMENT Often the data we depict in infographics is plentiful and impersonal, like financial trends or carbon emissions. But sometimes the data set is small and extremely personal. For this graphic about deaths in Virginia day care centers, my colleague Todd Lindeman had the idea of representing each child with an empty onesie. I ended up drawing overalls or dresses for the older children. This turned what could have been a small by-the-num- bers graphic into a sprawling visual that forces the reader to come to terms with how tragic these deaths are.

PUBLICATION *Washington Post* (August 31, 2014)

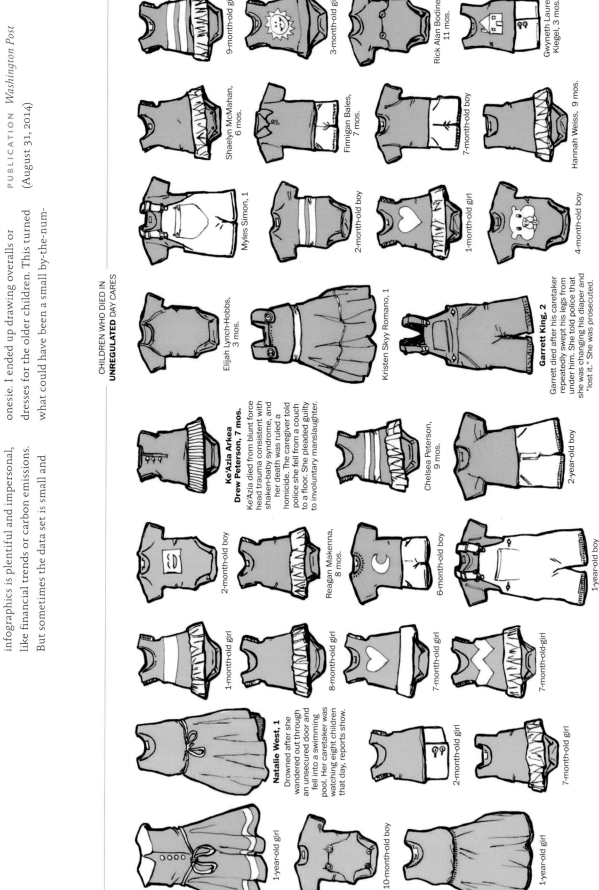

CHILDREN WHO DIED IN **UNREGULATED** DAY CARES

9-month-old girl

3-month-old girl

Rick Alan Bodine Jr., 11 mos.

Gwyneth Lauren Kiegel, 3 mos.

Shaelyn McMahan, 6 mos.

Finnigan Bales, 7 mos.

7-month-old boy

Hannah Weiss, 9 mos.

Myles Simon, 1

2-month-old boy

1-month-old girl

4-month-old boy

Elijah Lynch-Hobbs, 3 mos.

Kristen Skyy Romano, 1

Garrett King, 2
Garrett died after his caretaker repeatedly swept his legs from under him. She told police that she was changing his diaper and "lost it." She was prosecuted.

Ke'Azia Arkea Drew Peterson, 7 mos.
Ke'Azia died from blunt force head trauma consistent with shaken-baby syndrome, and her death was ruled a homicide. The caregiver told police she fell from a couch to a floor. She pleaded guilty to involuntary manslaughter.

Chelsea Peterson, 9 mos.

2-year-old boy

2-month-old boy

Reagan Makenna, 8 mos.

6-month-old boy

1-year-old boy

1-month-old girl

8-month-old girl

7-month-old girl

7-month-old-girl

Natalie West, 1
Drowned after she wandered out through an unsecured door and fell into a swimming pool. Her caretaker was watching eight children that day, reports show.

2-month-old girl

7-month-old girl

1-year-old girl

10-month-old boy

1-year-old girl

CIRCUMSTANCES OF DEATH

- Sleep-related
- Abuse-related
- Accident
- Illness or natural causes
- Unknown circumstances*

*Seven of these cases were classified as sudden infant death syndrome (SIDS) or sudden unexpected infant death (SUID), but with no other details publicly available. They could have been sleep-related.

44 of the 60 children were younger than 1

AGE and GENDER

Boy Girl (Younger than 1)
Boy Girl (Older than 1)

CHILDREN WHO DIED IN
UNREGULATED DAY CARES

43 | 17

CHILDREN WHO DIED IN
REGULATED DAY CARES

Nearly three-quarters of the children died in unregulated child-care homes, where providers face no inspections, training or background checks.

31 children died in sleep-related circumstances, which includes sudden infant death syndrome (SIDS), sudden unexpected infant death (SUID), and strangulation or suffocation while sleeping.

10 children died of abuse, all while in unregulated homes

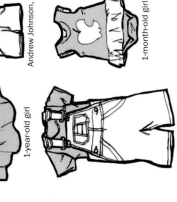
3-year-old boy
Andrew Johnson, 1
1-month-old girl

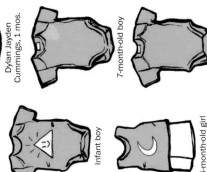
11-month-old girl
1-year-old girl

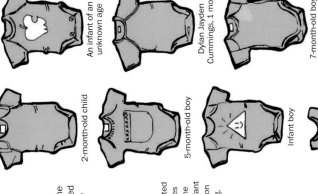
Justin Eric Simmons, 4
Justin died after he was run over by a riding lawn mower at a home day care.

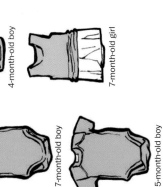
Henry Hall, 10 mos.
Henry died of asphyxia after he was put to sleep on the floor and became trapped in soft bedding. The caretaker had fallen asleep after taking Tylenol PM. She was prosecuted.

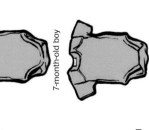
An infant of an unknown age
4-month-old boy
7-month-old girl

Dylan Jayden Cummings, 1 mo.
7-month-old boy
5-month-old boy

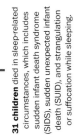
2-month-old child
5-month-old boy
Infant boy
4-month-old girl

Logan Daniel Guralny, 3 mos.

6-month-old boy

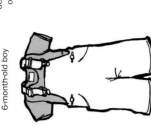
Noah Alexander Colassaco, 1
Asphyxiated after his neck was trapped between a crib and a dog crate that his caregiver had placed over the crib. She placed the crate on top of the crib to keep Noah from climbing out, investigators said.

Mila August Kohute, 7 mos.

1-year-old girl

C.J. Gordon, 9 mos.

Andy Thanh Ngo, 1

3-month-old girl

Teagan Gwen Sample, 2 mos.

1-month-old boy

Camden Katherine Lafkin, 3 mos.

Source: Compiled from state and local records and news reports

After English and Spanish, the answer gets interesting.

Most Commonly Spoken Language Other than English or Spanish

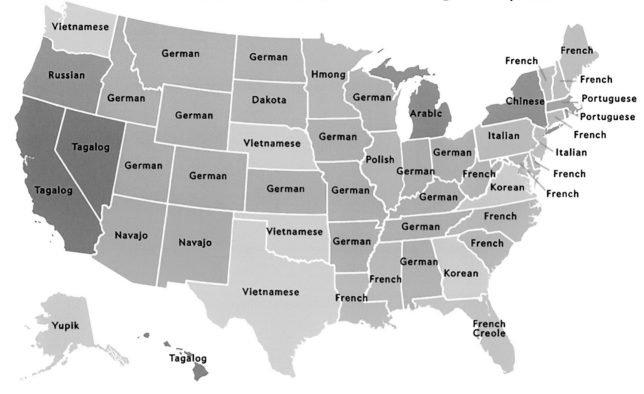

Most Commonly Spoken Scandinavian Language

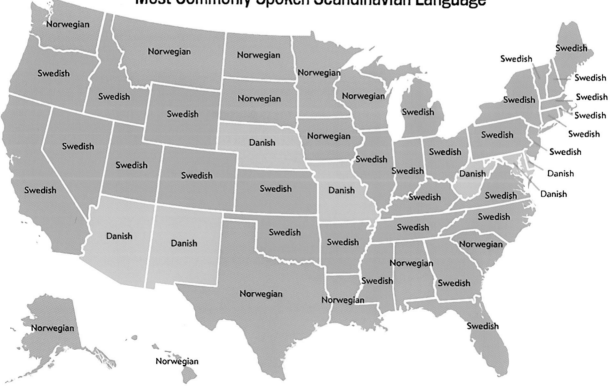

Most Commonly Spoken Native American Language

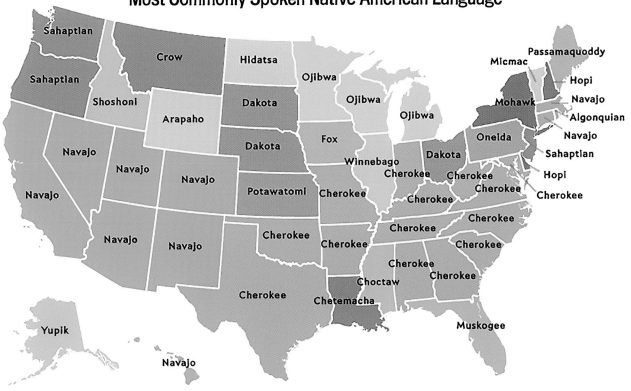

Most Commonly Spoken African Language

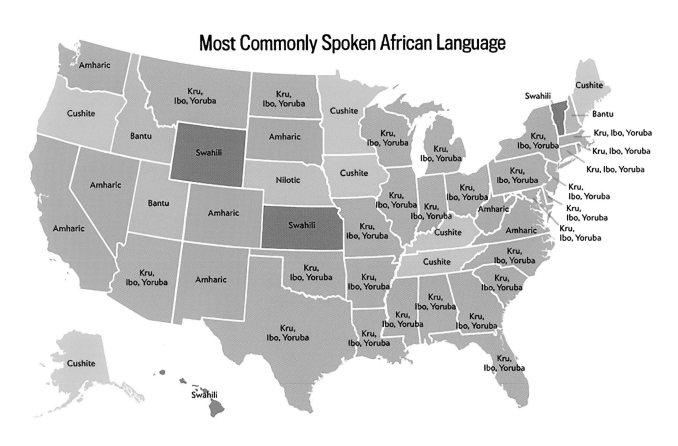

ARTIST Ben Blatt, writer at *Slate*.

STATEMENT English is the most commonly spoken language in every American state, and Spanish is the second most common nearly everywhere. But when you look beyond that, you see some surprising variation. In many states the third most commonly spoken language is German, in some it's Navajo, and in others French or Portuguese. These results offer a new window into the population, and sparked lots of discussion among people interested in the demographics of the United States.

PUBLICATION *Slate* (May 13, 2014)

LITERATURE, BROKEN DOWN

What do great opening sentences look like when you diagram them?

ARTIST Pop Chart Lab.

STATEMENT This chart brings together two great, and very different, language traditions: it analyzes 25 famous opening lines from revered works of fiction according to the dictates of the classic Reed-Kellogg system of sentence diagramming. From Cervantes to Faulkner to Pynchon, each sentence has been painstakingly curated and diagrammed by PCL's research team. The result parses classical prose by parts of speech and offers a partitioned, color-coded picto-grammatical representation of literary history—something for the aesthete in all of us.

PUBLICATION *PopChartLab.com* (March 2014)

Modal Verb · Particle · Verb · Conjunction · Preposition · Infinitive Verb · Copula · Predicate Verb · Subject Noun

It was a bright cold day in April, and the clocks were striking thirteen.
Orwell, *1984*

124 was spiteful.
Morrison, *Beloved*

He was an old man who fished alone in a skiff in the Gulf Stream and he had gone eighty-four days now without taking a fish.
Hemingway, *The Old Man and the Sea*

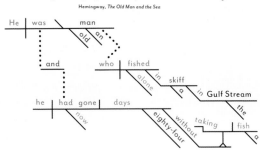

I am seated in an office, surrounded by heads and bodies.
Wallace, *Infinite Jest*

Many years later, as he faced the firing squad, Colonel Aureliano Buendía was to remember that distant afternoon when his father took him to discover ice.
García Márquez, *One Hundred Years of Solitude*

Call me Ishmael.
Melville, *Moby Dick*

In the beginning, sometimes I left messages in the street.
Markson, *Wittgenstein's Mistress*

It was a pleasure to burn.
Bradbury, *Fahrenheit 451*

In my younger and more vulnerable years my father gave me some advice I've been turning over in my mind ever since.
Fitzgerald, *The Great Gatsby*

Through the fence, between the curling flower spaces, I could see them hitting.
Faulkner, *The Sound and the Fury*

A screaming comes across the sky.
Pynchon, *Gravity's Rainbow*

To the red country and part of the gray country of Oklahoma, the last rains came gently, and they did not cut the scarred earth.
Steinbeck, *The Grapes of Wrath*

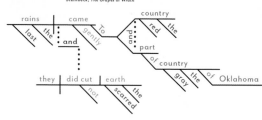

Lolita, light of my life, fire of my loins.
Nabokov, *Lolita*

We were somewhere around Barstow on the edge of the desert when the drugs began to take hold.
Thompson, *Fear and Loathing in Las Vegas*

It is a truth universally acknowledged, that a single man
in possession of a good fortune must be in want of a wife.

Austen, Pride and Prejudice

Happy families are all alike; every unhappy family is unhappy in its own way.

Tolstoy, Anna Karenina

All children, except one, grow up.

Barrie, Peter Pan

He—for there could be no doubt of his sex, though the fashion
of the time did something to disguise it—was in the act of slicing at the head
of a Moor which swung from the rafters.

Woolf, Orlando

It was about eleven o'clock in the morning, mid October,
with the sun not shining and a look of hard wet rain in the clearness of the foothills.

Chandler, The Big Sleep

When he woke in the woods in the dark and the cold of the night
he'd reach out to touch the child sleeping beside him.

McCarthy, The Road

All this happened, more or less.

Vonnegut, Slaughterhouse Five

It was a queer, sultry summer, the summer they electrocuted
the Rosenbergs, and I didn't know what I was doing in New York.

Plath, The Bell Jar

The Time Traveller (for so it will be convenient to speak of him)
was expounding a recondite matter to us.

Wells, The Time Machine

Somewhere in la Mancha, in a place whose name I do not care to remember,
a gentleman lived not long ago, one of those who has a lance and ancient shield
on a shelf and keeps a skinny nag and a greyhound for racing.

Cervantes, Don Quixote

As Gregor Samsa awoke one morning from uneasy dreams
he found himself transformed in his bed into a monstrous vermin.

Kafka, Metamorphosis

Subject Complement

Adverb

Adjective

Noun

Pronoun

Direct Object

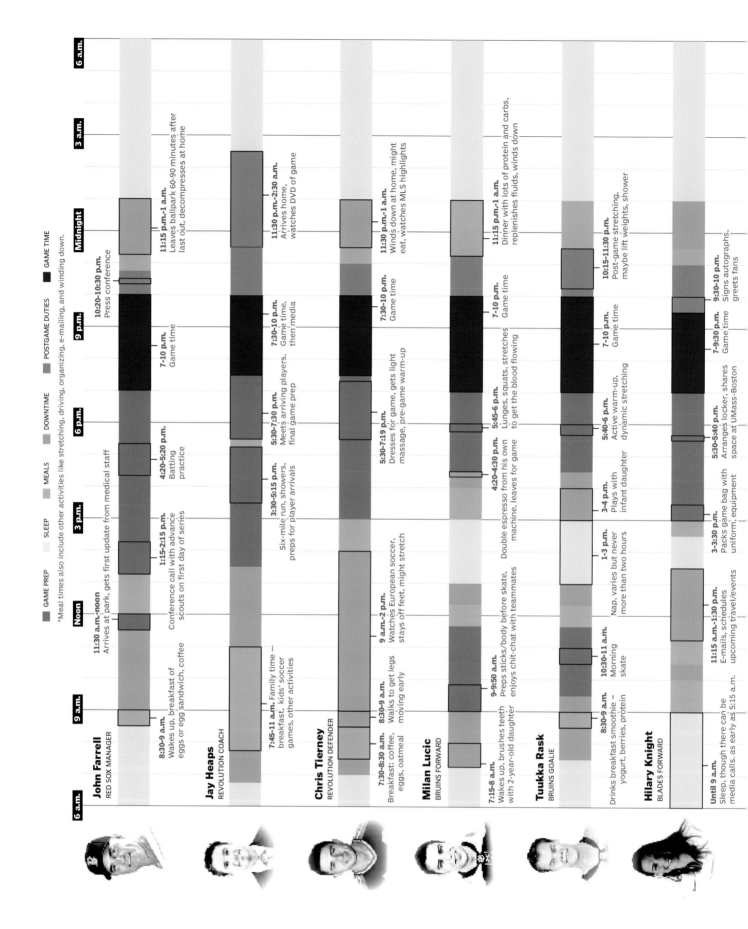

Legend:
- GAME PREP
- SLEEP
- MEALS
- DOWNTIME
- POSTGAME DUTIES
- GAME TIME

*Meal times also include other activities like stretching, driving, organizing, e-mailing, and winding down.

Time scale (top): 6 a.m. — 3 a.m. — Midnight — 9 p.m. — 6 p.m. — 3 p.m. — Noon — 9 a.m. — 6 a.m.

John Farrell
RED SOX MANAGER

- **8:30-9 a.m.** Wakes up, breakfast of eggs or egg sandwich, coffee
- **11:30 a.m.-noon** Arrives at park, gets first update from medical staff
- **1:15-2:15 p.m.** Conference call with advance scouts on first day of series
- **4:20-5:20 p.m.** Batting practice
- **7-10 p.m.** Game time
- **10:20-10:30 p.m.** Press conference
- **11:15 p.m.-1 a.m.** Leaves ballpark 60-90 minutes after last out, decompresses at home

Jay Heaps
REVOLUTION COACH

- **7:45-11 a.m.** Family time — breakfast, kids' soccer games, other activities
- **3:30-5:15 p.m.** Six-mile run, showers, preps for player arrivals
- **5:30-7:30 p.m.** Meets arriving players, final game prep
- **7:30-10 p.m.** Game time, then media
- **11:30 p.m.-2:30 a.m.** Arrives home, watches DVD of game

Chris Tierney
REVOLUTION DEFENDER

- **7:30-8:30 a.m.** Breakfast: coffee, eggs, oatmeal
- **8:30-9 a.m.** Walks to get legs moving early
- **9 a.m.-2 p.m.** Watches European soccer, stays off feet, might stretch
- **5:30-7:19 p.m.** Dresses for game, gets light massage, pre-game warm-up
- **7:30-10 p.m.** Game time
- **11:15 p.m.-1 a.m.** Dinner with lots of protein and carbs, replenishes fluids, winds down

Milan Lucic
BRUINS FORWARD

- **7:15-8 a.m.** Wakes up, brushes teeth with 2-year-old daughter
- **9-9:50 a.m.** Preps sticks/body before skate, enjoys chit-chat with teammates
- **4:20-4:30 p.m.** Double espresso from his own machine, leaves for game
- **5:45-6 p.m.** Lunges, squats, stretches to get the blood flowing
- **7-10 p.m.** Game time
- **11:30 p.m.-1 a.m.** Winds down at home, might eat, watches MLS highlights

Tuukka Rask
BRUINS GOALIE

- **8:30-9 a.m.** Drinks breakfast smoothie — yogurt, berries, protein
- **10:30-11 a.m.** Morning skate
- **1-3 p.m.** Nap, varies but never more than two hours
- **3-4 p.m.** Plays with infant daughter
- **5:40-6 p.m.** Active warm-up, dynamic stretching
- **7-10 p.m.** Game time
- **10:15-11:30 p.m.** Post-game stretching, maybe lift weights, shower

Hilary Knight
BLADES FORWARD

- **Until 9 a.m.** Sleep, though there can be media calls as early as 5:15 a.m.
- **11:15 a.m.-1:30 p.m.** E-mails, schedules upcoming travel/events
- **3-3:30 p.m.** Packs game bag with uniform, equipment
- **5:30-5:40 p.m.** Arranges locker, shares space at UMass-Boston
- **7-9:30 p.m.** Game time
- **9:30-10 p.m.** Signs autographs, greets fans

A DAY IN THE LIFE OF A PRO ATHLETE

How coaches and athletes spend game day.

ARTISTS Graphic and text by Luke Knox, graphic artist; text by Shira Springer, reporter; editing and suggestions by Chiqui Esteban, graphics director, and Joe Sullivan, sports editor, at the *Boston Globe*.

STATEMENT Many fans are familiar with what their favorite sports figures do during competition, but there's some mystery about the rest of their days: How much do they sleep each night? How much do they eat? Do they take time to see their families? We investigated the daily lives of

 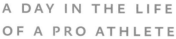

Devin McCourty
PATRIOTS SAFETY

8–8:30 a.m. Big breakfast of eggs, French toast, bacon

10:30–11 a.m. Listens to music, preps uniform, talks to teammates

1–4:15 p.m. Game time

4:15–5 p.m. Decompress 15 minutes, then talks to media

6:30 p.m.–2 a.m. Winds down with friends and family, relaxes until bedtime

Matthew Slater
PATRIOTS SPECIAL-TEAMER

8–9 a.m. Window for light breakfast of oatmeal and eggs

12:45–1 p.m. Reviews game plan, prepares mentally, prays, keeps body warm

1–4:15 p.m. Game time

6–7 p.m. Dinner

After 11 p.m. Sleep, prefers not to draw out the evening after a game

Kelly Olynyk
CELTICS CENTER

Morning shootaround, time varies depending on team schedule

10–11 a.m.

1–2:30 p.m. Nap

5–5:30 p.m. Massage

6:50–6:55 p.m. Pregame speech by Brad Stevens

7:30–10:15 p.m. Game time

11:15 p.m.–midnight Back home, eats more, watches TV, winds down

Gerald Wallace
CELTICS FORWARD

8:30–10 a.m. Breakfast, gets to facility for shootaround

11 a.m.–noon Body maintenance, takes care of lingering sore spots

2–4 p.m. Walks, time with friends, watches opponent film, prefers not to nap

5:45–6 p.m. Arrives at arena, then heads to hot tub

7:30–10:15 p.m. Game time

11:15 p.m.–4 a.m. Eats, watches TV, plays video games, relaxes

Paul Rabil
CANNONS MIDFIELDER

7:30–8:30 a.m. Wake up, stretch, shower

10–11:30 a.m. Morning shootaround

7–9:15 p.m. Game time

9:15–11 p.m. Signs autographs, handles media obligations, gets treatment, usually last one out of locker room

After 4 a.m. Sleep – a night person, usually goes to bed between 3–4 a.m.

Shalane Flanagan
MARATHONER FROM MARBLEHEAD

6–6:30 a.m. Wakes up

8–10 a.m. Long run, speed/track session or light workout

11:30 a.m.–1 p.m. Showers, eats, stretches, gets into recovery mode

4–6 p.m. Run, light stretching, core work, maybe a massage

6:30–9:30 p.m. Relaxes, heads to bed between 8–9 p.m.

6 a.m. 9 a.m. Noon 3 p.m. 6 p.m. 9 p.m. Midnight 3 a.m. 6 a.m.

professional athletes in the Boston area, and graphed them at a granular level. Bruins forward Milan Lucic wakes up around 8 a.m. on game days; his two-year-old-daughter is the alarm, and they brush their teeth together. Revolution coach Jay Heaps can't sleep after a 7 p.m. soccer game, and stays up until 2:30 a.m. watching video of his team's performance. Philosophically, the graphic was built to put the data first; the grayscale images allow the color-coding in the bars to stand out. The part I'm proudest of is the amount of data included in the graphic, both in visuals and type.

PUBLICATION *Boston Globe*
(December 27, 2014)

The guns

From 1984 to today, mass killers have utilized 22 shotguns, 23 revolvers, 29 rifles and 77 semiautomatic handguns. According to Mother Jones, more than three-quarters of these had been legally purchased.

ALL THE GUNS

The weapons used in 30 years' worth of mass shootings.

ARTISTS Richard Johnson and Todd Lindeman, senior graphics editors; Alberto Cuadra and Kennedy Elliot, graphics editors; and Ted Mellnik, database editor, at the *Washington Post*.

The killers

In December 2012 in Newtown, Conn., a 20-year-old with a history of mental problems shot his mother dead at their home then drove to Sandy Hook Elementary School. Once inside he opened fire, killing 20 children and six adults before committing suicide. Mental health issues have been noted in many of the killers, shown here at the time of their attacks.

■ WITH MENTAL HEALTH ISSUE ■ UNCLEAR ■ WITH NO MENTAL HEALTH ISSUE

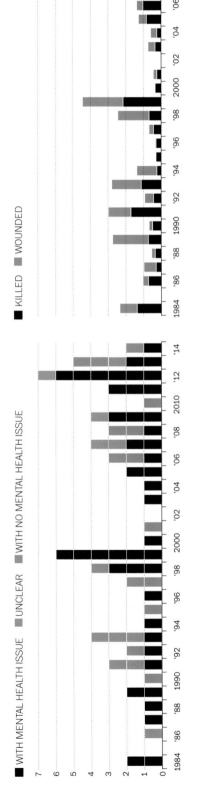

The victims

More than half of the mass killers of the last 30 years possessed assault weapons or high-capacity magazines, according to Mother Jones. High-capacity magazines allow a gun to fire without the need to reload, maximizing damage, increasing body count and minimizing risk to the shooter. Below is a look at the numbers of dead and wounded.

■ KILLED ■ WOUNDED

Killers by age and race

Almost 65 percent of the killers were white, which is comparable to their share of the population. More than 16 percent of the killers were black, slightly higher than their 12 percent share of the population. More than 16 percent of the killers were Hispanic, well below the approximately 17 percent of the total population share. And only two, less than 3 percent, have been women.

● WHITE ● BLACK ● HISPANIC ● ASIAN, NATIVE AMERICAN AND UNKNOWN

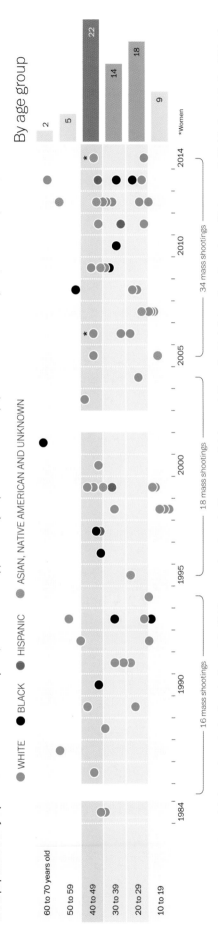

By age group

60 to 70 years old
50 to 59
40 to 49
30 to 39
20 to 29
10 to 19

2 5 22 14 18 9 *Women

1984 1990 1995 2000 2005 2010 2014

— 16 mass shootings —
— 18 mass shootings —
— 34 mass shootings —

STATEMENT After what seemed to be an unremitting series of mass shootings in America, we were worried that readers' attention spans were waning, and searched for a way to bring a shock to the senses. We were fascinated with the idea of seeing all of the guns that contributed to these horrific events at once, a sheer mass of machinery, as if they were all dumped out of a bag onto a table in a large, jumbled mess. We wanted the reader to feel overwhelmed and unsettled, but unable to look away. We experimented with a more haphazard way of organizing the guns to reflect the madness of these events, but ultimately opted for a more orderly organization so the reader could more easily interpret the scale and number of guns. Each gun was carefully drawn according to data we had on each shooting. On the Web, we enabled readers to hover over the guns to reveal information on the type of gun, the shooting event it was involved in, and the other guns used in that event.

PUBLICATION *Washington Post* (June 1, 2014)

NOTE: Mother Jones mass data contain both mass and spree shootings of more than four people. The FBI defines mass murder as the murder of four or more people during an event with no cooling-off period between the murders, and a spree killer is someone who kills victims in a short time in multiple locations.
Source: Mother Jones - A Guide to Mass Shootings in America, United States census and news reports

The dude-lands, and "buddy," "pal," and "fella."

Not common →

Very common →

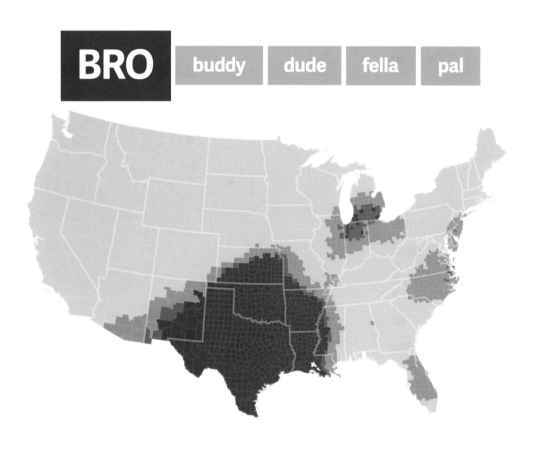

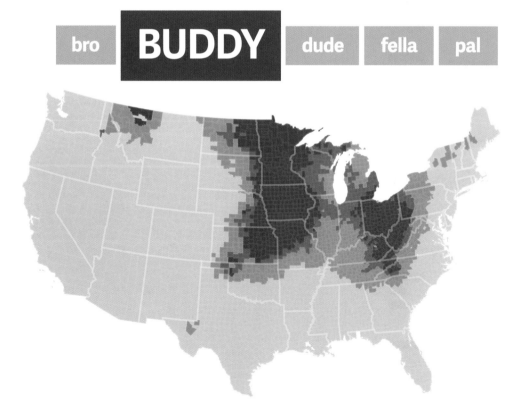

DUDE bro buddy fella pal

FELLA bro buddy dude pal

PAL bro buddy dude fella

ARTIST Design, coding, and text by Nikhil Sonnad, reporter at *Quartz*.

STATEMENT I worked with forensic linguist Jack Grieve to analyze how popular vocatives—terms that describe a person—differ across regions of the United States. He put the words *dude*, *bro*, *buddy*, *pal*, and *fella* through a database of billions of geocoded tweets, collected by Diansheng Guo of the University of South Carolina, to analyze these linguistic trends. *Dude* is the most widespread such term on Twitter, with usage sweeping from the Midwest down to Texas and southern California. Other terms are more heavily concentrated in particular areas, like *pal* in the north or *fella* in the south.

The design mostly focused around choosing appropriately diverging colors. Hot spots for a given word should be obvious at a glance, but the granularity of less dense clusters should remain visible upon further inspection. These maps show how Twitter is fast becoming one of the most robust data sets for linguists interested in natural and conversational usage. Where else, after all, could you find billions of instances of *dude* and *bro*?

PUBLICATION *Quartz*
(December 23, 2014)

THE MONEY-GO-ROUND

How Silicon Valley avoids taxes.

ARTIST Lee Simmons, write; Josef Reyes, designer; Valerio Pellegrini, artist; and Sarah Fallon, editor, at *WIRED*.

STATEMENT This chart shows how Big Tech shuffles intellectual property (IP) around the world to avoid paying corporate income taxes. The dotted lines are IP flows; the solid lines are money flows.

Companies like Apple and Google are fabulously profitable, but they contribute relatively little to public coffers. We wanted to find out how they pull this off. The key, it turns out, is these elaborate corporate structures that shift earnings to tax havens like Ireland and Bermuda. Now, to move profits offshore, you have to relocate your productive assets, and for many companies that's not an option; you can't ship blast furnaces or farmland to the Caymans. But for tech companies it's easy: by moving patents and code to offshore subsidiaries—often with no employees—they can claim the income was earned there, making it tax-exempt in the United States.

The companies are secretive about all this, naturally, but aspects of the picture were revealed in some recent public hearings, and we pieced together the rest with a lot of detective work by Lee Simmons. Our idea was to trace out the moves in this global shell game like an airline route map—until we realized the world doesn't fit the vertical orientation of a magazine page. We finally hit on this solution, a sort of abstracted map that keeps the spatial relationships but compresses the distances. Broad arcs and loops emphasize the circular, farcical nature of these internal company transactions. The result is a real mare's nest—but, actually, that's the point!

PUBLICATION *WIRED* (April 2014)

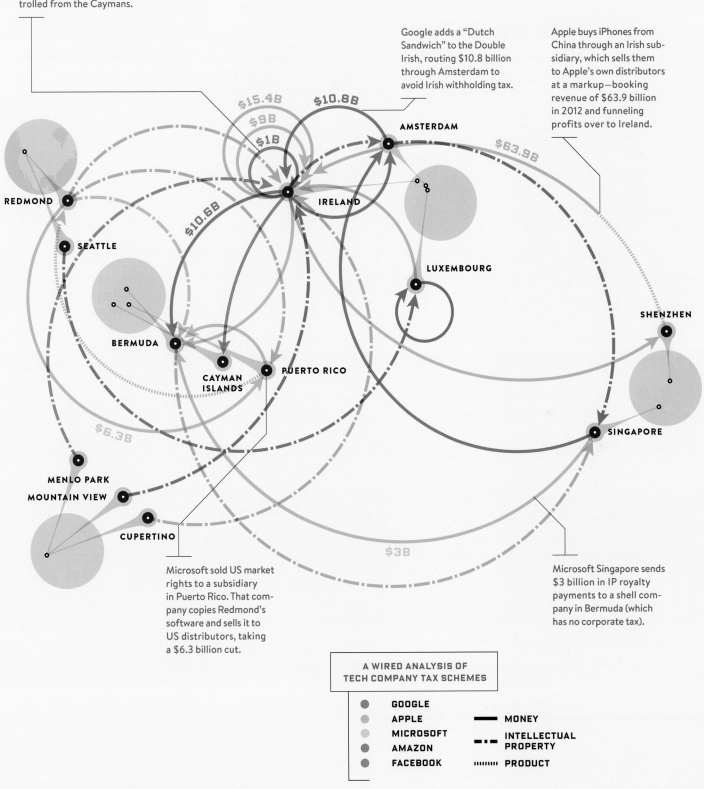

To minimize its tax exposure, Facebook employs the popular "Double Irish" play, moving $1 billion in IP royalty payments from one Irish company to another, one that's controlled from the Caymans.

Google adds a "Dutch Sandwich" to the Double Irish, routing $10.8 billion through Amsterdam to avoid Irish withholding tax.

Apple buys iPhones from China through an Irish subsidiary, which sells them to Apple's own distributors at a markup—booking revenue of $63.9 billion in 2012 and funneling profits over to Ireland.

$15.4B
$10.8B
$9B
$1B
$63.9B

AMSTERDAM

$10.6B

REDMOND

IRELAND

SEATTLE

LUXEMBOURG

SHENZHEN

BERMUDA

CAYMAN ISLANDS

PUERTO RICO

SINGAPORE

$6.3B

MENLO PARK
MOUNTAIN VIEW

CUPERTINO

$3B

Microsoft sold US market rights to a subsidiary in Puerto Rico. That company copies Redmond's software and sells it to US distributors, taking a $6.3 billion cut.

Microsoft Singapore sends $3 billion in IP royalty payments to a shell company in Bermuda (which has no corporate tax).

A WIRED ANALYSIS OF
TECH COMPANY TAX SCHEMES

● GOOGLE
● APPLE
● MICROSOFT ━━━ MONEY
● AMAZON ╺ ╺ INTELLECTUAL
 PROPERTY
● FACEBOOK ┈┈┈ PRODUCT

HOTSPOT

Later this year, Turkey will complete the Ilisu Dam on the Tigris River, part of a national push to boost electrical power capacity. Besides submerging the 12,000-year-old settlement of Hasankeyf, the dam may damage the already fragile Mesopotamian marshes downstream in Iraq. Germany, Austria, and Switzerland withdrew funding for the dam in 2009.

Yukon

Nelson-Saskatchewan

NERD BOX

The map displays nearly 2,000 incidents, involving conflict and collaboration alike, over shared river basins from 1990 to 2008. The circles in the sidebar [facing page] compare about 2,200 events—including another 200 disputes over resources other than shared rivers—from the same period.

Saint Lawrence

Mississippi

Rio Grande

Orinoco

Amazon

WATER WAR AND PEACE

What happens when nations share a river.

La Plata

ARTISTS Wesley Grubbs, creative director; Mladen Balog, designer; Ri Liu, designer; Nick Yahnke, programmer; and Shujian Bu, programmer, at Pitch Interactive, Inc. Text by Katie Peek, information graphics editor at *Popular Science*.

STATEMENT For a special issue on water, we created this map showing how the resource has united and divided nations for decades. Three-quarters of nations share a river with a neighbor in some way, and wherever two or more countries lie in a single river basin, they must somehow allocate its water. Sometimes they collaborate, but this also leads to hostility. This map displays about 2,000 incidents recorded between 1990 and 2008, compiled by researchers at Oregon State University. You can quickly identify hotspots such as new dam sites in Ethiopia and Tajikistan, but one encouraging result appears in the "Events by Intensity" sidebar: positive, cooperative interactions between nations outnumber hostile ones.

PUBLICATION *Popular Science* (May 20, 2014)

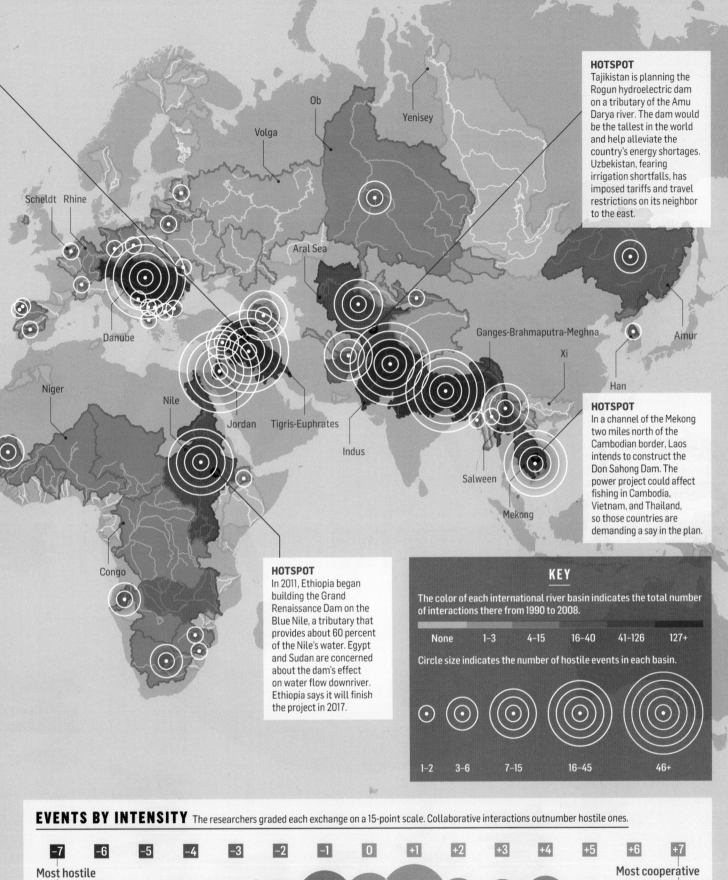

HOTSPOT
Tajikistan is planning the Rogun hydroelectric dam on a tributary of the Amu Darya river. The dam would be the tallest in the world and help alleviate the country's energy shortages. Uzbekistan, fearing irrigation shortfalls, has imposed tariffs and travel restrictions on its neighbor to the east.

HOTSPOT
In a channel of the Mekong two miles north of the Cambodian border, Laos intends to construct the Don Sahong Dam. The power project could affect fishing in Cambodia, Vietnam, and Thailand, so those countries are demanding a say in the plan.

HOTSPOT
In 2011, Ethiopia began building the Grand Renaissance Dam on the Blue Nile, a tributary that provides about 60 percent of the Nile's water. Egypt and Sudan are concerned about the dam's effect on water flow downriver. Ethiopia says it will finish the project in 2017.

KEY

The color of each international river basin indicates the total number of interactions there from 1990 to 2008.

| None | 1–3 | 4–15 | 16–40 | 41–126 | 127+ |

Circle size indicates the number of hostile events in each basin.

| 1–2 | 3–6 | 7–15 | 16–45 | 46+ |

Map labels: Scheldt, Rhine, Volga, Ob, Yenisey, Danube, Aral Sea, Niger, Nile, Jordan, Tigris-Euphrates, Indus, Congo, Salween, Mekong, Ganges-Brahmaputra-Meghna, Xi, Han, Amur

EVENTS BY INTENSITY The researchers graded each exchange on a 15-point scale. Collaborative interactions outnumber hostile ones.

| -7 | -6 | -5 | -4 | -3 | -2 | -1 | 0 | +1 | +2 | +3 | +4 | +5 | +6 | +7 |

Most hostile Most cooperative

0 EVENTS
Declaration of war

9 EVENTS
Hostile action like troop movement or water-supply disruption

394 EVENTS
Leaders use language of discord in an official or unofficial setting

580 EVENTS
Leaders express mild verbal support in talks or policy exchanges

250 EVENTS
Nations agree to support projects like irrigation or river management

0 EVENTS
Voluntary unification into a single country

SOURCE: THE TRANSBOUNDARY FRESHWATER DISPUTE DATABASE, DEPARTMENT OF GEOSCIENCES, OREGON STATE UNIVERSITY

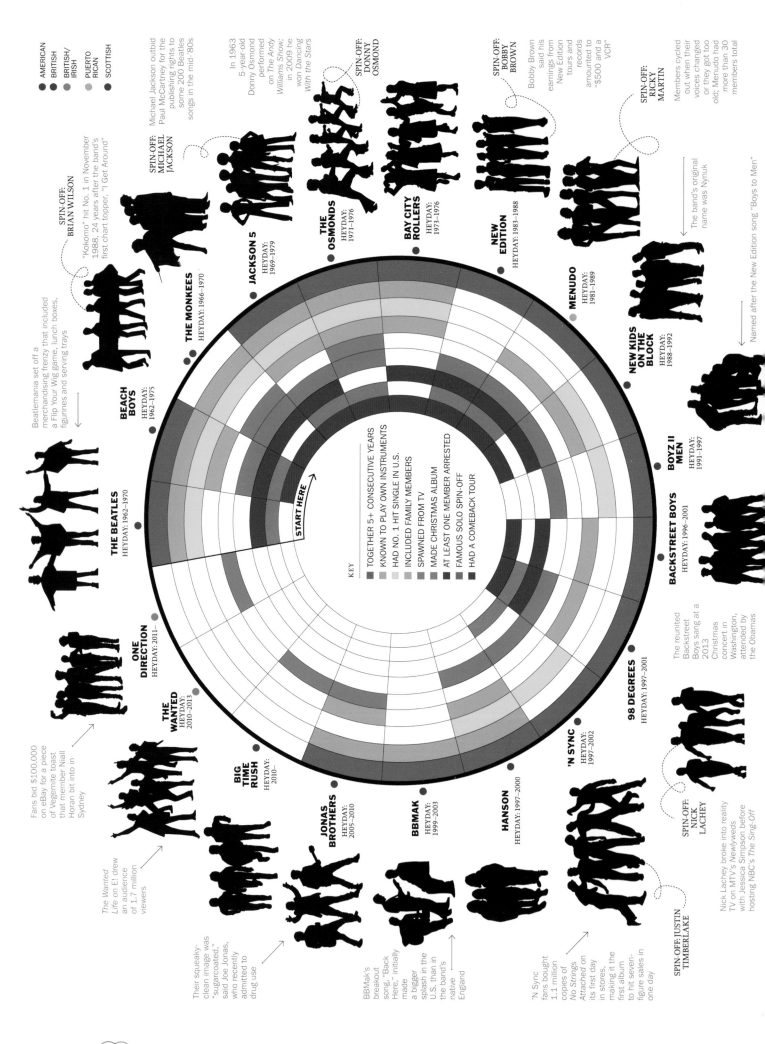

KEY

- TOGETHER 5+ CONSECUTIVE YEARS
- KNOWN TO PLAY OWN INSTRUMENTS
- HAD NO. 1 HIT SINGLE IN U.S.
- INCLUDED FAMILY MEMBERS
- SPAWNED FROM TV
- MADE CHRISTMAS ALBUM
- AT LEAST ONE MEMBER ARRESTED
- FAMOUS SOLO SPIN-OFF
- HAD A COMEBACK TOUR

START HERE

- AMERICAN
- BRITISH
- BRITISH/ IRISH
- PUERTO RICAN
- SCOTTISH

SPIN-OFF: MICHAEL JACKSON

Michael Jackson outbid Paul McCartney for the publishing rights to some 200 Beatles songs in the mid-'80s

SPIN-OFF: DONNY OSMOND

In 1963 5-year-old Donny Osmond performed on *The Andy Williams Show*; in 2009 he won *Dancing With the Stars*

SPIN-OFF: BOBBY BROWN

Bobby Brown said his earnings from New Edition tours and records amounted to "$500 and a VCR"

SPIN-OFF: RICKY MARTIN

Members cycled out when their voices changed or they got too old; Menudo had more than 30 members total

THE OSMONDS
HEYDAY: 1971–1976

BAY CITY ROLLERS
HEYDAY: 1973–1976

NEW EDITION
HEYDAY: 1983–1988

MENUDO
HEYDAY: 1981–1989

JACKSON 5
HEYDAY: 1969–1979

THE MONKEES
HEYDAY: 1966–1970

SPIN-OFF: BRIAN WILSON

"Kokomo" hit No. 1 in November 1988, 24 years after the band's first chart topper, "I Get Around"

Beatlemania set off a merchandising frenzy that included a Flip Your Wig game, lunch boxes, figurines and serving trays

BEACH BOYS
HEYDAY: 1962–1975

THE BEATLES
HEYDAY: 1962–1970

The band's original name was Nynuk

Named after the New Edition song "Boys to Men"

NEW KIDS ON THE BLOCK
HEYDAY: 1988–1992

BOYZ II MEN
HEYDAY: 1991–1997

BACKSTREET BOYS
HEYDAY: 1996–2001

The reunited Backstreet Boys sang at a 2013 Christmas concert in Washington, attended by the Obamas

98 DEGREES
HEYDAY: 1997–2001

SPIN-OFF: NICK LACHEY

Nick Lachey broke into reality TV on MTV's *Newlyweds* with Jessica Simpson before hosting NBC's *The Sing-Off*

'N SYNC
HEYDAY: 1997–2002

'N Sync fans bought 1.1 million copies of *No Strings Attached* on its first day in stores, making it the first album to hit seven-figure sales in one day

SPIN-OFF: JUSTIN TIMBERLAKE

HANSON
HEYDAY: 1997–2000

BBMAK
HEYDAY: 1999–2003

BBMak's breakout song, "Back Here," initially made a bigger splash in the U.S. than in the band's native England

BIG TIME RUSH
HEYDAY: 2010–

JONAS BROTHERS
HEYDAY: 2005–2010

Their squeaky-clean image was "sugarcoated," said Joe Jonas, who recently admitted to drug use

THE WANTED
HEYDAY: 2010–2013

The Wanted Life on E! drew an audience of 1.7 million viewers

ONE DIRECTION
HEYDAY: 2011–

Fans bid $100,000 on eBay for a piece of Vegemite toast that member Niall Horan bit into in Sydney

BOY-BAND BLUEPRINT

From the Beatles to One Direction, how the adorable-popster thing works.

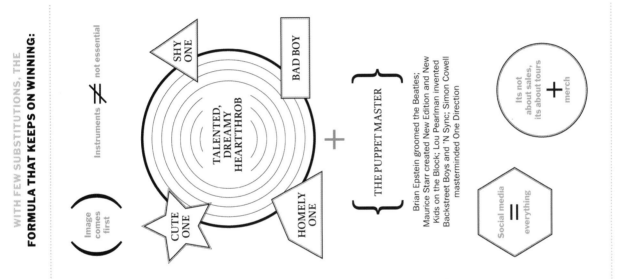

WITH FEW SUBSTITUTIONS, THE
FORMULA THAT KEEPS ON WINNING:

Image comes first

Instruments ≠ not essential

SHY ONE

BAD BOY

TALENTED, DREAMY HEARTTHROB

CUTE ONE

HOMELY ONE

+

THE PUPPET MASTER

Brian Epstein groomed the Beatles; Maurice Starr created New Edition and New Kids on the Block; Lou Pearlman invented Backstreet Boys and 'N Sync; Simon Cowell masterminded One Direction

Its not about sales, its about tours + merch

Social media = everything

SOURCES: BILLBOARD.COM; BAND WEBSITES. REPORTING BY ALEX ACIMAN, MOLLY MARTIN, BROOK TWEETEN AND VICTOR WILLIAMS

ARTISTS Graphic by Heather Jones, infographics designer; written by Emily Barone, infographics researcher, at *Time.*

STATEMENT We all know "boy bands" have a formulaic feeling, especially in the US and UK, but I hadn't seen an illustrated graphic that tried to analyze just what the formula was. After some research we decided to go all the way back to the Beatles—they had the cute one, the smart one, the funny one, the shy one—and pegged the graphic to their appearance on *The Ed Sullivan Show,* 50 years earlier. We learned a lot just in the process of plotting out various bands and filling in the colored rings; more categories led to more questions that we tried to answer in various parts of the graphic. I really liked the addition of the little equation diagram, where the puppet master came into play as the sort of invisible force.

PUBLICATION *Time* (February 2014)

STYROFOAM POPULATION

Data you can feel.

ARTIST Ewa Tuteja, a data visualization
designer and coder in Berlin.

STATEMENT This is a handcrafted visualization of the population density around the world, using a Styrofoam ball and over 700 toothpicks. I am passionate about visualizing interesting information and data, and enjoy crafting by hand even more. I have just started my career in data visualization and have no formal design background; this was prepared as the final piece for an online design course. Shortly before, I had seen a map with the population density mapped as peaks and valleys, which I found very inspiring. The idea was born to create an abstract blue flower that would not only be an artistic piece in itself, but at the same time convey information with which one can interact physically. The goal in all my work is to give life to information.

PUBLICATION
designtransfer gallery in Berlin
(April 2014)

MATERIAL
WORLD

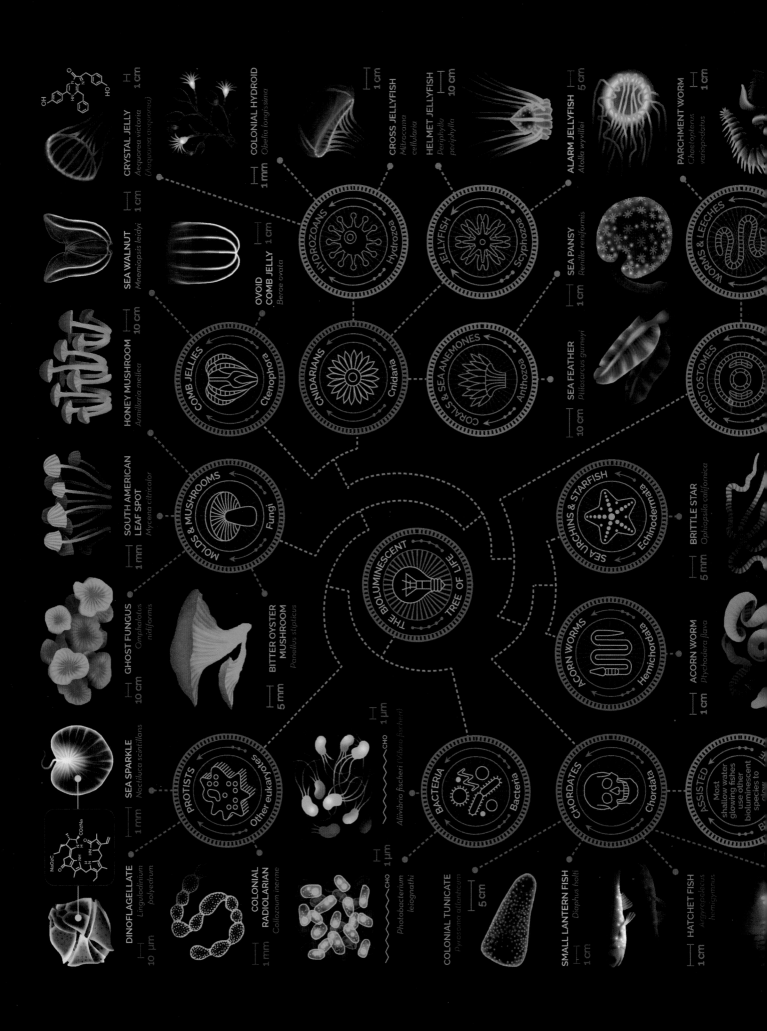

CRYSTAL JELLY
Aequorea victoria
(*Aequorea aequorea*)
1 cm

COLONIAL HYDROID
Obelia longissima
1 cm

CROSS JELLYFISH
Mitrocoma
cellularia
1 cm

HELMET JELLYFISH
Periphylla
periphylla
10 cm

ALARM JELLYFISH
Atolla wyvillei
5 cm

PARCHMENT WORM
Chaetopterus
variopedatus
1 cm

SEA WALNUT
Mnemiopsis leidyi
1 cm

OVOID
COMB JELLY
Beroe ovata
1 mm

HYDROZOANS
Hydrozoa

JELLYFISH
Scyphozoa

SEA PANSY
Renilla reniformis
1 cm

WORMS & LEECHES

HONEY MUSHROOM
Armillaria mellea
10 cm

COMB JELLIES
Ctenophora

CNIDARIANS
Cnidaria

CORALS & SEA ANEMONES
Anthozoa

SEA FEATHER
Ptilosarcus gurneyi
10 cm

PROTOSTOMES

SOUTH AMERICAN
LEAF SPOT
Mycena citricolor
1 mm

MOLDS & MUSHROOMS
Fungi

THE BIOLUMINESCENT TREE OF LIFE

SEA URCHINS & STARFISH
Echinodermata

BRITTLE STAR
Ophiopsila californica
5 mm

GHOST FUNGUS
Omphalotus
nidiformis
10 cm

BITTER OYSTER
MUSHROOM
Panellus stipticus
5 mm

ACORN WORMS
Hemichordata

ACORN WORM
Ptychodera flava
1 cm

SEA SPARKLE
Noctiluca scintillans
1 mm

PROTISTS
Other eukaryotes

Allivibrio fischeri (Vibrio fischeri)
1 µm

BACTERIA
Bacteria

CHORDATES
Chordata

ASSISTED
Most
shallow water
glowing fishes
use other
bioluminescent
species to

DINOFLAGELLATE
Lingulodinium
polyedrum
10 µm

COLONIAL
RADIOLARIAN
Collozoum inerme
1 mm

Photobacterium
leiognathi
1 µm

COLONIAL TUNICATE
Pyrosoma atlanticum
5 cm

SMALL LANTERN FISH
Diaphus holti
1 cm

HATCHET FISH
Argyropelecus
hemigymnus
1 cm

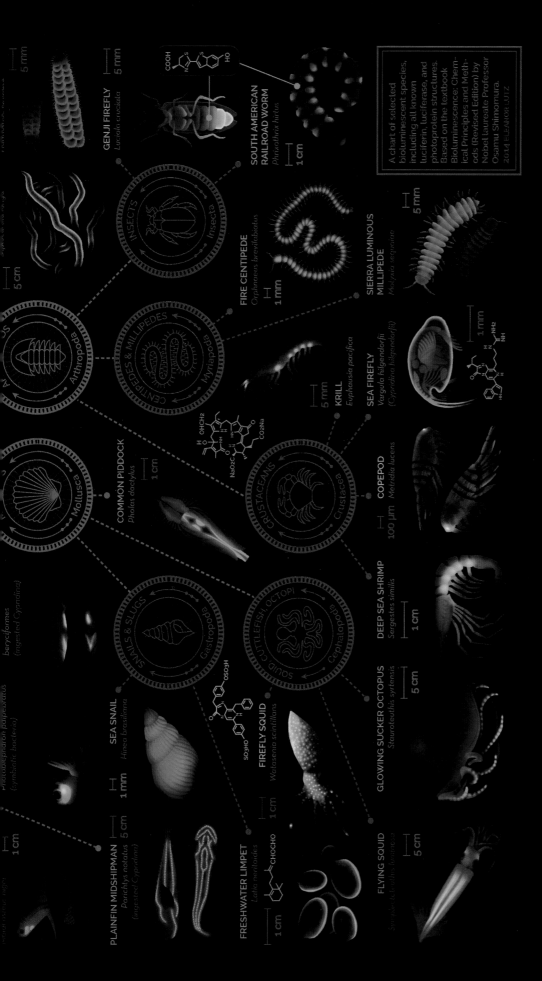

A chart of selected bioluminescent species, including all known luciferin, luciferase, and photoprotein structures. Based on the textbook Bioluminescence: Chemical Principles and Methods (Revised Edition) by Nobel laureate Professor Osamu Shimomura. 2014 ELEANOR LUTZ

GENJI FIREFLY
Luciola cruciata

SOUTH AMERICAN RAILROAD WORM
Phrixothrix hirtus

INSECTS
Insecta

CENTIPEDES & MILLIPEDES
Myriapoda

FIRE CENTIPEDE
Orphanaeus brevilabiatus

SIERRA LUMINOUS MILLIPEDE
Motyxia sequoiae

Arthropoda

KRILL
Euphausia pacifica

SEA FIREFLY
Vargula hilgendorfii
(*Cypridina hilgendorfii*)

COMMON PIDDOCK
Pholas dactylus

Mollusca

CRUSTACEANS
Crustacea

COPEPOD
Metridia lucens

DEEP SEA SHRIMP
Sergestes similis

beryciformes
(ingested *Cypridina*)

Photoblepharon palpebratus
(symbiotic bacteria)

SNAILS & SLUGS
Gastropoda

SQUID, CUTTLEFISH, OCTOPI
Cephalopoda

GLOWING SUCKER OCTOPUS
Stauroteuthis syrtensis

SEA SNAIL
Hinea brasiliana

FIREFLY SQUID
Watasenia scintillans

PLAINFIN MIDSHIPMAN
Porichthys notatus
(ingested *Cypridina*)

FRESHWATER LIMPET
Latia neritoides

FLYING SQUID
Sthenoteuthis luminosa

A FAMILY TREE OF GLOW

Bioluminescent animals, mushrooms, and more.

ARTIST Eleanor Lutz, freelance designer and creator of *Tabletop Whale* blog.

STATEMENT Bioluminescent organisms create their own light using chemical reactions. This infographic shows a selection of the many bioluminescent species in the world, as well as the structures of all seven known bioluminescence molecules. The hardest part was gathering all the photo references—a lot of bioluminescent species are very rare, or inhabit hard-to-access environments like the deep ocean. It's also difficult to photograph glowing animals, so for some of the species here I could only find one or two photos. The design is based on the textbook *Bioluminescence: Chemical Principles and Methods,* by Professor Osamu Shimomura. I think biology and design are both incredibly interesting, and my goal is to combine the two in a unique way.

PUBLICATION *Tabletop Whale, tabletopwhale.com* (July 21, 2014)

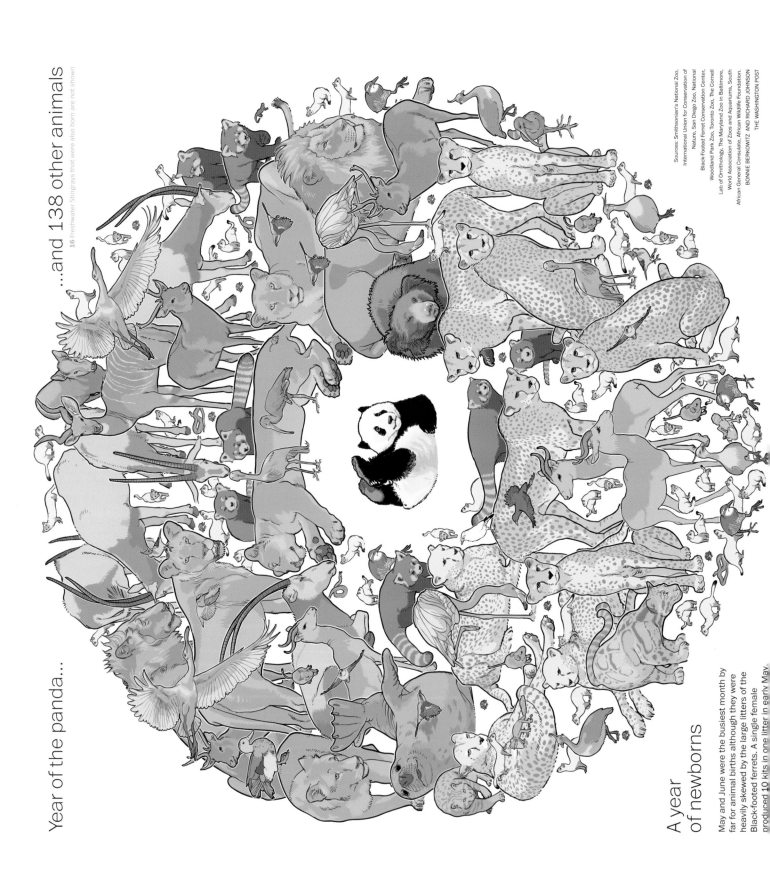

Year of the panda...

...and 138 other animals

16 freshwater Stingrays that were also born are not shown

Sources: Smithsonian's National Zoo, International Union for Conservation of Nature, San Diego Zoo. National Black-Footed Ferret Conservation Center, Woodland Park Zoo, Toronto Zoo, The Cornell Lab of Ornithology, The Maryland Zoo in Baltimore, World Association of Zoos and Aquariums, South African General Consulate, African Wildlife Foundation.
BONNIE BERKOWITZ AND RICHARD JOHNSON THE WASHINGTON POST

A year of newborns

May and June were the busiest month by far for animal births although they were heavily skewed by the large litters of the Black-footed ferrets. A single female produced 10 kits in one litter in early May.

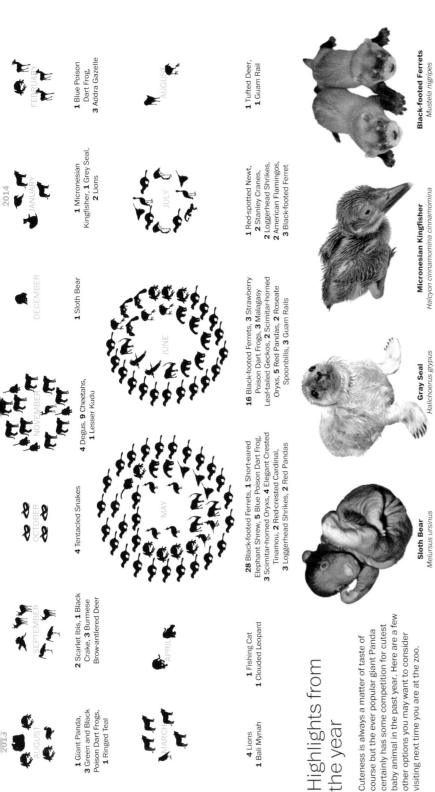

FEBRUARY
1 Blue Poison Dart Frog,
3 Addra Gazelle

2014 JANUARY
1 Micronesian Kingfisher, **1** Grey Seal, **2** Lions

AUGUST

JULY

DECEMBER
1 Sloth Bear

JUNE
16 Black-footed Ferrets, **3** Strawberry Poison Dart Frogs, **3** Malagasy Leaf-tailed Geckos, **2** Scimitar-horned Oryx, **5** Red Pandas, **2** Roseate Spoonbills, **3** Guam Rails

NOVEMBER
4 Degus, **9** Cheetahs, **1** Lesser Kudu

OCTOBER
4 Tentacled Snakes

MAY
28 Black-footed Ferrets, **1** Short-eared Elephant Shrew, **5** Blue Poison Dart Frog, **3** Scimitar-horned Oryx, **4** Elegant Crested Tinamou, **2** Red-crested Cardinal, **3** Loggerhead Shrikes, **2** Red Pandas

1 Tufted Deer, **1** Guam Rail

1 Red-spotted Newt, **2** Stanley Cranes, **2** Loggerhead Shrikes, **2** American Flamingos, **3** Black-footed Ferret

SEPTEMBER
2 Scarlet Ibis, **1** Black Crake, **3** Burmese Brow-antlered Deer

APRIL

2013 AUGUST
1 Giant Panda, **3** Green and Black Poison Dart Frogs, **1** Ringed Teal

MARCH

4 Lions
1 Bali Mynah

1 Fishing Cat
1 Clouded Leopard

Black-footed Ferrets
Mustela nigripes

Micronesian Kingfisher
Halcyon cinnamomina cinnamomina

Gray Seal
Halichoerus grypus

Sloth Bear
Melursus ursinus

Highlights from the year

Cuteness is always a matter of taste of course but the ever popular giant Panda certainly has some competition for cutest baby animal in the past year. Here are a few other options you may want to consider visiting next time you are at the zoo.

BABY ANIMALS

The National Zoo as an obstetrics ward.

ARTISTS Richard Johnson, senior graphics editor, and Bonnie Berkowitz, graphics reporter, at the *Washington Post*.

STATEMENT When the first birthday of the Smithsonian National Zoo's popular panda cub Bao Bao approached, Rich and Bonnie feared being assigned yet another panda graphic. In self-defense, Bonnie proposed something different: a piece on all the other, far-less-publicized animals that had been born at the zoo in the previous year. Rich devised a way to illustrate the numbers while keeping the visual just panda-centric enough to make people happy. (That wasn't easy: we published this during a major birthing season, so the totals kept rising right up until deadline.) This visualization tells no great truth, other than that the zoo has a lot of worthy critters that aren't black and white. Some readers hated it, but it was something different. The interactive version, designed by intern Annie Daniel, gave readers a nugget of information and a photo of a baby from each species.

PUBLICATION *Washington Post*
(August 22, 2014)

HOW WE PAY

New ways of
moving money.

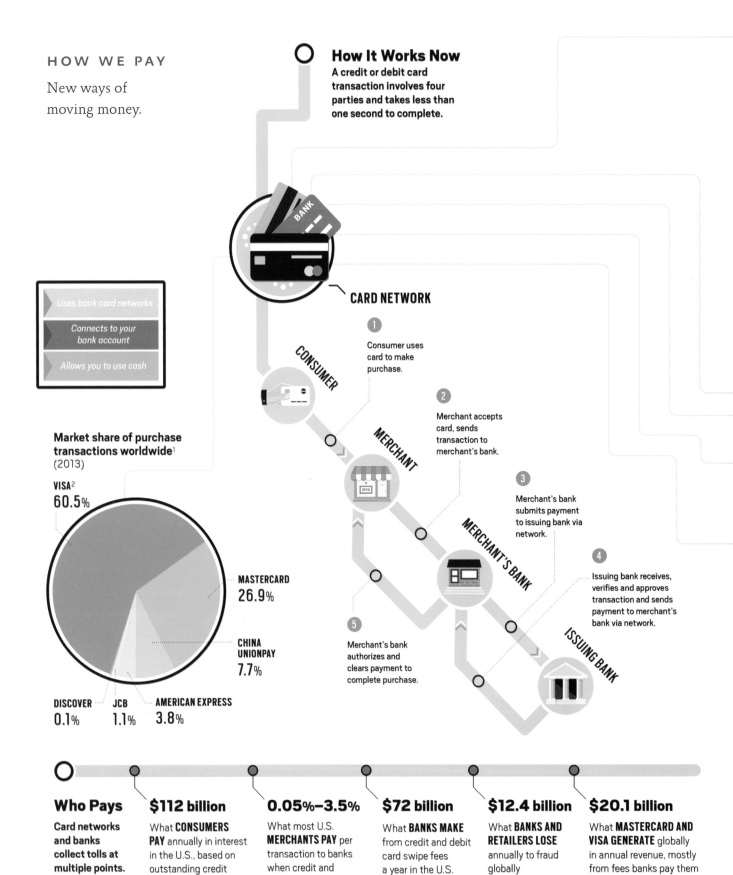

How It Works Now
A credit or debit card transaction involves four parties and takes less than one second to complete.

Legend:
- Uses bank card networks
- Connects to your bank account
- Allows you to use cash

CARD NETWORK

CONSUMER

MERCHANT

MERCHANT'S BANK

ISSUING BANK

1. Consumer uses card to make purchase.
2. Merchant accepts card, sends transaction to merchant's bank.
3. Merchant's bank submits payment to issuing bank via network.
4. Issuing bank receives, verifies and approves transaction and sends payment to merchant's bank via network.
5. Merchant's bank authorizes and clears payment to complete purchase.

Market share of purchase transactions worldwide[1] (2013)

- **VISA**[2] **60.5**%
- **MASTERCARD 26.9**%
- **CHINA UNIONPAY 7.7**%
- **AMERICAN EXPRESS 3.8**%
- **JCB 1.1**%
- **DISCOVER 0.1**%

Who Pays
Card networks and banks collect tolls at multiple points.

$112 billion
What **CONSUMERS PAY** annually in interest in the U.S., based on outstanding credit card debt and current interest rates

0.05%–3.5%
What most U.S. **MERCHANTS PAY** per transaction to banks when credit and debit cards are used

$72 billion
What **BANKS MAKE** from credit and debit card swipe fees a year in the U.S.

$12.4 billion
What **BANKS AND RETAILERS LOSE** annually to fraud globally

$20.1 billion
What **MASTERCARD AND VISA GENERATE** globally in annual revenue, mostly from fees banks pay them to be in their networks and process card transactions

ARTISTS Design by Lily Chow, Bloomberg Markets graphics director; illustration of icons by Ben Gibson, Pop Chart Lab; writing and research by Elizabeth Dexheimer, Bloomberg Finance Americas reporter; editing by Robert Friedman, Bloomberg Finance editor at large, and Ronald Henkoff, *Bloomberg Markets Magazine* editor in chief; direction by Siung Tjia, Bloomberg Markets creative director.

STATEMENT Visa and MasterCard account for 87 percent of global credit and debit card transactions, but new payment technologies are posing some challenges. Using the vernacular of a subway map, we show how the current credit or debit

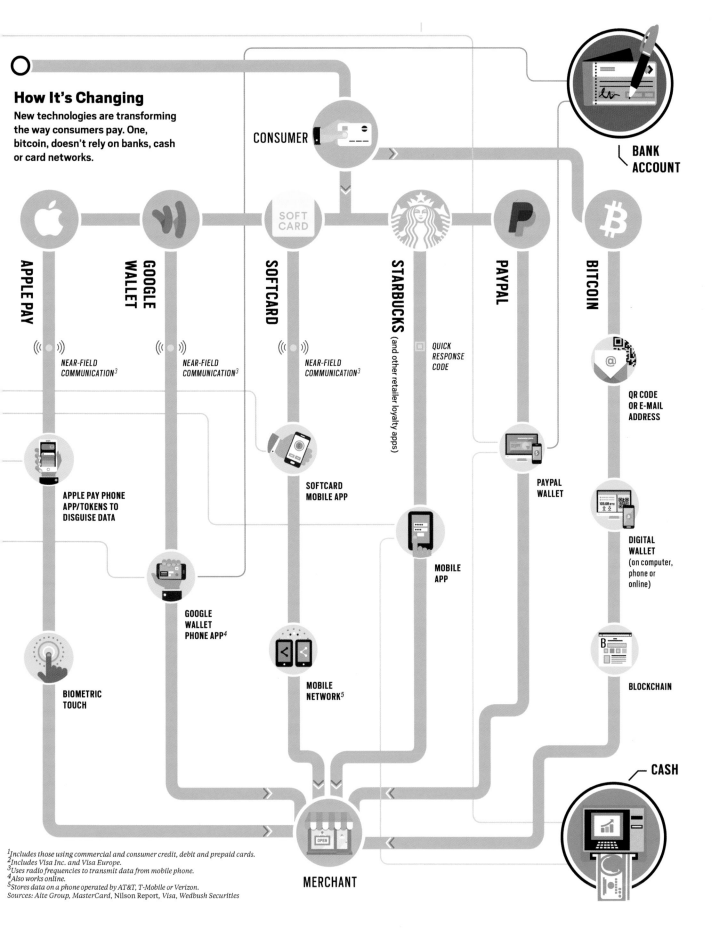

How It's Changing

New technologies are transforming the way consumers pay. One, bitcoin, doesn't rely on banks, cash or card networks.

CONSUMER

BANK ACCOUNT

APPLE PAY

GOOGLE WALLET

SOFTCARD

STARBUCKS (and other retailer loyalty apps)

PAYPAL

BITCOIN

NEAR-FIELD COMMUNICATION[3]

NEAR-FIELD COMMUNICATION[3]

NEAR-FIELD COMMUNICATION[3]

QUICK RESPONSE CODE

QR CODE OR E-MAIL ADDRESS

APPLE PAY PHONE APP/TOKENS TO DISGUISE DATA

SOFTCARD MOBILE APP

PAYPAL WALLET

DIGITAL WALLET (on computer, phone or online)

GOOGLE WALLET PHONE APP[4]

MOBILE APP

BIOMETRIC TOUCH

MOBILE NETWORK[5]

BLOCKCHAIN

CASH

MERCHANT

[1] Includes those using commercial and consumer credit, debit and prepaid cards.
[2] Includes Visa Inc. and Visa Europe.
[3] Uses radio frequencies to transmit data from mobile phone.
[4] Also works online.
[5] Stores data on a phone operated by AT&T, T-Mobile or Verizon.
Sources: Aite Group, MasterCard, Nilson Report, Visa, Wedbush Securities

payment network works, while showing how some of the new competitors plug and play with the network—or bypass it. Clarity of the information was our guiding principle, quickly conveying the three main hubs of payment systems and the

sampling of six new technologies. Given the depth of information that needed to be relayed, on top of changing last-minute news (Apple Pay was launched four days before the graphic went to print!), we went through several sketch and

fact-checking rounds. Hopefully Massimo Vignelli is smiling somewhere.

PUBLICATION *Bloomberg Markets Magazine* (October 1, 2014)

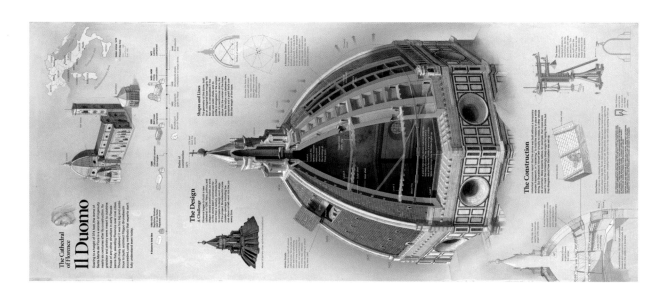

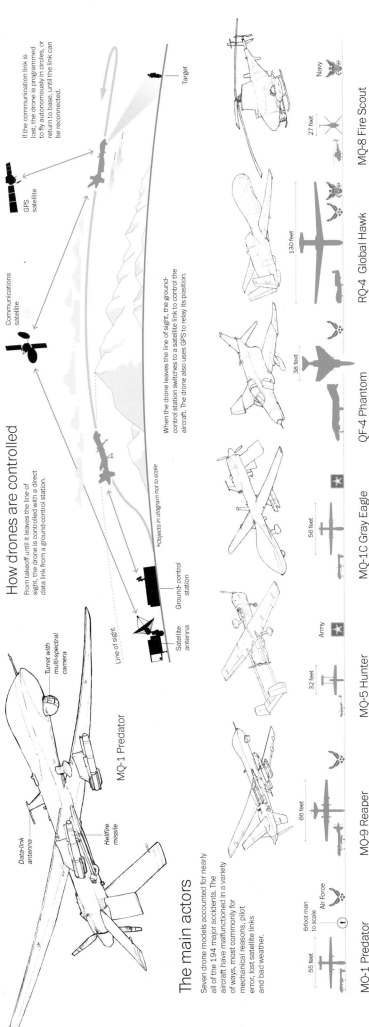

How drones are controlled

From takeoff until it leaves the line of sight, the drone is controlled with a direct data link from a ground-control station.

When the drone leaves the line of sight, the ground-control station switches to a satellite link to control the aircraft. The drone also uses GPS to relay its position.

If the communication link is lost, the drone is programmed to fly autonomously in circles, or return to base, until the link can be reconnected.

GPS satellite

Communications satellite

Target

Line of sight

Satellite antenna

Ground-control station

*Objects in diagram not to scale

Data-link antenna

Turret with multi-spectral camera

Hellfire missile

MQ-1 Predator

The main actors

Seven drone models accounted for nearly all of the 194 major accidents. The aircraft have malfunctioned in a variety of ways, most commonly for mechanical reasons, pilot error, lost satellite links and bad weather.

6-foot man to scale

55 feet

Air Force

MQ-1 Predator

First flown in 1994, it later became the first weaponized drone. Designed to conduct surveillance with powerful cameras and sensors, it can be armed with laser-guided Hellfire missiles. It often stays aloft on missions for more than 20 hours at a time and can reach an altitude of 25,000 feet.

66 feet

MQ-9 Reaper

The bigger, faster and more reliable successor to the Predator. It can fly as high as 50,000 feet and carry four Hellfire missiles, twice as many as the Predator. The Air Force expects to replace all its Predators with Reapers by 2018. The civilian version of the MQ-9 is called the Predator B.

32 feet

Army

MQ-5 Hunter

Originally developed in the 1990s, the Hunter features an unusual twin tail-boom design and is powered by two engines. Upgraded versions can carry Viper Strike munitions and climb to a ceiling of 20,000 feet.

56 feet

MQ-1C Gray Eagle

The Army's upgraded version of the Predator system, and the successor to the Army's MQ-1 Warrior. It can carry four Hellfire missiles and stay aloft as long as 25 hours. Predecessor versions were the Warrior and I-Gnat.

38 feet

QF-4 Phantom

Old F-4 fighter jets that have been modified and retrofitted into a drone for target practice. The remotely controlled aircraft is used as a target for missiles fired by other aircraft and to evaluate the effectiveness of various weapons systems.

130 feet

RQ-4 Global Hawk

A high-altitude, reconnaissance aircraft that conducts missions as the U-2 spy plane. It can reach a ceiling of 60,000 feet and has a range of nearly 9,000 nautical miles. Its wingspan is comparable in size to a Boeing 757's.

Navy

27 feet

MQ-8 Fire Scout

A helicopter drone operated by the Navy, usually in support of Special Operations forces. It is designed to take off and land from ships at sea, but also has been deployed to Afghanistan. It can climb to a ceiling of 20,000 feet and has a range of about 110 miles.

Sources: Air Force, Army, Navy accident investigation reports; Defense Department records; General Atomics Aeronautical Systems Inc.; Northrop Grumman Corp.

ALBERTO CUADRA AND CRAIG WHITLOCK /THE WASHINGTON POST

STATEMENT Drones crash, sometimes dramatically. There were roughly 400 cases of military and civilian drones that crashed in the United States and abroad between September 11, 2001, and December 2013, and a subset of these crashes were considered "Class A" crashes — either destroying the drone or causing $2 million or more in damage. Many were a result of lost connections; a quarter happened in the US. We decided to use a modified sankey diagram to show relationships between three of the most interesting and concrete pieces of information we knew about each crash — service, location, and drone type. The ink illustrations of the different drone types added an organic touch to the package and helped illustrate how lost connections can happen.

ARTISTS Alberto Cuadra, graphics editor; Emily Chow, graphics editor; and Craig Whitlock, reporter, at the *Washington Post*.

PUBLICATION *Washington Post* (June 22, 2014)

NATIVE HORSES

How horses arrived in America, and changed it.

ARTISTS Graphic design by Fernando G. Baptista, senior graphics editor; art by Aldo Chiappe; map by Debbie Gibbons, senior graphics editor; production by Matthew Twombly, graphic design specialist; and text by Jane Vessels, staff writer, at *National Geographic*. Research by Patricia Healy, freelance researcher.

STATEMENT The horse first arose in prehistoric North America, but had long vanished from the continent by the time Spanish colonists began to arrive with European horses on their ships. Southeastern Native American tribes began adapting Spanish breeds to their needs, and soon horses were spreading across North and South America through trade and colonization. In the graphic, we show how the most important horses, both domesticated and wild, were bred, and the tribes that bred them. We connect the different breeds with a map of the expansion of the horse in North America.

PUBLICATION

National Geographic (March 2014)

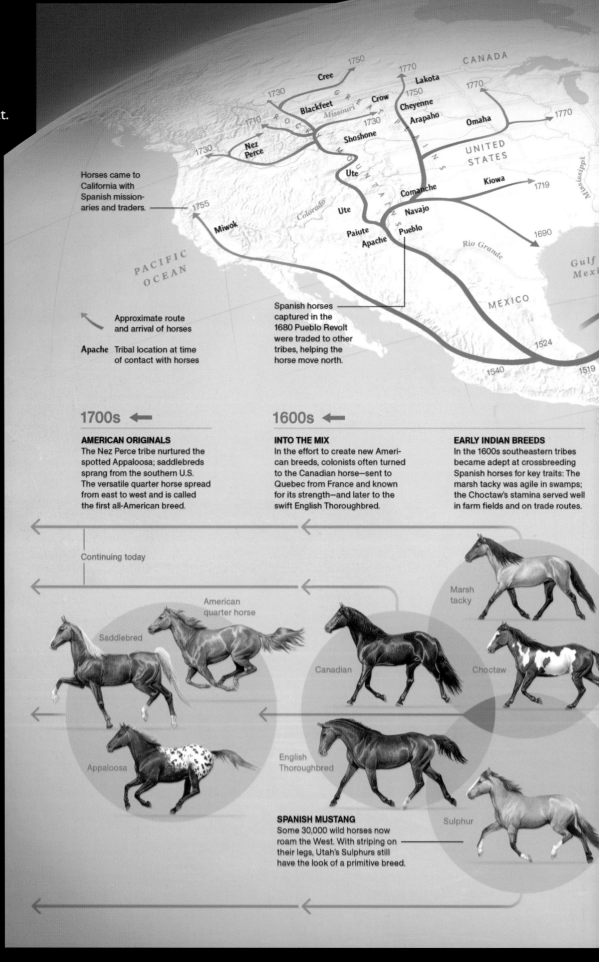

Horses came to California with Spanish missionaries and traders.

Spanish horses captured in the 1680 Pueblo Revolt were traded to other tribes, helping the horse move north.

↖ Approximate route and arrival of horses

Apache Tribal location at time of contact with horses

1700s ←

AMERICAN ORIGINALS
The Nez Perce tribe nurtured the spotted Appaloosa; saddlebreds sprang from the southern U.S. The versatile quarter horse spread from east to west and is called the first all-American breed.

Continuing today

1600s ←

INTO THE MIX
In the effort to create new American breeds, colonists often turned to the Canadian horse—sent to Quebec from France and known for its strength—and later to the swift English Thoroughbred.

EARLY INDIAN BREEDS
In the 1600s southeastern tribes became adept at crossbreeding Spanish horses for key traits: The marsh tacky was agile in swamps; the Choctaw's stamina served well in farm fields and on trade routes.

American quarter horse

Saddlebred

Appaloosa

Canadian

English Thoroughbred

Marsh tacky

Choctaw

Sulphur

SPANISH MUSTANG
Some 30,000 wild horses now roam the West. With striping on their legs, Utah's Sulphurs still have the look of a primitive breed.

RETURN
OF A NATIVE

The horse originated in North America nearly two million years ago and spread to Eurasia over the Bering land bridge. Then, about 10,000 B.C., horses vanished from the New World, possibly killed for food by humans who had come to the continent from Eurasia. When the horse returned with European conquistadores and colonists (map), it transformed the culture of many tribes. In turn, Native Americans and settlers changed the horse, developing new breeds from Old World stock (bottom).

France 1665

England 1630

Dutch 1625

Seneca

APPALACHIAN MTS.

England 1610

Tuscarora
1650

Cherokee

ATLANTIC
OCEAN

Choctaw 1565

Chickasaw

1539

Columbus reintro-
duced horses to the
New World on his
second voyage.

1521

Spain 1493

CUBA

1540

Caribbean
Sea

HONDURAS

1509

1514

PANAMA

COLOMBIA

1493-1500s ⬅

COLONIAL SPANISH
Expeditions carried a variety of Iberian breeds to the Caribbean. As the herds grew, Spaniards seeking gold and glory took horses to mainland North America. The first to do so: Hernán Cortés in 1519.

Old World stock

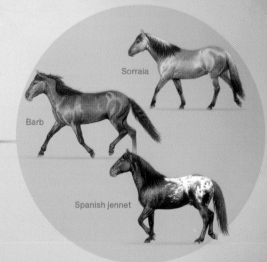

DOMESTICATED

Sorraia

Barb

By 1529 so many horses had escaped that Mexican cattlemen set rules for capturing and branding the runaways, which came to be called mustangs, from the medieval Spanish word *mestengo*, for "stray."

Spanish jennet

WILD

FERNANDO G. BAPTISTA AND MATTHEW TWOMBLY, NGM STAFF; PATRICIA HEALY; DEBBIE GIBBONS, NG STAFF (MAP). ALDO CHIAPPE (HORSE ART). SOURCES: EMIL HER MANY HORSES, NATIONAL MUSEUM OF THE AMERICAN INDIAN; PHILLIP SPONENBERG, VIRGINIA TECH; JEANETTE BERANGER, LIVESTOCK CONSERVANCY

INSIDE A DEADLY RECALL

The trouble with an ignition switch.

ARTIST Guilbert Gates, graphics editor, *New York Times.*

STATEMENT My aim was to pinpoint for readers the
exact cause of the ignition switch fault that led to the
recall of the Chevy Cobalt and many other cars, and was
so much in the news at the time. In speaking with several
engineers who had studied the issue, I was fascinated to
learn that the crux of this huge problem had been a tiny
metal pin, about a quarter of an inch long, called the
detent plunger. I got hold of one of the faulty ignition
switches and housings on eBay and took it apart. For the
graphic, I used a few straightforward technical illustra-
tions to show the location of the switch and explain its
function, and then focused on the specifics of the prob-
lem. I think the graphic succeeds by giving enough visual
context to interest readers and help them understand
the issue quickly, without becoming too visually noisy or
overly complicated.

PUBLICATION *New York Times* (June 6, 2014)

The Design Flaw in the Cobalt Ignition Switch

An internal inquiry at General Motors showed years of inaction in responding to the dangers of an ignition-switch flaw, which ultimately led to the recall of 2.6 million small cars. At the heart of the problem was a tiny metal pin called the detent plunger, a part that would normally keep the ignition on once the car was started.

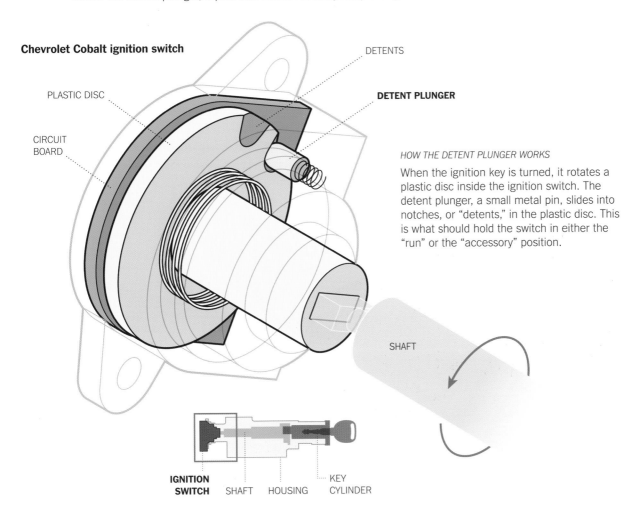

Chevrolet Cobalt ignition switch

PLASTIC DISC

CIRCUIT BOARD

DETENTS

DETENT PLUNGER

HOW THE DETENT PLUNGER WORKS

When the ignition key is turned, it rotates a plastic disc inside the ignition switch. The detent plunger, a small metal pin, slides into notches, or "detents," in the plastic disc. This is what should hold the switch in either the "run" or the "accessory" position.

SHAFT

IGNITION SWITCH SHAFT HOUSING KEY CYLINDER

Problem 1

Early-model detent plungers were slightly too short, so the plastic disc could slip out of "run" and back into the "accessory" position, causing the car to stall. In later models, the pin was lengthened to address the problem.

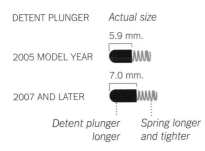

DETENT PLUNGER *Actual size*

5.9 mm.

2005 MODEL YEAR

7.0 mm.

2007 AND LATER

Detent plunger longer *Spring longer and tighter*

Problem 2

The problem was made worse by a key that had a wide slot. A heavy key ring swaying in this slot, or jostled by a knee, could pull the key out of run, into the "accessory" position.

FORCE

WEIGHT OF KEY RING

The Result

If the ignition were switched off while the car was in motion, as could happen in the faulty Chevy Cobalts, the main computer controlling the air bags would stop working after one or two seconds. If the car crashed after that period, then the air bags would not deploy.

Sources: McSwain Engineering; Hallman Engineering

Using history to look ahead.

+6°F

Average change in spring temperatures in Concord, Mass., since Thoreau lived there in the mid-1800s.

ARTISTS Writing and chart illustration by Katie Peek, art direction by Todd Detwiler, photography by Jonathon Kambouris, illustration of birds and flowers by Joel Kimmel, editing by Amber Williams, and research by Kate Baggaley of *Popular Science*.

STATEMENT As the climate changes, and the warm temperatures of spring arrive earlier in the year, nature's patterns aren't shifting uniformly in response. How exactly will spring change? Ecologists are looking to the past to help them predict: historical records help them understand how temperatures affect each individual marker of spring, such as flower blossoming and bird migration. My inspiration came as I walked down a tree-lined avenue in New York one morning and noticed that when warm weather finally arrived after an unusually chilly spring, trees everywhere burst into bloom nearly simultaneously. That set me exploring how the long-term warming patterns might change spring in the future, a journey that led me to a millennium's worth of Japanese cherry-blossom records and the trove of Henry David Thoreau's meticulous record-keeping near Boston. Thanks to the scientists who have unearthed them, it's possible to see that a complex ecological shift is underway.

PUBLICATION *Popular Science* (March 18, 2014)

1

Leaves appear earlier

In 2012, plants leafed out a full month early in some parts of the Northeast, as measured by satellite images that document levels of foliage. Scientists attribute the premature greening to abnormally warm weather.

Anomaly in leaf arrival
- 18–36 days early
- 0–18 days early
- 0–18 days late
- 18–36 days late

2

Cherry trees bloom earlier too

More than 1,200 years of cherry-blossom records for Kyoto, Japan, show a trend toward earlier blooms in the past 100 years.

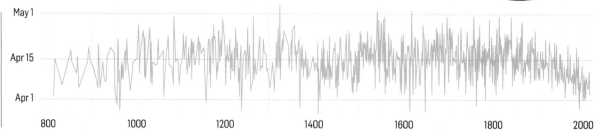

May 1 · Apr 15 · Apr 1

800 · 1000 · 1200 · 1400 · 1600 · 1800 · 2000

SOURCES: 1—JOSHUA GRAY, BOSTON UNIVERSITY; 2—YASUYUKI AONO, OSAKA PREFECTURE UNIVERSITY
3.5—ELIZABETH ELLWOOD ET AL., BOSTON UNIVERSITY; 4—CAROLINE POLGAR ET AL., BOSTON UNIVERSITY

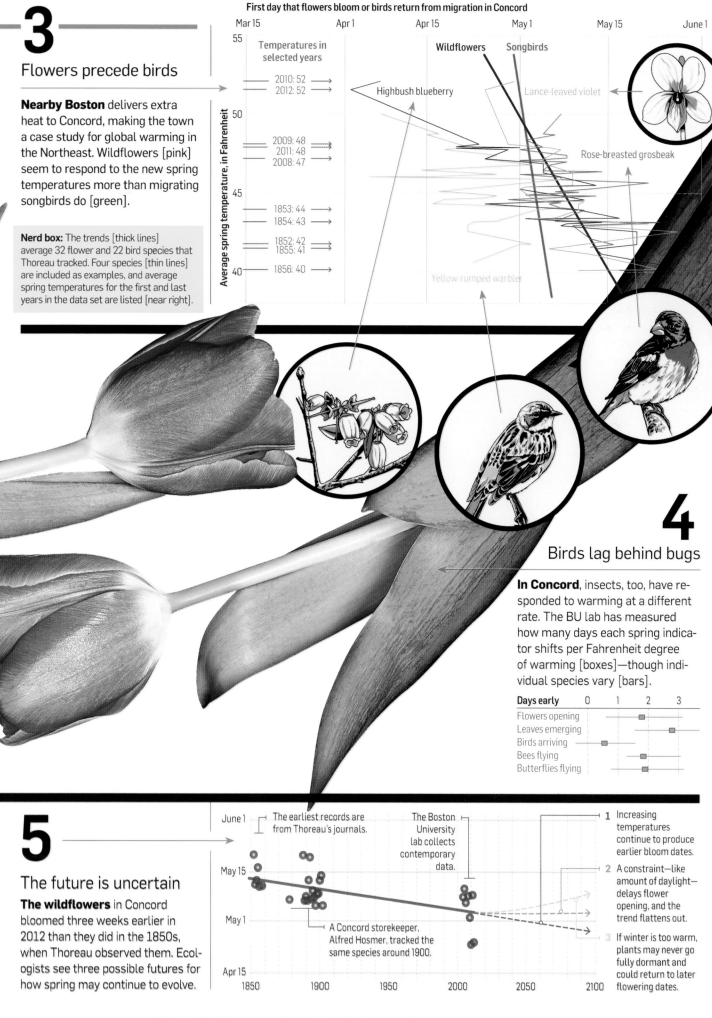

3

Flowers precede birds

Nearby Boston delivers extra heat to Concord, making the town a case study for global warming in the Northeast. Wildflowers [pink] seem to respond to the new spring temperatures more than migrating songbirds do [green].

Nerd box: The trends [thick lines] average 32 flower and 22 bird species that Thoreau tracked. Four species [thin lines] are included as examples, and average spring temperatures for the first and last years in the data set are listed [near right].

First day that flowers bloom or birds return from migration in Concord

Mar 15 Apr 1 Apr 15 May 1 May 15 June 1

Average spring temperature, in Fahrenheit

Temperatures in selected years

2010: 52
2012: 52

2009: 48
2011: 48
2008: 47

1853: 44
1854: 43

1852: 42
1855: 41

1856: 40

Wildflowers Songbirds

Highbush blueberry

Lance-leaved violet

Rose-breasted grosbeak

Yellow-rumped warbler

4

Birds lag behind bugs

In Concord, insects, too, have responded to warming at a different rate. The BU lab has measured how many days each spring indicator shifts per Fahrenheit degree of warming [boxes]—though individual species vary [bars].

Days early 0 1 2 3

Flowers opening
Leaves emerging
Birds arriving
Bees flying
Butterflies flying

5

The future is uncertain

The wildflowers in Concord bloomed three weeks earlier in 2012 than they did in the 1850s, when Thoreau observed them. Ecologists see three possible futures for how spring may continue to evolve.

June 1

The earliest records are from Thoreau's journals.

The Boston University lab collects contemporary data.

May 15

A Concord storekeeper, Alfred Hosmer, tracked the same species around 1900.

May 1

Apr 15

1850 1900 1950 2000 2050 2100

1 Increasing temperatures continue to produce earlier bloom dates.

2 A constraint—like amount of daylight—delays flower opening, and the trend flattens out.

3 If winter is too warm, plants may never go fully dormant and could return to later flowering dates.

Spring temperatures are an average of March, April, and May, except the bird trend line, which is March and April.

Michael Fincke (US)
American who has spent the most time in space
- ● SECONDS YOUNGER // 0.0093
- ● DAYS IN ORBIT // 382

Thomas Reiter (Germany)
Most time in space for a non-Russian, non-American
- ● SECONDS YOUNGER // 0.0087
- ● DAYS IN ORBIT // 350

Hubble Space Telescope
One of the largest (and most famous) space telescopes
- ● SECONDS YOUNGER // 0.2030
- ● DAYS IN ORBIT // 8,936

International Space Station
The astronauts with the greatest time dilation were on the ISS, on Mir, on shuttle missions, or a combination.
- ● SECONDS YOUNGER // 0.1418 ● DAYS IN ORBIT // 5,805

| 400 km | 560 km | 700 km | 800 km |

3,174 km WHERE THE EFFECTS OF SPEED AND GRAVITY CANCEL OUT

POSITIVE TIME SHIFT
Earth's clock moves ahead of the travelers' and satellites'. So they are younger than they'd have been had they remained on Earth.

$+$ $-$

NEGATIVE TIME SHIFT
Earth's clock is falling behind the satellites'. That means they are older than they would have been had they remained on Earth.

Sergei K. Krikalev (Russia)
Person who has spent the most time in space
- ● SECONDS YOUNGER // 0.020
- ● DAYS IN ORBIT // 803

Peggy Whitson (US)
Has spent longer in space than any other woman
- ● SECONDS YOUNGER // 0.0092
- ● DAYS IN ORBIT // 377

Landsat 5 (decommissioned)
Longest-operating Earth-observing satellite
- ● SECONDS YOUNGER // 0.2357 ● DAYS IN ORBIT // 11,181

TIME TRAVEL

How to beat the clock.

ARTISTS Carl De Torres and Erik Carnes, designers; Seth Kadish, writer; Sarah Fallon, editor; Lexi Pandell, research; Billy Sorrentino, creative director; Caleb Bennett, design director; and Allie Fisher, art director, at *WIRED*.

STATEMENT Time only moves forward. But thanks to Albert Einstein's theory of relativity, we know that how quickly it passes is not constant. This graphic, created for an issue of *WIRED* magazine guest-edited by *Interstellar* director Christopher Nolan, visualizes these so-called time dilation effects for astronauts and satellites.

Both velocity and gravity alter the rate at which seconds tick. The astronauts aboard the International Space Station (ISS) have a high orbital speed, which slows their passage of time relative to the rate on Earth's surface. Consequently, astronauts are younger than they would have been had they never made the trip. The effect is extremely small: it would take about 112 years on the ISS to be just one second younger than your twin on Earth! Gravitational fields also slow time, so moving away from a large mass like Earth speeds up the aging process. GPS and communications satellites, traveling in medium and high Earth orbits, experience weaker gravity and travel more slowly than the ISS. So a clock on board one of these satellites ticks faster than a clock on Earth. Ignoring this relativistic effect would be catastrophic—GPS devices would be so inaccurate they'd be rendered useless!

PUBLICATION
WIRED (December 2014)

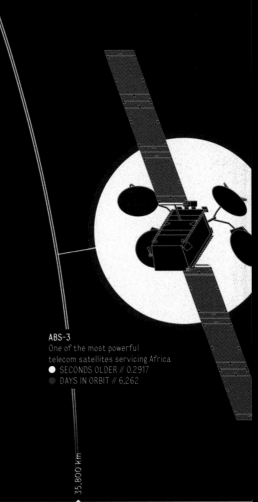

ABS-3
One of the most powerful
telecom satellites servicing Africa
● SECONDS OLDER // 0.2917
● DAYS IN ORBIT // 6,262

35,800 km

20,200 km

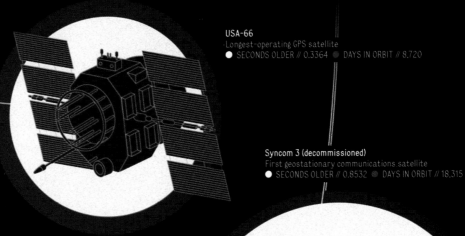

Cosmos 158 (decommissioned)
First Soviet prototype navigation satellite
● SECONDS YOUNGER // 0.3454
● DAYS IN ORBIT // 17,316

USA-66
Longest-operating GPS satellite
● SECONDS OLDER // 0.3364 ● DAYS IN ORBIT // 8,720

Syncom 3 (decommissioned)
First geostationary communications satellite
● SECONDS OLDER // 0.8532 ● DAYS IN ORBIT // 18,315

ORBITAL ALTITUDE

NUMBERS AS OF
OCTOBER 11. ORBITAL SPACING
NOT TO SCALE.

The many guises of trilobites.

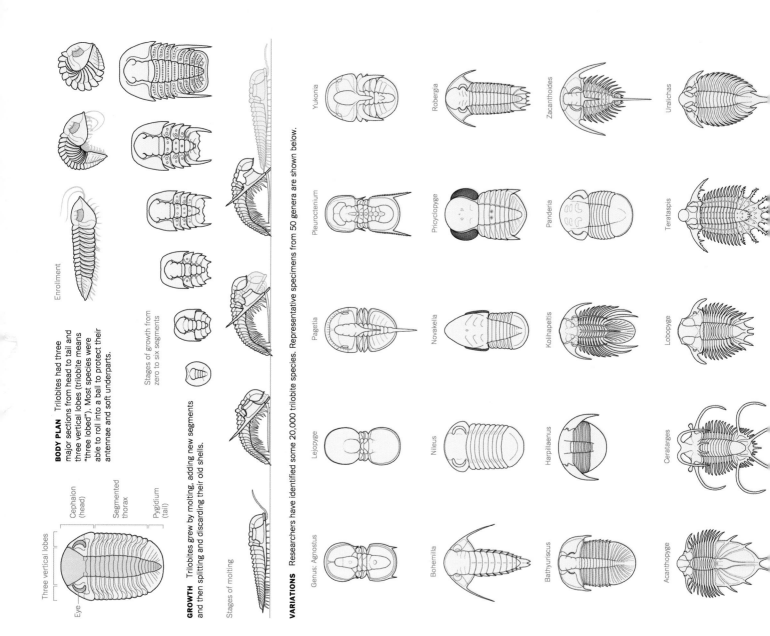

BODY PLAN Trilobites had three major sections from head to tail and three vertical lobes (trilobite means "three lobed"). Most species were able to roll into a ball to protect their antennae and soft underparts.

Three vertical lobes

Eye

Cephalon (head)

Segmented thorax

Pygidium (tail)

Enrollment

Stages of growth from zero to six segments

GROWTH Trilobites grew by molting, adding new segments and then splitting and discarding their old shells.

Stages of molting

VARIATIONS Researchers have identified some 20,000 trilobite species. Representative specimens from 50 genera are shown below.

Yukonia

Robergia

Zacanthoides

Uralichas

Pleuroctenium

Pricyclopyge

Pandena

Terataspis

Pagetia

Novakella

Kolihapeltis

Lobopyge

Leiopyge

Nileus

Harpillaenus

Ceratarges

Genus: Agnostus

Bohemilla

Bathyuriscus

Acanthopyge

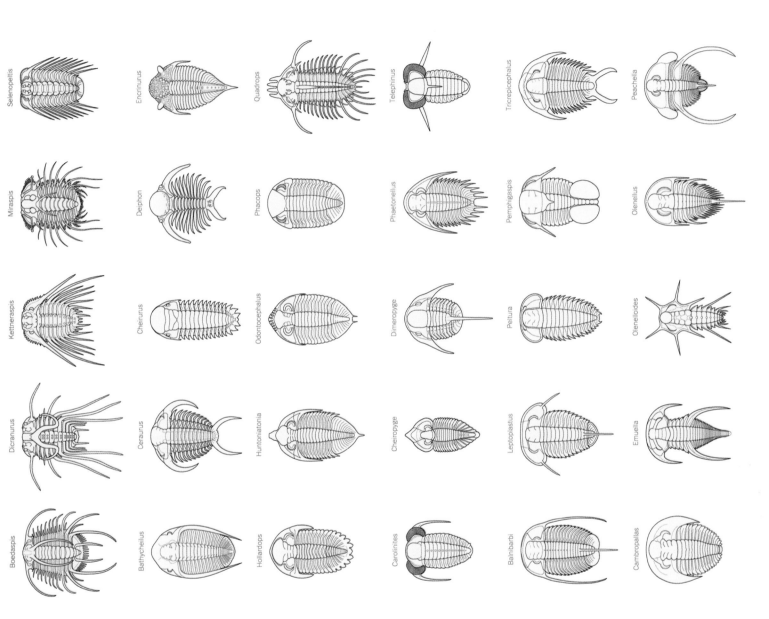

Selenopeltis · Encrinurus · Quadrops · Telephinus · Tricrepicephalus · Peachella

Miraspis · Deiphon · Phacops · Phaetonellus · Pemphigaspis · Olenellus

Kettneraspis · Cheirurus · Odontocephalus · Dimeropyge · Peltura · Olenelloides

Dicranurus · Ceraurus · Huntoniatonia · Cheiropyge · Leptoplastus · Ermuella

Boedaspis · Bathycheilus · Hollardops · Carolinites · Balnibarbi · Cambropallas

ARTISTS Jonathan Corum, science graphics editor at the *New York Times*; Samuel M. Gon III, author of *A Pictorial Guide to the Orders of Trilobites*, illustrator.

STATEMENT The ancient marine dwellers called trilobites were among the most successful animals in the history of the planet. I bought a copy of Sam Gon's guide to trilobites in 2004, and was stunned by the detail and care he put into the illustrations. Ten years later, an article on trilobites made me remember his work, and I asked Sam if I could reproduce some of his drawings. I wanted to give a sense of the huge range of shapes and forms among different trilobite species, and to provide a quick visual explanation of how the animals moved and grew. I tried to keep the design spare and simple, with minimal use of color, to reveal patterns and emphasize variations.

PUBLICATION *New York Times* (March 3, 2014)

NOT JUST UNIQUE

A bestiary of snowflakes.

ARTIST Andy Brunning, secondary
school chemistry teacher in the UK,
creator of the *Compound Interest* website
(compoundchem.com).

STATEMENT Although individual
snowflakes may be unique, they can still
be grouped into categories based on their
shapes, and these are much more varied
than the traditional six-sided snowflake
we're all familiar with. This graphic,
based on a classification system created by
Japanese researchers in 2013, is a fantastic
example of the complexities of crystals
formed by even a simple molecule like
water. (It is even more complex than it
looks here: the 39 "intermediate" catego-

ries shown here can actually be broken
down into 121 "elementary" categories.)
I was also inspired to make the graphic by
the spectacular macro images of snow-
flakes taken by the Russian photographer
Alexey Kljatov. I think people are sur-
prised to learn that the classic snowflake
image is by no means the only possibility.

PUBLICATION *Compound Interest,
compoundchem.com* (December 10, 2014)

SNOWFLAKES
Classifications & shapes

PLANE CRYSTALS
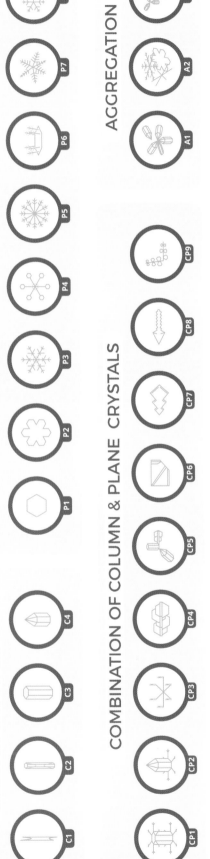

COLUMN CRYSTALS

COMBINATION OF COLUMN & PLANE CRYSTALS

AGGREGATION

GERM OF ICE CRYSTALS

RIMED SNOW CRYSTALS

IRREGULAR PARTICLES

OTHER SOLID PRECIPITATION
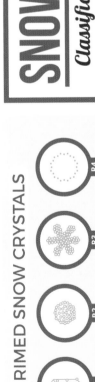

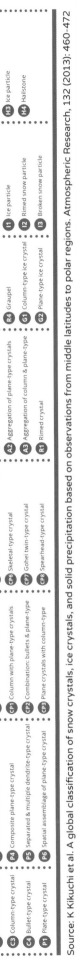

Snowflakes can occur in a huge variety of shapes. This chart shows the general and intermediate levels of classification for these shapes; they can also be divided further into elementary levels, which are not shown here.

GENERAL	INTERMEDIATE	ELEMENTARY
8	39	121
CATEGORIES	CATEGORIES	CATEGORIES

KEY
Shape
CODE

- C1 Needle-type crystal
- C2 Sheath-type crystal
- C3 Column-type crystal
- C4 Bullet-type crystal
- P1 Plate-type crystal
- P2 Sector-type crystal
- P3 Dendrite-type crystal
- P4 Composite plane-type crystal
- P5 Separated & multiple dendrite-type crystal
- P6 Spatial assemblage of plane-type crystal
- P7 Radiating assemblage of plane-type
- P8 Asymmetrical plane-type crystal
- CP1 Column with plane-type crystals
- CP2 Combination: bullets & plane-type
- CP3 Plane crystals with column-type
- CP4 Crossed plate-type crystal
- CP5 Irregular combo: column/plane-type
- CP6 Skeletal-type crystal
- CP7 Gohei twin-type crystal
- CP8 Spearhead-type crystal
- CP9 Seagull-type crystal
- A1 Aggregation of column-type crystals
- A2 Aggregation of plane-type crystals
- A3 Aggregation of column & plane-type
- R1 Rimed crystal
- R2 Densely rimed crystal
- R3 Graupel-like snow
- R4 Graupel
- G1 Column-type ice crystal
- G2 Plane-type ice crystal
- G3 Polyhedral ice-type crystal
- G4 Polycrystalline-type ice crystal
- I1 Ice particle
- I2 Rimed snow particle
- I3 Broken snow particle
- H1 Frozen hydrometeor particle
- H2 Sleet particle
- H3 Ice particle
- H4 Hailstone

Source: K Kikuchi et al. A global classification of snow crystals, ice crystals, and solid precipitation based on observations from middle latitudes to polar regions. Atmospheric Research, 132 (2013): 460-472

Sometime next year, D.C. Water will begin using something it has a lot of (yes, poop, although folks there call it "biosolids") to generate something it needs: electricity. Key to the $470 million system is a unique process, the first of its kind in North America, created by Norwegian company Cambi.

The process is called "thermal hydrolysis," and the basic idea is to cook the biosolids into a recipe that methane-making microbes can't resist, then burn the methane they produce to generate power. Here's how the system will work:

What about the smell?
The entire plant has various types of odor-control gadgetry that removes ammonia and hydrogen sulfide for the safety of people working there and for the happiness of its neighbors.

Potomac River

Fats, oil and grease and other "floatables" are skimmed off and sent to the landfill.

Water is treated to remove carbon and nitrogen, then filtered and disinfected before it is released into the Potomac. During these processes, more solids settle out and are sent back into the main solids treatment path.

CITY SEWER / SCREENING SYSTEM

1 "Solids" travel from your toilet through some of the 1,800 miles of sewer pipes that lead to Blue Plains. The plant processes 370 million gallons of wastewater per day, enough to fill RFK Stadium to the brim.

2 Screening systems get rid of rocks, Legos, and anything else that is a ¼ inch or bigger. All that is sent to a landfill.

SEDIMENTATION TANK

3 The rest goes into primary sedimentation tanks, where solid particles settle to the bottom and fats, oil and grease float to the top.

GRAVITY THICKENER TANK

4 Solids are thickened and blended together.

This is the unique part
Taken together these next three stages are called thermal hydrolysis. Engineer Chris Peot, D.C. Water's

5 A centrifuge spins out some of the water.

Water is sent through its treatment process.

SLUDGE SILO

6 The sludge-like residue drops into one of four

POOP TO POWER

A novel source of energy, and how it works.

ARTISTS Bonnie Berkowitz, graphics reporter, and Todd Lindeman, graphic artist, at the *Washington Post*.

STATEMENT When a group of us visited DC Water for another story, the utility's media representative mentioned another

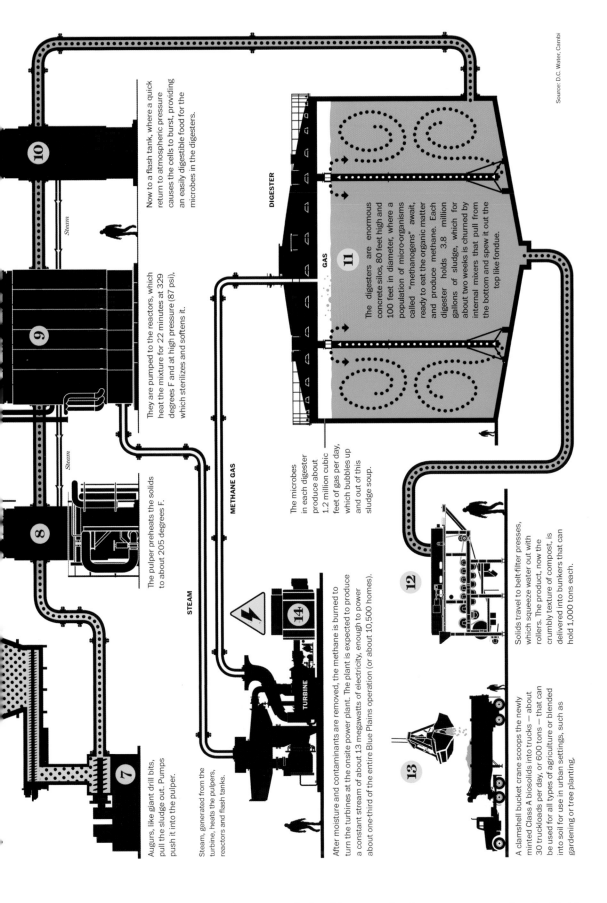

Now to a flash tank, where a quick return to atmospheric pressure causes the cells to burst, providing an easily digestible food for the microbes in the digesters.

They are pumped to the reactors, which heat the mixture for 22 minutes at 329 degrees F and at high pressure (87 psi), which sterilizes and softens it.

DIGESTER

GAS

The digesters are enormous concrete silos, 80 feet high and 100 feet in diameter, where a population of micro-organisms called "methanogens" await, ready to eat the organic matter and produce methane. Each digester holds 3.8 million gallons of sludge, which for about two weeks is churned by internal mixers that pull from the bottom and spew it out the top like fondue.

METHANE GAS

The microbes in each digester produce about 1.2 million cubic feet of gas per day, which bubbles up and out of this sludge soup.

The pulper preheats the solids to about 205 degrees F.

STEAM

Steam, generated from the turbine, heats the pulpers, reactors and flash tanks.

Augurs, like giant drill bits, pull the sludge out. Pumps push it into the pulper.

After moisture and contaminants are removed, the methane is burned to turn the turbines at the onsite power plant. The plant is expected to produce a constant stream of about 13 megawatts of electricity, enough to power about one-third of the entire Blue Plains operation (or about 10,500 homes).

TURBINE

Solids travel to belt-filter presses, which squeeze water out with rollers. The product, now the crumbly texture of compost, is delivered into bunkers that can hold 1,000 tons each.

A clamshell bucket crane scoops the newly minted Class A biosolids into trucks — about 30 truckloads per day, or 600 tons — that can be used for all types of agriculture or blended into soil for use in urban settings, such as gardening or tree planting.

Steam

Source: D.C. Water, Cambi

project: she called it "poop-to-power." How could we not do a graphic? Bonnie and Todd went to the facility assuming Todd would draw a representation of the process as it is laid out, following the biosolids from building to building. But after he saw how many steps were involved and how complex the route was, it became clear that something like that would be unreadable. So he came up with a stylized, schematic version reminiscent of a Rube Goldberg machine winding around the page. His original version began with a person on the toilet reading the *Washington Post,* but that was nixed by editors.

PUBLICATION *Washington Post* (April 5, 2014)

Epic Bluefin Migrations

Bluefin are highly migratory fish, crossing seas around the world in yearly cycles of spawning and feeding. At least two groups share the Atlantic. One spawns in the Gulf of Mexico, the other in the Mediterranean. The groups mingle in the center of the ocean. Some fish even spend years on the opposite side of the ocean from where they spawn.

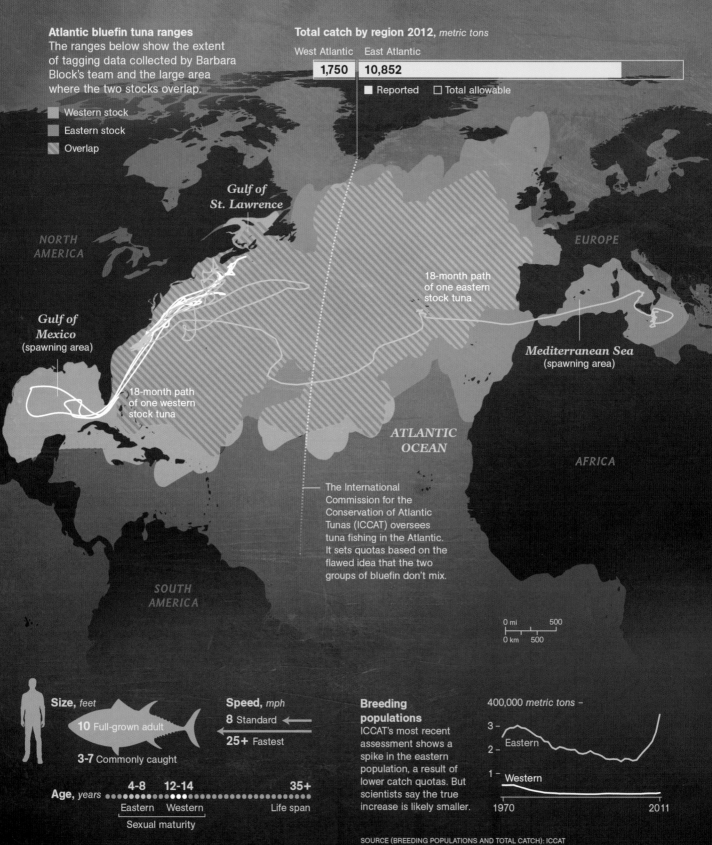

Atlantic bluefin tuna ranges
The ranges below show the extent of tagging data collected by Barbara Block's team and the large area where the two stocks overlap.

- Western stock
- Eastern stock
- Overlap

Total catch by region 2012, *metric tons*

West Atlantic	East Atlantic
1,750	10,852

■ Reported ☐ Total allowable

Gulf of St. Lawrence

NORTH AMERICA

Gulf of Mexico (spawning area)

18-month path of one western stock tuna

18-month path of one eastern stock tuna

EUROPE

Mediterranean Sea (spawning area)

ATLANTIC OCEAN

AFRICA

The International Commission for the Conservation of Atlantic Tunas (ICCAT) oversees tuna fishing in the Atlantic. It sets quotas based on the flawed idea that the two groups of bluefin don't mix.

SOUTH AMERICA

0 mi 500
0 km 500

Size, *feet*
10 Full-grown adult
3-7 Commonly caught

Speed, *mph*
8 Standard ←
25+ Fastest

Age, *years*
4-8 12-14 35+
Eastern Western Life span
Sexual maturity

Breeding populations
ICCAT's most recent assessment shows a spike in the eastern population, a result of lower catch quotas. But scientists say the true increase is likely smaller.

400,000 *metric tons* –
3 –
Eastern
2 –
1 –
Western
1970 2011

SOURCE (BREEDING POPULATIONS AND TOTAL CATCH): ICCAT

The Super Fish

BREATHING

A bluefin swims with its mouth open, forc[...]
the gills in a process called ram ventilati[...]
up to 30 times more surface area than th[...]
and they extract nearly half the oxygen [...]
water. If the tuna ever stops swimming, it[...]

Tuna key

- Arteries carry oxygenated blood away from the heart
- Veins carry deoxygenated blood toward the heart
- Heat-exchange system
- Retractable fins fit into grooves on the body

Cranial cavity

Diving deep
Tunas spend much of their lives in the sun-warmed water near the surface. Juveniles and smaller species always hover and feed there, but large adult bluefin dive to deep, cold waters, where their heat-exchange systems keep the brain and eyes alert for prey—and predators.

Tuna
Surfa[...]

-1,64[...]

MAP: RYAN MORRIS, NGM STAFF. SOURCE: BARBARA BLOCK, ST[...]

PORTRAIT OF A FISH

The remarkable bluefin tuna.

ARTISTS Fernando G. Baptista and Shizuka Aoki.

STATEMENT Bluefin tuna are amazing fish. They can migrate long distances and pass through oceans of varying temperatures, changing their body temperature as needed. The body of a tuna is highly streamlined, and it propels itself mostly with its tail, which is unusual. The map shows bluefin populations and migration areas, and uses the cutaway to highlight the tuna's incredible anatomy and unique organs.

PUBLICATION *National Geographic* (March 2014)

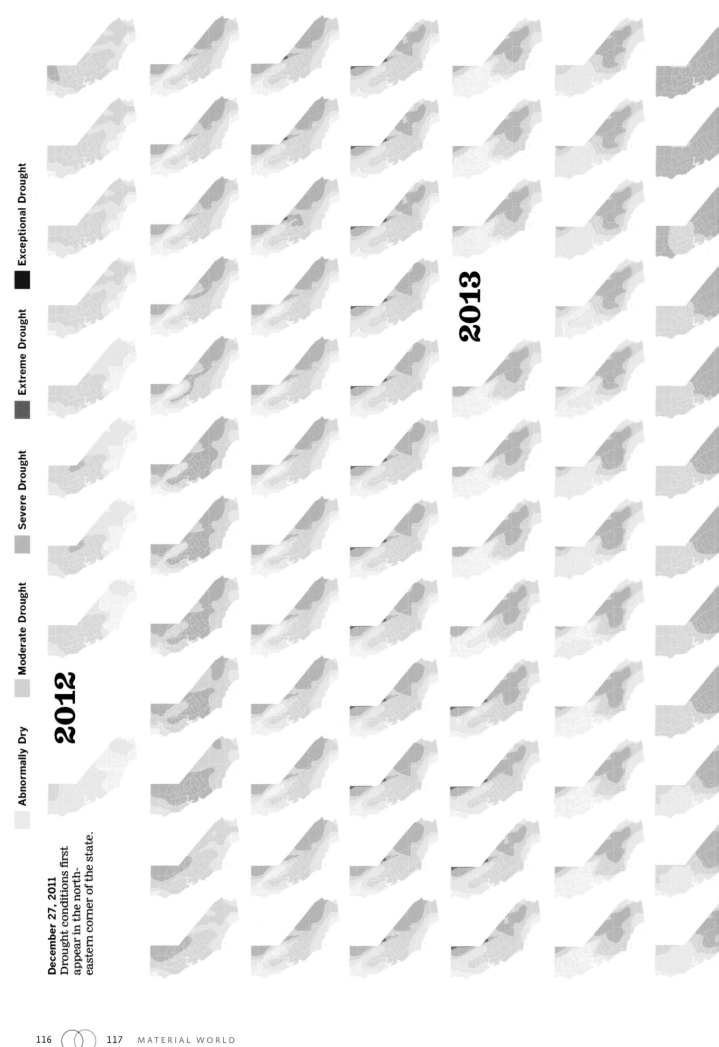

Abnormally Dry | Moderate Drought | Severe Drought | Extreme Drought | Exceptional Drought

December 27, 2011
Drought conditions first appear in the north-eastern corner of the state.

2012

2013

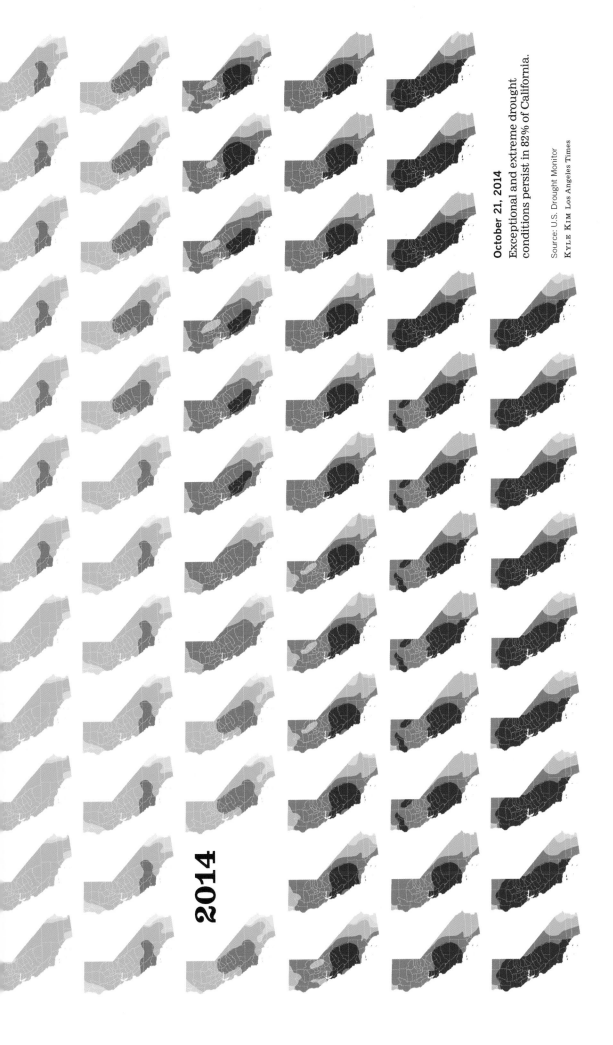

2014

October 21, 2014
Exceptional and extreme drought
conditions persist in 82% of California.

Source: U.S. Drought Monitor
KYLE KIM Los Angeles Times

CALIFORNIA DRYING

The growth of a drought.

ARTISTS Graphics and writing by Kyle
Kim, graphics and data journalist; research
by Thomas Suh Lauder, senior journalist,
at the *Los Angeles Times*. Data from the US
Drought Monitor.

STATEMENT I had wanted to do a project
that used "small multiples," depicting in-
formation with repeating images or charts,
and when the idea to illustrate California's
drought came up, I knew it would be a
perfect opportunity. One of the strengths of
this technique is how well it shows change
over time. We edited through nearly 200
PDFs to create the finished product.

PUBLICATION *Los Angeles Times*
(October 25, 2014)

MOSQUITO WEEK

World's Deadliest Animals

Number of humans killed by animals 2013

| Number of deaths | Killer |

- 10 Shark
- 10 Wolf
— 100 Lion
— 100 Elephant

500 Hippopatumus

1,000 Crocodile

2,000 Tapeworm

2,500 Ascaris roundworm

10,000 Fresh water snail (schistosomiasis)

10,000 Assassin bug (Chagas disease)

10,000 Tsetse fly (sleeping sickness)

25,000 Dog (rabies)

50,000 Snake

THE PLANET'S TOP KILLERS

How lives are lost.

ARTISTS Carl De Torres and Luke Shuman, designers; Ian Saunders, senior creative director; Josh Daniel, creative director; Anu Horsman, associate creative director; and David Roodman, data collection.

475,000
People

1,300,000
Mosquito

SOURCES: IHME; crocodile-attack.info; Kasturiratne et al. (doi.org/10.1371/journal.pmed.0050218); FAO (webcitation.org/6OgpS8SVO); Linnell et al. (webcitation.org/6ORL7DBUO); Packer et al. (doi.org/10.1038%2F436927a); Alessandro De Maddalena. All calculations have wide error margins.

STATEMENT "The World's Deadliest Animals" infographic was conceived to be the heart, soul, and surprise element in a 10-day-long "Mosquito Week" campaign on Bill Gates's blog, *GatesNotes*. The goal was to raise awareness about the Bill and Melinda Gates Foundation's commitment to eradicate malaria. Beginning with a familiar predator, the shark, the graphic references the ubiquitous "Shark Week" while minimizing the danger of sharks compared with other animals, especially the mosquito. The design tells a story about malaria without speaking about the subject directly.

PUBLICATION *gatesnotes.com* (April 25, 2014)

ROSETTA, PHILAE, AND THE COMET

In space, a lot can go wrong.

ARTISTS Design and illustration by Jasiek Krzysztofiak, art editor; art direction by Kelly Krause, creative director, and Wesley Fernandes, art director; and text by Elizabeth Gibney, staff reporter, at *Nature*. 3D illustrations: probe, J. Huart, European Space Agency (ESA); comet, ESA/Rosetta/NAVCAM.

67P/Churyumov–Gerasimenko comet orbit

March 2004 launch

Earth

Sun

Mars

Rosetta's journey

November 2014 probe landing

August 2014 rendezvous

Jupiter orbit

STATEMENT In November 2014, the European Space Agency (ESA) landed a probe on a comet, a complex feat never before attempted. This is a step-by-step guide to the Philae probe's scheduled descent, from its launch from a speeding satellite called Rosetta, to its landing on a rotating comet nine hours later. We explain what is supposed to happen, along with what could go wrong at key moments, as indicated by little red caution signs throughout the graphic. We also found it interesting to include a comparison to the smaller comet for which Rosetta's mission was originally intended—important information not widely reported at the time, which added to the complexity of the mission. The touchdown scenarios proved to be particularly prescient: unfortunately, the lander actually did bounce and land on its side, and landed in a spot that at the moment precludes solar charging.

PUBLICATION *Nature* (November 13, 2014)

BYE-BYE MISSION CONTROL
T − 9 h

Rosetta is steered by infrequent thruster burns, directed from mission control in Darmstadt, Germany. The last burn before landing comes when Rosetta turns towards the comet.

Rosetta's trajectory

T − 9 h
Pre-delivery manoeuvre
How accurately engineers predict Rosetta's speed and position — and execute the manoeuvre — will determine whether Philae arrives on target. The calculations need to factor in winds streaming from the comet and the irregular gravitational field produced by 67P's rubber-duck shape.

Rosetta
Philae

T − 7 h
Philae separation

T − 6'20 h
Escape manoeuvre

T − 5 h
Phoning home

22.5 km

Even tiny flaws in the calculations are magnified as Philae falls.

T 0 h
Landing
Target site Agilkia, chosen for offering the biggest scientific returns at the lowest risk, lies on the 'head' of the duck and covers 1 square kilometre.

COMET SWITCHEROO

ESA originally planned for Rosetta to visit a smaller comet, 46P/Wirtanen, but a postponed launch forced the agency to choose a replacement. The bigger comet increases the distance at which separation must occur, decreasing Philae's landing precision. It also has a stronger gravitational pull, making the landing heavier.

Landing speed
1 m s⁻¹

Landing speed
0.5 m s⁻¹

1.2 km
46P/Wirtanen
(Exact shape unknown)

Surface area
46 km²

4.1 km
67P/Churyumov–Gerasimenko

SYNCHRONIZED SEPARATION

`T − 7h`

Following a cue from a control centre in Cologne, Germany, Philae ejects from the mother ship and begins to go it alone. Forty minutes later, Rosetta pulls back and heads for a more distant orbit.

Release speed
0.76 m s⁻¹

Coordination challenge
The two craft must coordinate perfectly: ejection produces torques that Rosetta compensates for at specific times, so Philae can leave only once Rosetta is ready.

0.8 m

PHONING HOME

`T − 5h`

When Philae is about 17 km from the centre of the comet, Rosetta attempts to establish radio contact. Once Philae falls below 10 km, it is in virgin territory. Any data it beams back are completely novel.

Radio contact
If Rosetta and Philae cannot connect, Philae may as well be lost.

Landing speed
1 m s⁻¹

INSTRUMENTS

During separation and descent, some of Philae's instruments are at work, taking images, studying the comet's surface, tracking the rate of descent, sampling the comet's halo of evaporating water, gas and dust, and measuring interactions with the solar wind.

TOUCHDOWN

`T0h`

Assuming that mission control got the sums right for the final manoeuvre (see T − 9 h), Philae hits somewhere within Agilkia. But much can still go wrong.

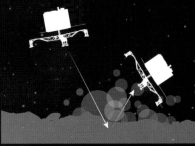

The surface is too hard and Philae bounces. The surface is too soft and the lander struggles to secure itself with harpoons and screws. Low gravity makes drilling difficult.

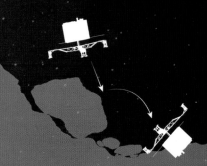

A steep slope or a boulder as small as a chair flips the lander. Philae's legs can cope with a slight tilt, but the lander has no way to fully right itself.

EXPLORATION

Philae's main science phase lasts for three days and includes drilling into the comet's surface and analysing what it finds. But if its solar panels work, Philae can keep going after that, studying how conditions change as the comet gets closer to the Sun and looking for evidence of amino acids. By March 2015, the comet will be too hot for Philae to operate.

Portable chemistry lab, radar, temperature sensors, magnetometer and other instruments probe the comet.

Cameras
Take a panoramic picture of the landing site, the first ever from the surface of a comet.

Solar panels
If the climate is dusty, Philae's solar panels might fail, causing the batteries to die after three days. The main science phase would be complete but the end would be premature.

Ice screws
Burrow down to secure Philae.

Harpoons
Fire on landing to anchor Philae.

Drills
Retrieve pristine material from 20 cm down.

What Is Known About Flight 370

Since the Malaysia Airlines plane went missing on March 8, officials have offered sometimes conflicting details of what they believe happened. Here is the current understanding of the flight, based on the most recent statements from officials and investigators.

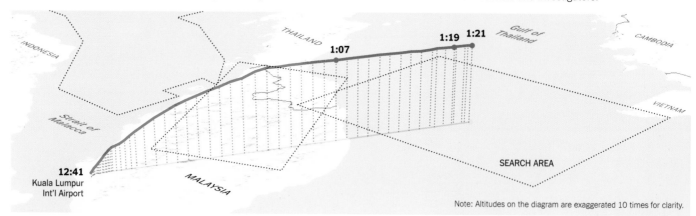

Note: Altitudes on the diagram are exaggerated 10 times for clarity.

12:41 a.m.

The Boeing 777-200 operated by Malaysia Airlines leaves Kuala Lumpur International Airport bound for Beijing with 227 passengers, of whom two-thirds are Chinese, and a Malaysian crew of 12.

1:07 a.m.

The Aircraft Communications Addressing and Reporting System, or Acars, which transmits data about the plane's performance, sends a scheduled message. The next one is scheduled for 1:37.

1:19 a.m.

Someone in the cockpit, believed to be the co-pilot, — makes the last voice contact with ground control, saying, "All right, good night."

1:21 a.m.

The plane's transponder, which broadcasts its identity, altitude and speed, stops working.

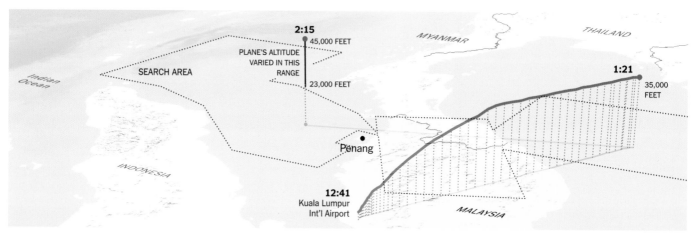

After 1:21 a.m.

The plane turns off course and heads west. The turn is not executed manually using cockpit controls. Rather, it is entered into a cockpit computer sometime before or after takeoff. This has reinforced investigators' belief that the plane was deliberately diverted.

1:37 a.m.

Acars fails to send a scheduled message, which suggests that it has been shut off or has failed sometime in the past half-hour.

2:15 a.m.

The plane is detected by military radar flying west. It ascends to 45,000 feet, above the approved limit for a Boeing 777, then descends unevenly to 23,000 feet and eventually flies out over the Indian Ocean.

7:24 a.m.

Malaysia Airlines announces that it has lost contact with the aircraft, about one hour after it was scheduled to land in Beijing.

A PLANE VANISHES

The Malaysia Airlines mystery.

8:11 a.m.

The plane sends hourly signals to a satellite, suggesting that it is still intact and flying. Malaysian authorities say it had enough fuel to keep flying for perhaps a half-hour after the last signal was received, at 8:11.

Why the Search Area Is Along an Arc

The only location information that can be determined from the plane's last signal is the plane's distance from the satellite. This creates a range of possible locations of the plane along the edge of a circle centered on the satellite.

Parts of the circle can be eliminated if they are too far for the plane to have flown given its fuel or if the curve goes through areas where radar coverage would have detected the plane.

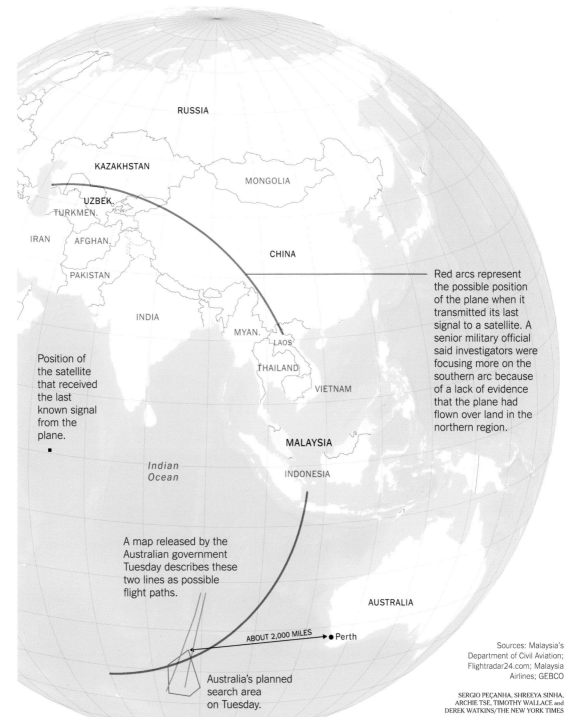

Red arcs represent the possible position of the plane when it transmitted its last signal to a satellite. A senior military official said investigators were focusing more on the southern arc because of a lack of evidence that the plane had flown over land in the northern region.

Position of the satellite that received the last known signal from the plane.

A map released by the Australian government Tuesday describes these two lines as possible flight paths.

ABOUT 2,000 MILES ● Perth

Australia's planned search area on Tuesday.

Sources: Malaysia's Department of Civil Aviation; Flightradar24.com; Malaysia Airlines; GEBCO

SERGIO PEÇANHA, SHREEYA SINHA, ARCHIE TSE, TIMOTHY WALLACE and DEREK WATKINS/THE NEW YORK TIMES

ARTISTS Research and design by Sergio Peçanha, graphics editor, international news; map design by Timothy Wallace and Derek Watkins, graphics editors and cartographers; editing by Archie Tse, deputy editor, at the *New York Times*.

STATEMENT Malaysia Airlines Flight 370 disappeared on March 8, 2014, with 239 people aboard. By the time of publication, the plane had been missing for 12 days and the search area was of continental scale. The graphic attempted to update what was known at the time, and to show the massive challenges of the search. One year after its disappearance, the whereabouts of the plane and its passengers remained unknown.

PUBLICATION *New York Times* (March 20, 2014)

The fight for first bird

For more than a century, scientists looked to *Archaeopteryx* to understand the transition from dinosaurs to birds. But more-recently discovered fossils are threatening to strip *Archaeopteryx* of its 'first bird' title. One by one, the features that once made *Archaeopteryx* stand out as a transitional species are falling away.

Zanabazar junior

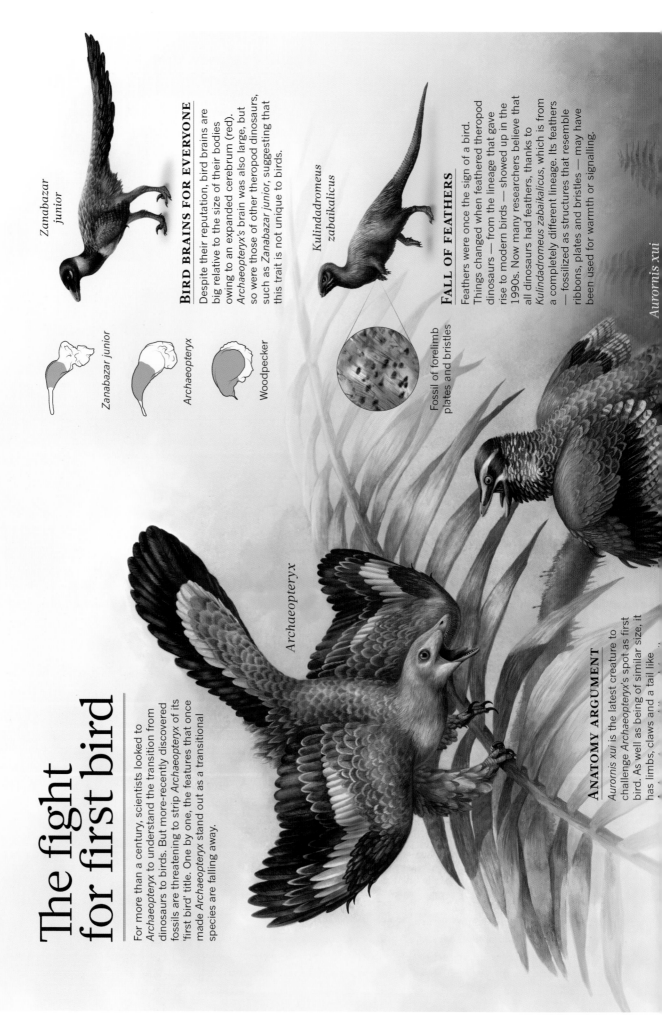

Zanabazar junior

Archaeopteryx

Woodpecker

BIRD BRAINS FOR EVERYONE

Despite their reputation, bird brains are big relative to the size of their bodies owing to an expanded cerebrum (red). *Archaeopteryx's* brain was also large, but so were those of other theropod dinosaurs, such as *Zanabazar junior*, suggesting that this trait is not unique to birds.

Kulindadromeus zabaikalicus

Fossil of forelimb plates and bristles

FALL OF FEATHERS

Feathers were once the sign of a bird. Things changed when feathered theropod dinosaurs — from the lineage that gave rise to modern birds — showed up in the 1990s. Now many researchers believe that all dinosaurs had feathers, thanks to *Kulindadromeus zabaikalicus*, which is from a completely different lineage. Its feathers — fossilized as structures that resemble ribbons, plates and bristles — may have been used for warmth or signalling.

Archaeopteryx

ANATOMY ARGUMENT

Aurornis xui is the latest creature to challenge *Archaeopteryx's* spot as first bird. As well as being of similar size, it has limbs, claws and a tail like

Aurornis xui

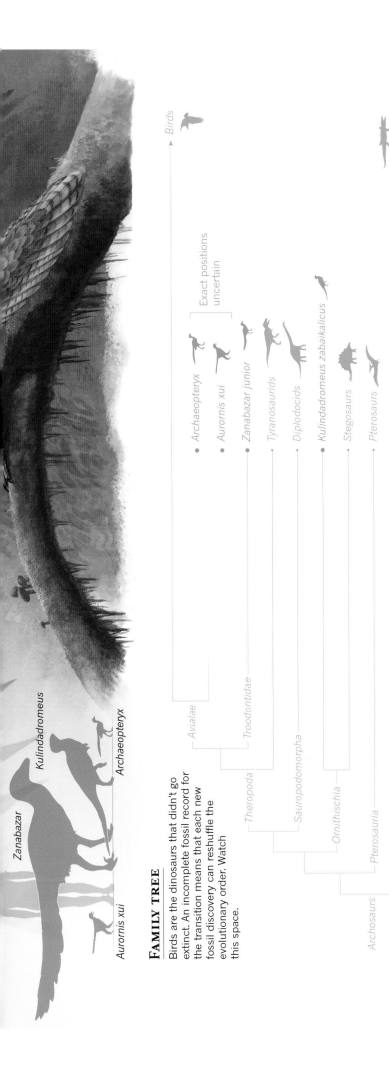

Zanabazar

Kulindadromeus

Aurornis xui

Archaeopteryx

FAMILY TREE

Birds are the dinosaurs that didn't go extinct. An incomplete fossil record for the transition means that each new fossil discovery can reshuffle the evolutionary order. Watch this space.

Family tree diagram:

- Birds
- Archaeopteryx
- Aurornis xui
 (Exact positions uncertain)
- Zanabazar junior
- Tyranosaurids
- Diplodocids
- Kulindadromeus zabaikalicus
- Stegosaurs
- Pterosaurs
- Crocodiles

Tree nodes: Avialae, Troodontidae, Theropoda, Sauropodomorpha, Ornithischia, Pterosauria, Crocodylomorpha, Archosaurs

FIGHT FOR "FIRST BIRD"

Why a famous fossil species might be knocked off its perch.

and dinosaur features, to understand the evolutionary transition from dinosaurs to birds. But more recently discovered fossils are threatening to strip *Archaeopteryx* of its "first bird" title: one by one, the features that once made *Archaeopteryx* stand out as a transitional species are falling away.

The biggest challenger to *Archaeopteryx* at the moment is *Aurornis xui*, which is similar in anatomy but predates its rival by about 10 million years. For the graphic, we asked artist Emily Willoughby to make the

two animals the centerpiece of the composition, with *Archaeopteryx* desperately trying to hold on to its perch. The animals are engaging each other, but if you look closely they are actually from two different worlds. *Archaeopteryx* fossils are located in Europe, while *Aurornis* fossils are from China.

PUBLICATION *Nature* (December 4, 2014)

ARTISTS Illustration by Emily Willoughby, freelance artist. Design by Jasiek Krzysztofiak, art editor; design and art direction by Kelly Krause, creative director; art direction by Wesley Fernandes, art director; and text by Ewen Callaway, staff reporter, at *Nature*. *Archaeopteryx* silhouette by Vladimir Nikolov, freelance artist.

STATEMENT For more than a century, scientists looked to *Archaeopteryx*, the first animal discovered with both bird

WEATHER RADIALS

Urban meteorology, in ring form.

Precipitation in mm

Historical temp. average (1971–2000)

−30 ℃ +50 ℃

🌡 Highest temperature: 46 ℃ in Sydney, Australia on January 18 🌡 Lowest temperature: −27 ℃ in Helsinki, Finland on January 19 💧 Highest amount of precipitation in one day: 165.1 mm/m² in Mexico City, Mexico on July 4

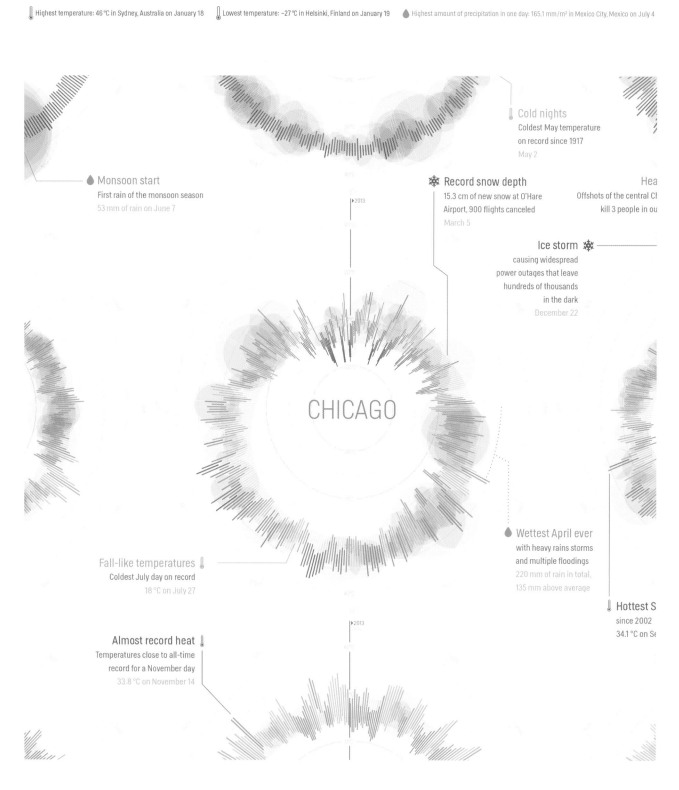

🌡 Cold nights
Coldest May temperature
on record since 1917
May 2

💧 Monsoon start
First rain of the monsoon season
53 mm of rain on June 7

❄ Record snow depth
15.3 cm of new snow at O'Hare
Airport, 900 flights canceled
March 5

Hea
Offshots of the central Cl
kill 3 people in ou

Ice storm ❄
causing widespread
power outages that leave
hundreds of thousands
in the dark
December 22

▶2013

CHICAGO

💧 Wettest April ever
with heavy rains storms
and multiple floodings
220 mm of rain in total,
135 mm above average

Fall-like temperatures 🌡
Coldest July day on record
18 ℃ on July 27

🌡 Hottest S
since 2002
34.1 ℃ on Se

▶2013

Almost record heat 🌡
Temperatures close to all-time
record for a November day
33.8 ℃ on November 14

ARTIST Timm Kekeritz, design director at the Berlin design consultancy Raureif.

STATEMENT Statistics on weather are everywhere, but weather is more than just abstract numbers—it influences and defines our life, day by day. Here, the annual weather cycle for each of 35 cities around the globe is visualized as a radial graph, representing the temperatures and precipitation for each day. Hotter temperatures are redder and further out on the ring; blue cold temperatures are toward the center. Precipitation is shaded blue circles. Each radial illus-

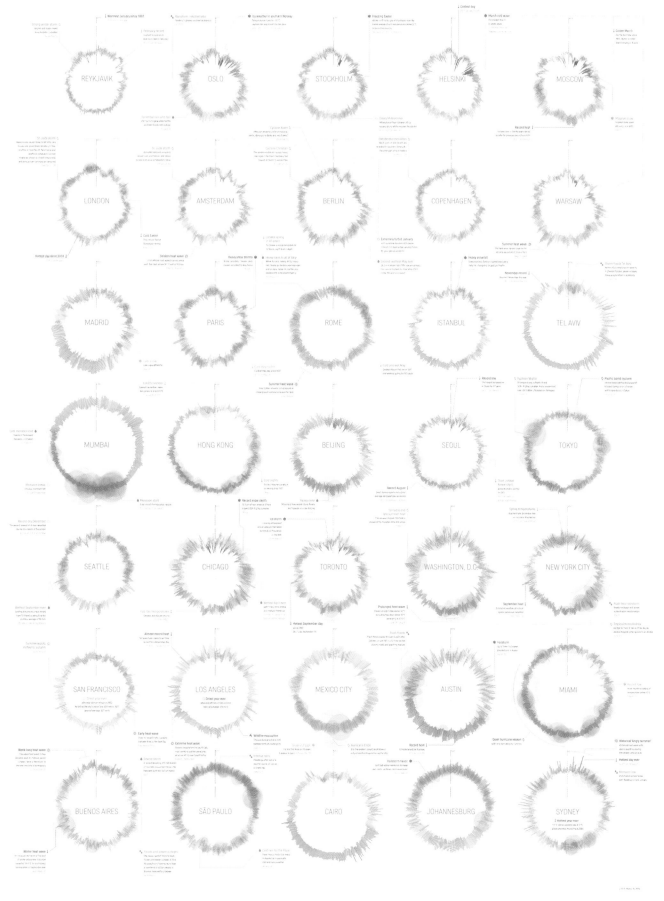

trates the climate characteristics of a specific city and displays unusual events from the year — the very wet spring in Berlin, the prolonged heat wave in Washington, the record temperature in Sydney, and the monsoon season in Mumbai. These "weather radials" not only tell the story of the four seasons of 2013 on a global scale, they also illustrate vividly how cities differ, and what it really means to live in Reykjavík, Los Angeles, or Seoul.

PUBLICATION *weather-radials.com* (January 2014)

OLYMPIC VISION

What would a luge course look like in New York?

The Downhill Alpine events would be challenging. But if you could fashion a facsimile of the 2.2-mile downhill course at Rosa Khutor Alpine Center, it would tower over Central Park. Starting above 59th Street at a height of two Empire State Buildings, the course (without many of its notorious turns) would end on the ballfields of the North Meadow. And it would take the skiers about two minutes to finish.

1,454 ft.
Empire State Building

3,205 ft.
Profile of downhill course

750 ft.
Time Warner Center

34th St. 59th St. 2 miles 101st St.

Luge, Bobsled and Skeleton

Racers might begin their starting sprints in the carpeted hallway of the Sheraton New York's 40th floor for the run down the city's own version of the Sanki Sliding Center's track stretched out over the painted streets, finishing in a big turn on the plaza in front of the Armed Services Recruiting Center.

W. 57TH ST.
EIGHTH AVE.
SEVENTH AVE.
BROADWAY
Midtown
W. 51ST ST.
Theater District
AVE. OF THE AMERICAS
Times Square
W. 42ND ST.

ARTISTS Wilson Andrews, Larry Buchanan, Joe Burgess, Shan Carter, Ford Fessenden, Mika Gröndahl, and Jeremy White, graphics editors; Angel Franco and Richard Perry, photographers, at the *New York Times*.

STATEMENT New York lost its bid for the 2012 Summer Olympics, and former Mayor Michael R. Bloomberg's vision of new sporting venues across the boroughs fizzled. But what if the city had tried to get the Winter Olympics instead? It would probably take even more hubris than this city can muster, but the exercise of plotting the size of Olympic venues against the Manhattan cityscape provides some telling measures of scale.

PUBLICATION *New York Times* (February 5, 2014)

LEGO STORY

A corporate turnaround expressed in plastic bricks.

ARTIST Elise Craig, writer; Sarah Fallon, editor; Josef Reyes, designer; and Todd Tankersley, photographer, at *WIRED*.

STATEMENT We work on a lot of cool projects at *WIRED*, but rarely has there been such enthusiasm and collaboration for a single-page infographic. Lego had recently become the world's most valuable toy company, and *The Lego Movie* seemed like the perfect opportunity to delve into its transformation. When we looked at the data about Lego earnings, it became clear that licensing had played a role in the company's resurgence, and we wanted to show readers what one company had managed to accomplish using some of our favorite characters. Brickset.com—a *very* serious fan site—walked us through all the licensed sets Lego had put out and shared their data. Our photo editor rented some of her son's collection (she actually paid him) and the editor made a trip to the Lego store to pick up additional bricks. Our IT guy put it together, our fact-checkers counted everything Lego by Lego to make sure it was accurate, and the photo department shot the result.

PUBLICATION *WIRED* (February 2014)

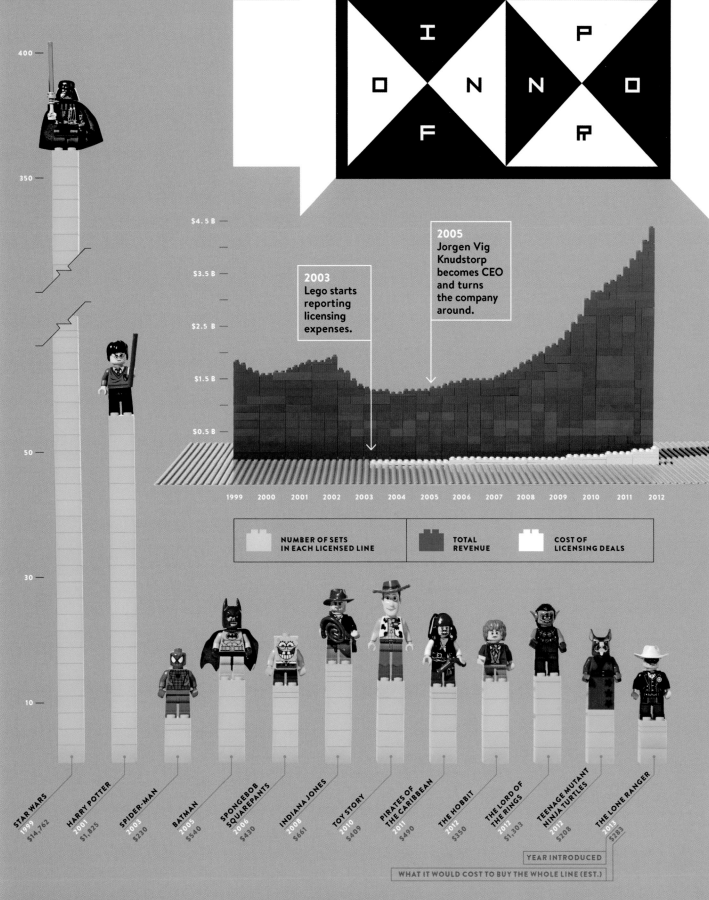

400 —

350 —

50 —

30 —

10 —

$4.5 B
$3.5 B
$2.5 B
$1.5 B
$0.5 B

2003
Lego starts reporting licensing expenses.

2005
Jorgen Vig Knudstorp becomes CEO and turns the company around.

1999 2000 2001 2002 2003 2004 2005 2006 2007 2008 2009 2010 2011 2012

NUMBER OF SETS IN EACH LICENSED LINE

TOTAL REVENUE

COST OF LICENSING DEALS

STAR WARS
1999
$14,762

HARRY POTTER
2001
$1,825

SPIDER-MAN
2003
$230

BATMAN
2005
$540

SPONGEBOB SQUAREPANTS
2006
$430

INDIANA JONES
2008
$661

TOY STORY
2010
$409

PIRATES OF THE CARIBBEAN
2011
$490

THE HOBBIT
2012
$350

THE LORD OF THE RINGS
2012
$1,303

TEENAGE MUTANT NINJA TURTLES
2012
$208

THE LONE RANGER
2013
$283

YEAR INTRODUCED

WHAT IT WOULD COST TO BUY THE WHOLE LINE (EST.)

AN EMPIRE OF BUILDERS

How Lego's band of licensed heroes conquered the world.

Lego, pre-millennium: stackable bricks, generic yellow-headed characters, revenue sputtering. Lego today: Crushing the toy industry under its interlocking feet, having overtaken Mattel and Hasbro as the most profitable toymaker in the world. That's partially due to licensing deals, which, starting in 1999, added icons like Darth Vader and Batman to the mix. Many other properties followed—and *The Lego Movie*, out in February, features many of our favorite modular heroes meeting for the first time. Here are some of the character lines that helped make it happen. —ELISE CRAIG

Source: Brickset.com

FORGOTTEN WORLD

A continent slightly underwater.

ARTIST Map by Ryan Morris, *National Geographic* staff. Source: Ron Blakey, Colorado Plateau Geosystems.

STATEMENT About 77 million years ago, during the late Cretaceous period, Earth was much warmer than it is today—and a shallow sea divided North America. Recently discovered fossils from Laramidia, as the western landmass is called, suggest that evolution was in high gear there: new species of dinosaurs and other animals were emerging in the south that were distinct from those up north.

PUBLICATION *National Geographic* (May 2014)

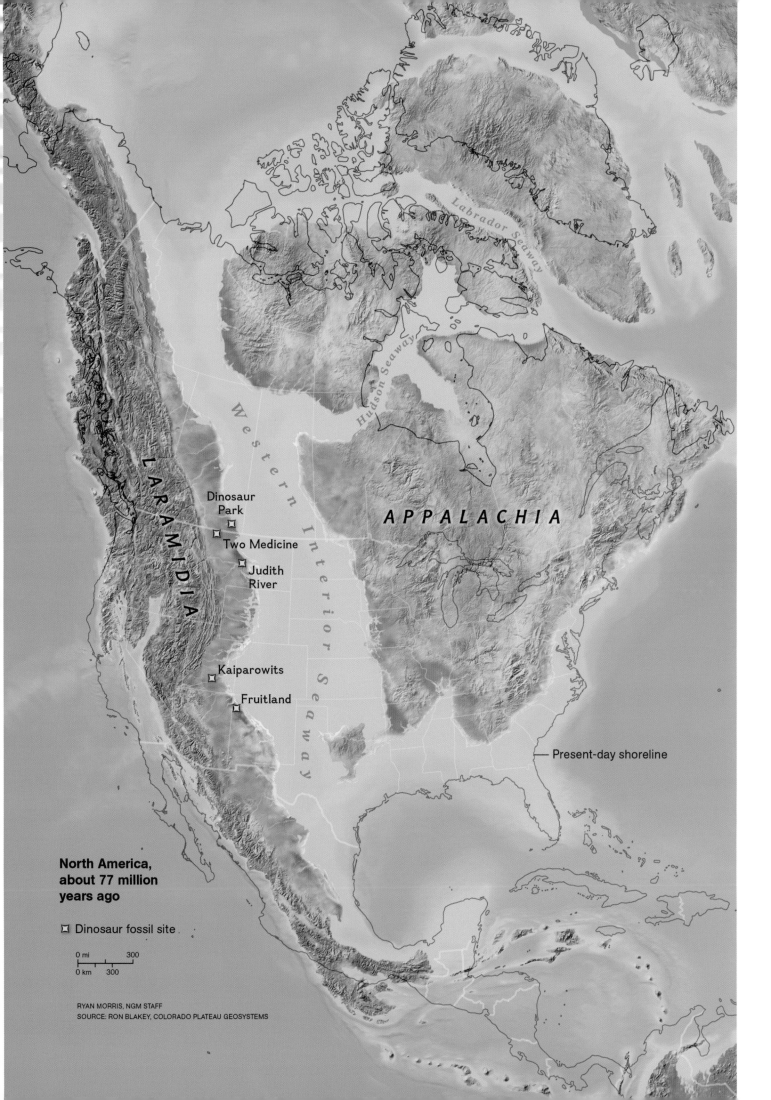

LARAMIDIA

Western Interior Seaway

Hudson Seaway

Labrador Seaway

APPALACHIA

Dinosaur Park

Two Medicine

Judith River

Kaiparowits

Fruitland

— Present-day shoreline

**North America,
about 77 million
years ago**

⊠ Dinosaur fossil site

0 mi 300

0 km 300

RYAN MORRIS, NGM STAFF
SOURCE: RON BLAKEY, COLORADO PLATEAU GEOSYSTEMS

THE TOP TEN BEST AMERICAN

INTERACTIVE INFOGRAPHICS OF 2015

by SIMON ROGERS

WELL, I'm going to call it: 2014 was the year that data journalism went mainstream. As the year drew to a close, we had sites producing daily data journalism, such as FiveThirty Eight from Nate Silver/ESPN and The Upshot from the *New York Times,* as well as mainstream news brands covering data in ways they just weren't doing two years ago. And that's in addition to a revolution that has taken place in data journalism across the world—with established American outlets such as the *LA Times* and the *Guardian*'s US operation part of a global movement toward telling news stories with numbers.

But what has that meant for the world of online visualization? Having so many outlets has certainly produced abundant content. And perhaps we're all starting to grow up a little. Data journalism and visualization has a long history in the United States, but today it's characterized by a new seriousness. The beginning of the present wave of data journalism and visualization was all about the hour of the amateur, and today it is about professionals pushing the technology further and further ahead.

So, choosing the 10 best interactive graphics of the year was not simple: every week seemed to produce new pieces that could easily make the list. Sometimes it's new takes on old approaches, such as the way the *New York Times* used "small multiples" to illustrate Derek Jeter's swing. Occasionally, it's developers taking public open data and turning it into a fascinating examination of modern life, such as an interactive guide to New York City's taxi data. I chose these works because it felt to me that each illustrated some of the new approaches, from the established media houses to the newest of the new. We could have had another 20, easily.

To see the interactive winners, go to hmhbooks.com/infographics2015.

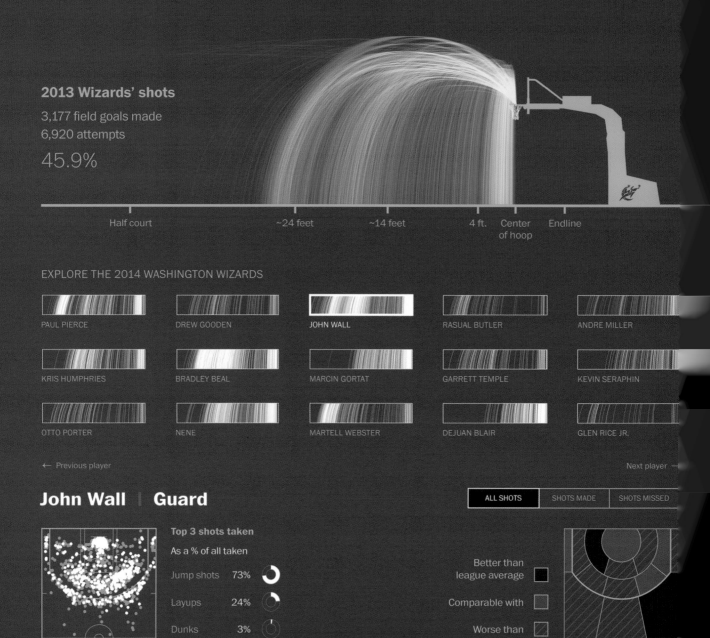

2013 Wizards' shots

3,177 field goals made
6,920 attempts

45.9%

Half court ~24 feet ~14 feet 4 ft. Center Endline
 of hoop

EXPLORE THE 2014 WASHINGTON WIZARDS

PAUL PIERCE DREW GOODEN JOHN WALL RASUAL BUTLER ANDRE MILLER

KRIS HUMPHRIES BRADLEY BEAL MARCIN GORTAT GARRETT TEMPLE KEVIN SERAPHIN

OTTO PORTER NENE MARTELL WEBSTER DEJUAN BLAIR GLEN RICE JR.

← Previous player Next player →

John Wall | Guard

| ALL SHOTS | SHOTS MADE | SHOTS MISSED |

Top 3 shots taken

As a % of all taken

Jump shots 73%

Layups 24%

Dunks 3%

Shot chart

Better than
league average

Comparable with

Worse than

Shooting by zone

WIZARDS' SHOOTING STARS

A deep look at an NBA team.

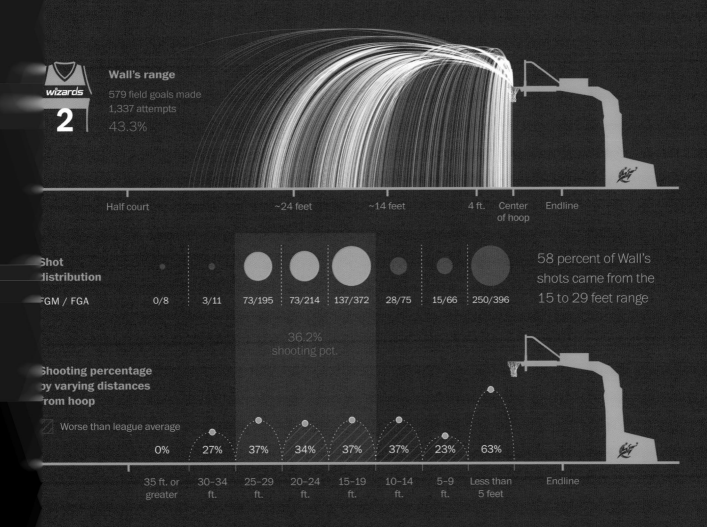

Wall's range

579 field goals made
1,337 attempts
43.3%

2

wizards

	Half court		~24 feet		~14 feet		4 ft.	Center of hoop	Endline

Shot distribution

FGM / FGA

0/8	3/11	73/195	73/214	137/372	28/75	15/66	250/396

36.2% shooting pct.

58 percent of Wall's shots came from the 15 to 29 feet range

Shooting percentage by varying distances from hoop

Worse than league average

0%	27%	37%	34%	37%	37%	23%	63%

35 ft. or greater	30–34 ft.	25–29 ft.	20–24 ft.	15–19 ft.	10–14 ft.	5–9 ft.	Less than 5 feet	Endline

Source: NBA.com/stats. Note: Trajectory of shots is schematic and not the actual arc of the ball.

ARTIST Visualization by Todd Lindeman, senior graphics editor; Web development by Lazaro Gamio, at the *Washington Post.*

STATEMENT Compared with other major sports, the NBA is one of the most thorough keepers of player and team statistics. Their data are so granular, it's as if you are peering at every aspect of a player's performance through an electron microscope. And since professional sports teams are always under intense scrutiny, good or bad, it was no secret that the Washington Wizards squandered too many scoring opportunities on inefficient mid-range shots.

With that in mind, we set out to create an interactive graphic on the Wizards' shooting performance, which would kick off our coverage of the season opener. The source of inspiration for the Wizards project was the NBA's traditional shooting chart—a top-down view of the court with the overlaid shots.

We asked, "How we can represent the data in a whole new way?" We sketched some ideas that ultimately led to the side profile of the court with each player's arcing shots plotted, and a statistical breakdown of how well each player shoots from various distances. Rather than a programmatic approach to rendering the arcs, the shots were plotted meticulously (and manually) in Adobe Illustrator because it allowed for the final desired effect of a "waterfall" or shots "raining down on the court." Player tendencies, strengths and weaknesses, even positional roles become clear when toggling between the Wizards in the interactive graphic.

PUBLICATION *WashingtonPost.com* (October 29, 2014)

Availability of News Homepages Inside China

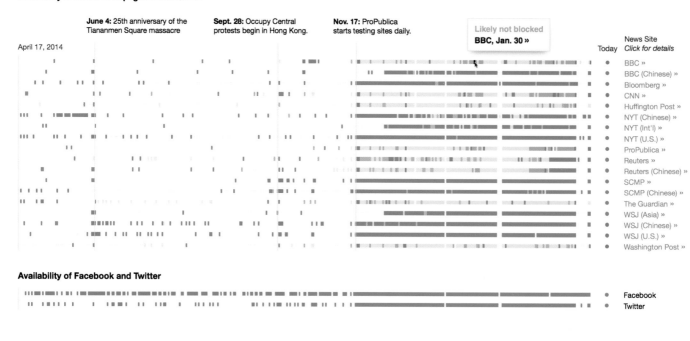

June 4: 25th anniversary of the Tiananmen Square massacre

Sept. 28: Occupy Central protests begin in Hong Kong.

Nov. 17: ProPublica starts testing sites daily.

Likely not blocked
BBC, Jan. 30 »

April 17, 2014

Today | News Site
Click for details

BBC »
BBC (Chinese) »
Bloomberg »
CNN »
Huffington Post »
NYT (Chinese) »
NYT (Int'l) »
NYT (U.S.) »
ProPublica »
Reuters »
Reuters (Chinese) »
SCMP »
SCMP (Chinese) »
The Guardian »
WSJ (Asia) »
WSJ (Chinese) »
WSJ (U.S.) »
Washington Post »

Availability of Facebook and Twitter

Facebook
Twitter

Inside the Firewall » This Week

News Homepages' Availability Within China This Week

Every day since Nov. 17, 2014, ProPublica has been testing whether the homepages of international news organizations are accessible to browsers inside China. Here is the latest week of data.

👆 *Click on a publication to see more details.*

KEY: ■ BLOCKED ▪ LIKELY BLOCKED ▪ INCONCLUSIVE ■ LIKELY NOT BLOCKED ■ NO CENSORSHIP DETECTED

BBC

TODAY'S STATUS: ■ NO CENSORSHIP DETECTED

PAST WEEK

April 11 April 12 April 13 April 14 April 15 April 16 Today

PAST YEAR

BBC (Chinese)

TODAY'S STATUS: ■ BLOCKED

PAST WEEK

April 11 April 12 April 13 April 14 April 15 April 16 Today

PAST YEAR

CNN

TODAY'S STATUS: ■ NO CENSORSHIP DETECTED

PAST WEEK

April 11 | April 12 | April 13 | April 14 | April 15 | April 16 | Today

PAST YEAR

Huffington Post

TODAY'S STATUS: ■ BLOCKED

PAST WEEK

April 11 | April 12 | April 13 | April 14 | April 15 | April 16 | Today

PAST YEAR

New York Times (Chinese)

TODAY'S STATUS: ■ BLOCKED

PAST WEEK

April 11 | April 12 | April 13 | April 14 | April 15 | April 16 | Today

PAST YEAR

New York Times (International)

TODAY'S STATUS: ■ BLOCKED

PAST WEEK

April 11 | April 12 | April 13 | April 14 | April 15 | April 16 | Today

PAST YEAR

On Feb. 17, 2015, the New York Times (U.S.) was blocked.

INSIDE THE GREAT FIREWALL

What can Chinese citizens read online?

ARTISTS Sisi Wei, Lena Groeger, and Mike Tigas, news applications developers; Yue Qiu, news applications fellow; and Scott Klein, assistant managing editor, at ProPublica. ProPublica is a nonprofit investigative journalism organization based in New York City.

STATEMENT The Chinese government aggressively polices its citizens' use of the Internet, with a website-blocking policy that has been nicknamed the "Great Firewall of China." Every day since November 17, 2014, ProPublica has been testing whether the homepages of international news organizations are accessible to browsers inside China. This infographic shows the results, as well as what was displayed on every news organization's homepage on that day.

The goal of this project is to constantly illuminate the status of news censorship in China, and to do it in a way that's easy to understand.

PUBLICATION *ProPublica.org*
(December 17, 2014)

THE GRAND BUDAPEST HOTEL

THE LION KING

THE GRAND BUDAPEST HOTEL

STAR WARS: EPISODE V -
THE EMPIRE STRIKES BACK

THE MATRIX

THE COLORS OF MOTION

A new way to see movies.

ARTIST Charlie Clark, interactive designer and creative coder in Brooklyn, NY.

STATEMENT Color is such an important aspect of filmmaking and can be a powerful way to convey tone and emotion. With this project, I wanted to strip away everything but the color from a film and display it in a beautiful and understandable way. What you see here is an interactive visualization of the use of color in movies, in which a program processes a movie file and calculates the average color of each frame, displaying it as a horizontal stripe. Each color stripe can be clicked on in order to view the frame from which the color was extracted.

The end result is something truly stunning. For example, you probably wouldn't be surprised that *The Matrix* is predominantly green and *Avatar* predominantly blue. You might be surprised, however, at how *Life of Pi* is not a very blue movie, even though it takes place almost entirely at sea. Animated movies tend to be much more saturated and colorful than live action films. It's also a fun exercise to try to recognize scenes from movies based on their color: the light blue ice-planet scene at the beginning of *The Empire Strikes Back* and the bright pink jellyfish scene in *Finding Nemo* are good examples.

PUBLICATION
thecolorsofmotion.com
(June 25, 2014)

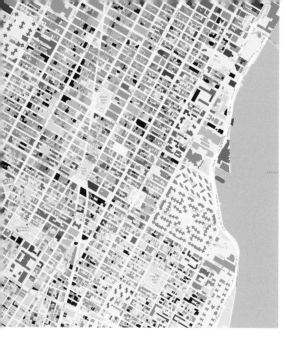

URBAN LAYERS

Exploring Manhattan's urban fabric.

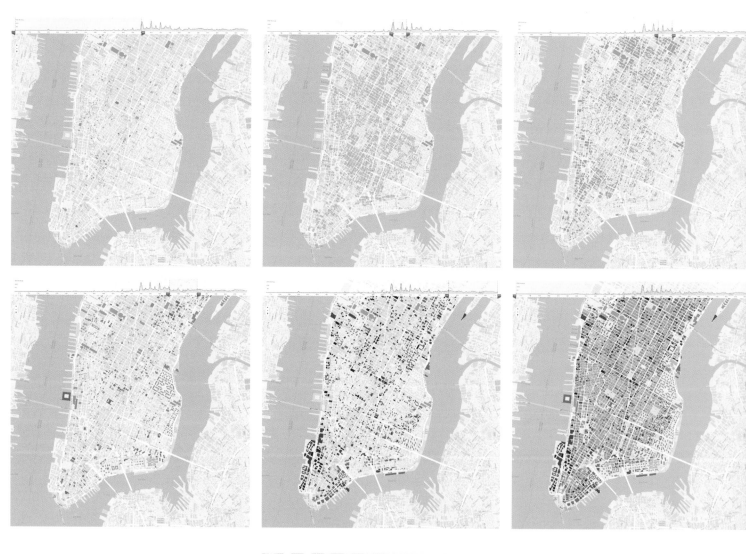

DATE BUILT

No Data	1765	1855	1875	1895	1915	1935	1955	1975	1995

Some dates are estimates.

Source: PLUTO data

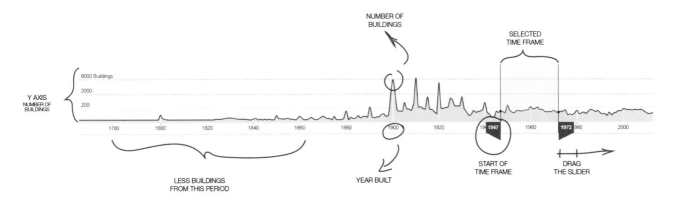

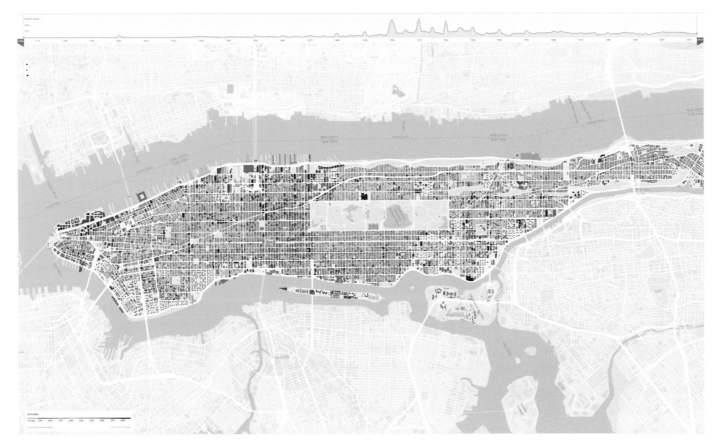

ARTISTS Greta Dimitrova and Kiril Mandov, principal architects at Morphocode.

STATEMENT This visualization allows you to navigate through historical layers of Manhattan's built environment, revealing hidden patterns and preserved fragments. The rigid archipelago of building blocks has been mapped as a succession of structural episodes starting from 1765.

The graph shows activity spikes and provides interaction with more than 45,000 buildings. By moving the time sliders, users can discover some of the island's oldest buildings, explore how the beginning of the twentieth century shaped its urban fabric, or identify the most recent constructions.

Urban Layers is based on two data sets: PLUTO and the NYC Building Footprints. PLUTO contains various information about each building in New York City: year built, height, borough, and so forth. It was released to the public in 2013 and was considered a huge win for the open data community. We are interested in how urban visualizations can raise awareness about urban conditions and provide valuable insights into how cities perform as well as how people interact with the urban environment.

PUBLICATION *morphocode.com* (October 6, 2014)

342,000 Swings Later, Derek Jeter Calls It a Career

By SHAN CARTER, JOE WARD and DAVID WALDSTEIN

The Times, with an assist from Jeter, has attempted to calculate the number of times he has swung a bat in his professional career — in practice and in games.

September 14, 2014

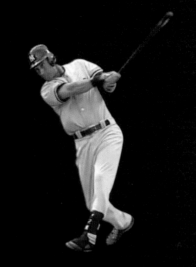

Pregame

He takes 60 swings before every game (30 in the indoor batting cage and 30 on the field in batting practice).

99 swings per hit

60 practice swings per game

2 swings per at-bat

Total Hits

If you add his postseason and All-Star Game hits, Jeter's total jumps to 3,663.

Home Runs

Jeter does not have a power stroke. It has taken about 1,300 swings for each of his home runs.

A CAREER AT BAT

How many times did Derek Jeter swing at a baseball?

ARTISTS Graphics creation by Shan Carter, graphics editor; writing by Joe Ward, graphics editor; and reporting and researching by David Waldstein, sports reporter, at the *New York Times*.

STATEMENT This piece is based on a very simple question: how many times had Derek Jeter, who retired from the Yankees last year after 20 seasons as a major leaguer, swung a baseball bat in his professional career? *Times* sports reporter

David Waldstein came to us with the idea. It was harder than we thought. Few sports are as rich in statistics as baseball, but even so, not every swing is recorded. Jeter and Waldstein worked on it and came up with an estimate of 342,000

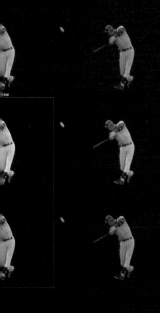

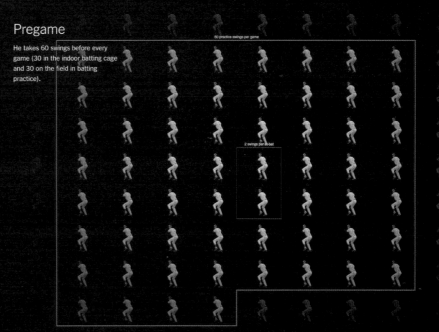

Pregame

He takes 60 swings before every game (30 in the indoor batting cage and 30 on the field in batting practice).

60 practice swings per game

2 swings per at-bat

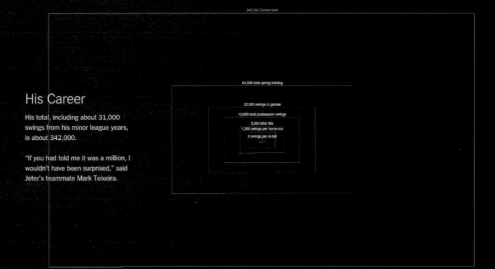

342,000 Career total

His Career

His total, including about 31,000 swings from his minor league years, is about 342,000.

"If you had told me it was a million, I wouldn't have been surprised," said Jeter's teammate Mark Teixeira.

61,500 total spring training

22,000 swings in games

10,600 total postseason swings

3,060 total hits

1,300 swings per home run

2 swings per at-bat

swings. My colleague Joe Ward and I then did our best to make people truly understand that number. We thought the best way to convey the rhythm—and especially the monotony—of batting practice was with a looping video of Jeter swinging, paired with a sequence of

steps that built to reveal the full breadth of Jeter's pursuit of a perfect swing.

Actually swinging a bat 342,000 times is a monumental task. Less monumental, perhaps, but still difficult: forcing a computer to show 342,000 simultaneous videos. It took many failed experiments

before we could be confident we could show that many videos without turning your computer into a space heater.

PUBLICATION *New York Times* (September 14, 2014)

A MAP OF EVERY SATELLITE

It's crowded up there.

ARTISTS Design, coding, and writing by David Yanofsky, and writing by Tim Fernholz, reporters at *Quartz*.

STATEMENT Earth's orbit isn't just a place for astronauts and government science experiments: it's a dense landscape of commercial, civil, government, and military activity. This graphic allows a reader to sort and explore the entire satellite ecosystem, from milk-carton-size microsats to school-bus-sized spy satellites. You can scroll down through distinct bands of orbit, starting with the diversity of satellites closest to Earth, moving through the geolocation orbiters, past the global communications infrastructure, and out toward the moon, where physicists have sent some of their instruments. Along the way you encounter some unique business achievements: Iridium's 71-satellite constellation, currently the largest; O3b's efforts to provide broadband Internet to the "other 3 billion" Internet users in emerging markets via space; and SiriusXM's six revolutionary stations in the sky.

PUBLICATION *Quartz* (November 17, 2014)

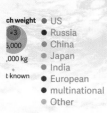

THE WORLD ABOVE US

This is every active satellite orbiting earth

By David Yanofsky and Tim Fernholz

There are more than 1,200 active satellites orbiting earth right now, taking pictures, relaying communications, broadcasting locations, spying on you, and even housing humans. Thanks to a database compiled by the Union of Concerned Scientists, we can show you each one, as of August 21, 2014.

The satellites are sized according to their launch mass and are colored by their **country** ⌄

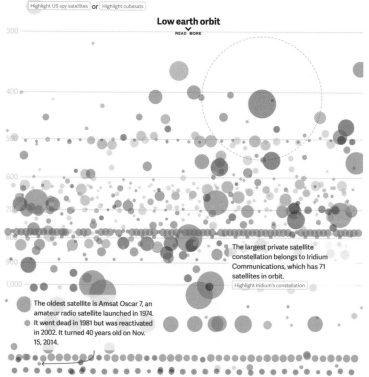

amateur radio satellite launched in 1974. It went dead in 1981 but was reactivated in 2002. It turned 40 years old on Nov. 15, 2014.

2,000

Most satellites have a life-span of just five to 10 years, which is why more than half of the active satellites were launched since 2008 and 60% since 2005. Only 33 active satellites were launched before 1995 , and 395—about one third—from 1995 to 2005.

Color by age

The United Nations regulates satellites in orbit. In 2013, 4,500 applications to launch satellite networks were submitted from 72 countries.

3,000

The US boasts the most satellites at 495 in orbit. That reflects the American government's world-leading $39 billion space budget and its wealthy economy.

The next highest total comes from Russia, home of ur-orbiter Sputnik, which has 131 satellites in orbit and operates the world's busiest spaceport in Kazakhstan. China, the rising space power with its own space station, Tiangong-1, operates 115 satellites.

4,000

5,000

6,000

7,000

The eight O3b Networks satellites provide broadband internet to the "other 3 billion" internet users in emerging markets.

Highlight O3b's constellation

8,000

9,000

10,000

494 satellites are used primarily for commercial purposes, but that undercounts the business importance of space: GPS and Glonass navigation satellites are included in the count of 337 primarily military orbiters.

Color by primary user

Medium earth orbit
˅
READ MORE

Geostationary orbit
˅
READ MORE

30,000

Sirius XM's constellation broadcasts to more than 26 million terrestrial listeners. Highlight Sirius XM's constellation

50,000

60,000

70,000

80,000

High earth orbit
˅
READ MORE

Sirius XM's constellation broadcasts to more than 26 million terrestrial listeners. Highlight Sirius XM's constellation

60,000

70,000

80,000

90,000

High earth orbit
˅
READ MORE

100,000

200,000

300,000

Orbit of the Moon

400,000

500,000

600,000

Notes: This graphic excludes satellites no longer in use but still orbiting, and passive satellites. Weight depicted is the launch weight, which includes the satellites fuel. The official names of US military satellites listed as "Keyhole" in the database are not known to the UCS. Satellites classified as European are either owned/operated exclusively by the ESA or multiple european countries. The SB-WASS satellites weigh in excess of 5,000 kg but the UCS is unaware of their exact size.

Data: Union of Concerned Scientists

Image: NASA/NOAA/GSFC/Suomi NPP/VIIRS/Norman Kuring Highlight the satellite that captured it *(it orbits around 800 km in low earth orbit)*

Easter egg: To see the relative speed of orbits (and possibly melt your browser), press Q and then the space bar. Currently: Disabled

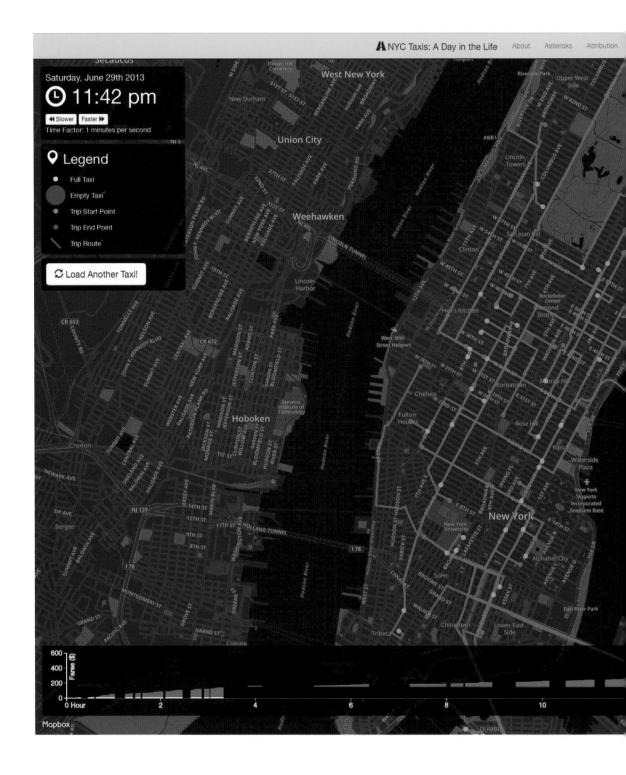

Saturday, June 29th 2013

🕐 11:42 pm

◀◀ Slower Faster ▶▶
Time Factor: 1 minutes per second

📍 Legend

● Full Taxi

⬤ Empty Taxi*

● Trip Start Point

● Trip End Point

╱ Trip Route*

↻ Load Another Taxi!

A DAY IN THE LIFE OF A TAXI

How far? How much? How many people?

ARTIST Chris Whong, urbanist, map-maker, and data junkie in New York City.

STATEMENT This Web infographic ani-mates the route and activities of a single random New York City taxicab over a single day. The animation shows pickups and drop-offs, passengers, approximate routes traveled, and fares earned. The data was obtained via a Freedom of Information Act request from the New York City Taxi and Limousine Commis-

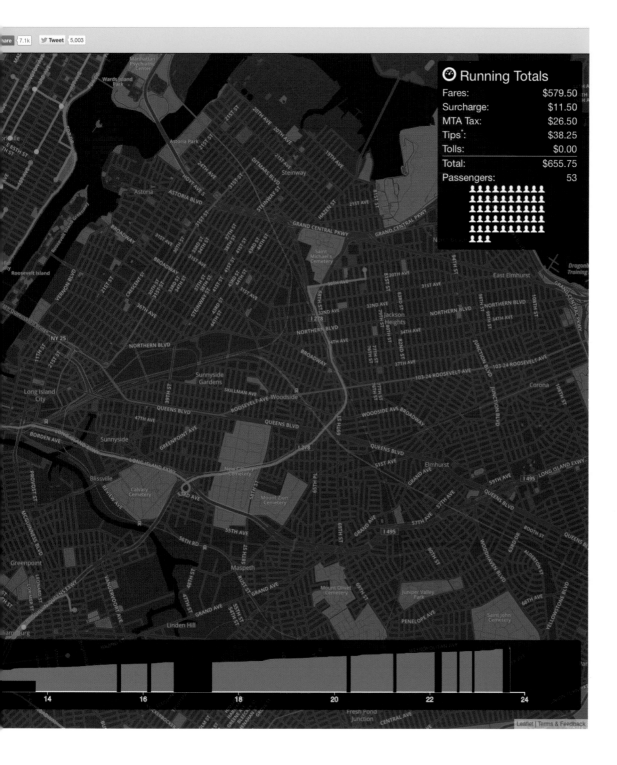

⊘ Running Totals

Fares:	$579.50
Surcharge:	$11.50
MTA Tax:	$26.50
Tips*:	$38.25
Tolls:	$0.00
Total:	$655.75
Passengers:	53

sion, and included all 173 million taxi trips taken during 2013. After obtaining the data, I had no immediate plans for it, but the idea came to me out of curiosity after riding in a cab. How far was their reach? How much money did they earn? The answers were in the data, and it's an interesting peek into an aspect of urban life we don't normally get to see.

Most people look at the total amount earned by these taxis, sometimes in excess of $700 in one day, and think that cabbies must make a lot of money. In reality, that amount is split between two 12-hour shifts, and most cab drivers must rent their shift. They spend a good portion of the shift trying to break even, and take home significantly less than the gross number shown on the screen.

PUBLICATION *nyctaxi.herokuapp.com*
(July 2014)

time: 1667 CE

Carlo Grossi
Edward Digby Wynne
John George

Edmond Scarborough
Theodoric Bland

Gabriel
William Brenton
Thomas Prence
Nicholas Whalley
Roger William Whalley
Stukeley Scott
Allan Perley

Karen Teshenakoui Catherine Montour
Robert Giffard de Moncel

Jeanne Mance

François B

John Clarke
William Coddington
John Crandall
John Wheelwright

John Washington

Benedict Arnold

John Throckmorton William Goffe

time: 1945 CE

time: 1800 CE

Massive centralization contrasts with multi-centric competition

time: 1960 CE

time: 1906 CE

Affordable cars spark an exodus

time: 1971 CE

BORN HERE, DIED THERE

The story of world culture in 100,000 lives.

ARTISTS Maximilian Schich, associate professor, University of Texas at Dallas; Mauro Martino, artist and scientist, IBM Watson Group; Kerri Smith, senior audio editor, Charlotte Stoddart, head of multimedia, and Alison Abbott, senior reporter, at *Nature.*

STATEMENT This animation distills hundreds of years of culture into just five minutes. It started as an academic research project to understand dynamic patterns in cultural history. The researchers catalogued over 100,000 births and deaths, tracking where and when notable people were born, and comparing it to where they died. Using birth-death migration as a proxy for skills and ideas, they were able to identify intellectual hotspots and track how empires rise and crumble.

We turned the findings into an animated map that shows individuals as particles, and blue-to-red arcs between birth and death locations. Concise subtitles and narration guide the audience as complex patterns emerge, mixing grand narrative with illuminating details. The animation shows Rome giving way to Paris as a cultural center, which was eventually overtaken by Los Angeles and New York. Although the approach is innovative in its choice of data, the visual paradigm is similar to airline maps, so it feels familiar to a broad audience.

PUBLICATION *Nature.com*
(July 31, 2014)

WHAT THE WORLD EATS

Your diet tells a story. So does Cuba's.

ARTISTS Fathom Information Design, concept/design/development. Xaquín González Veira, senior interactive graphics editor; Jason Treat, senior graphics editor; John Kondis, Web producer; and Alex Stegmaier, researcher, at *National Geographic*.

STATEMENT What you eat every day isn't just a matter of taste—it's also shaped by geopolitics. This graphic shows country-by-country patterns of food consumption and how they have changed over time. The results, based on data from the UN's Food and Agriculture Organization, demonstrate trends and tell interesting stories. In some cases you can see history play out: for example, Cuba's per capita caloric intake dropped after the collapse of the Soviet Union, while Saudi Arabia's meat consumption grew sixteenfold after its oil industry began to flourish. Cultural patterns also surfaced: India's primarily Hindu and Muslim populations influenced the country's predominantly vegetarian diet. And last, economic and demographic patterns emerged, where the diversification and growth of diets in China reflect the country's skyrocketing economy and population.

PUBLICATION
NationalGeographic.com
(October 15, 2014)

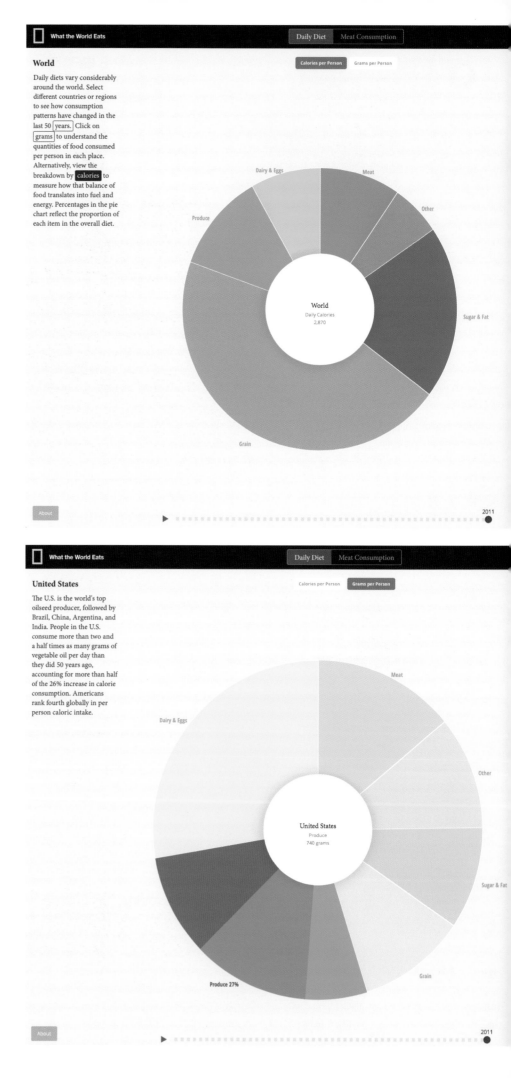

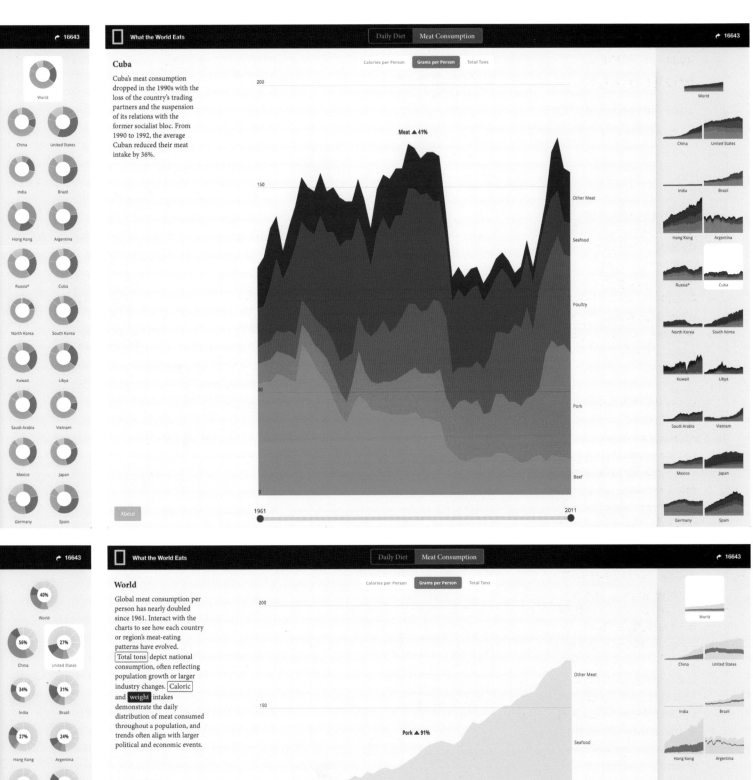

What the World Eats

Daily Diet | Meat Consumption

Calories per Person | **Grams per Person** | Total Tons

Cuba

Cuba's meat consumption dropped in the 1990s with the loss of the country's trading partners and the suspension of its relations with the former socialist bloc. From 1990 to 1992, the average Cuban reduced their meat intake by 36%.

Meat ▲ 41%

Other Meat

Seafood

Poultry

Pork

Beef

200

150

50

0

1961 — 2011

About

World

China | United States
India | Brazil
Hong Kong | Argentina
Russia* | Cuba
North Korea | South Korea
Kuwait | Libya
Saudi Arabia | Vietnam
Mexico | Japan
Germany | Spain

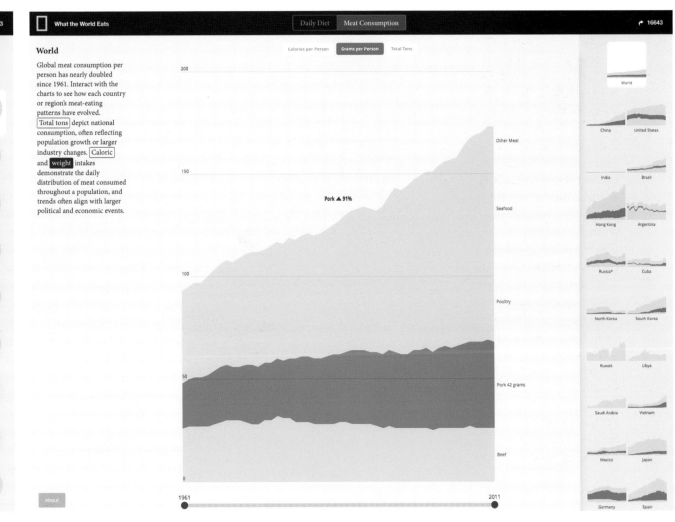

What the World Eats

Daily Diet | Meat Consumption

Calories per Person | **Grams per Person** | Total Tons

World

Global meat consumption per person has nearly doubled since 1961. Interact with the charts to see how each country or region's meat-eating patterns have evolved. Total tons depict national consumption, often reflecting population growth or larger industry changes. Caloric and weight intakes demonstrate the daily distribution of meat consumed throughout a population, and trends often align with larger political and economic events.

Pork ▲ 91%

Other Meat

Seafood

Poultry

Pork 42 grams

Beef

200

150

100

50

0

1961 — 2011

About

40%
World

56% China | 27% United States
34% India | 31% Brazil
27% Hong Kong | 24% Argentina
32% Russia* | 46% Cuba
53% North Korea | 39% South Korea
35% Kuwait | 44% Libya
33% Saudi Arabia | 33% Vietnam
25% Mexico | 31% Japan
25% Germany | 30% Spain

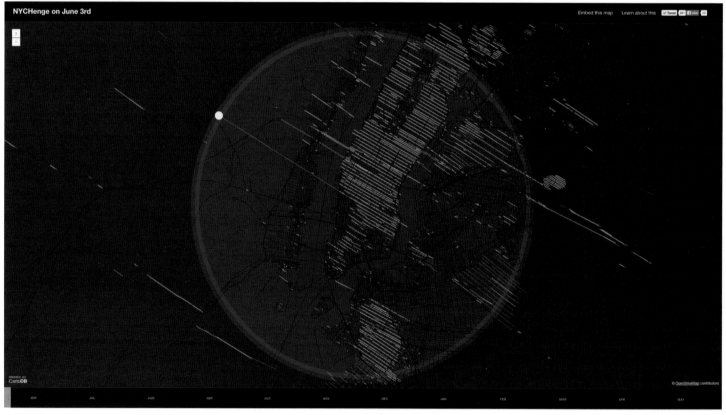

NYCHENGE

A guide to spectacular urban sunsets.

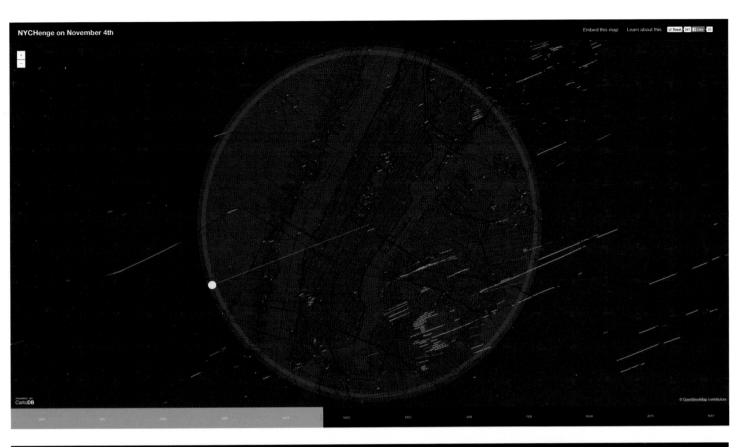

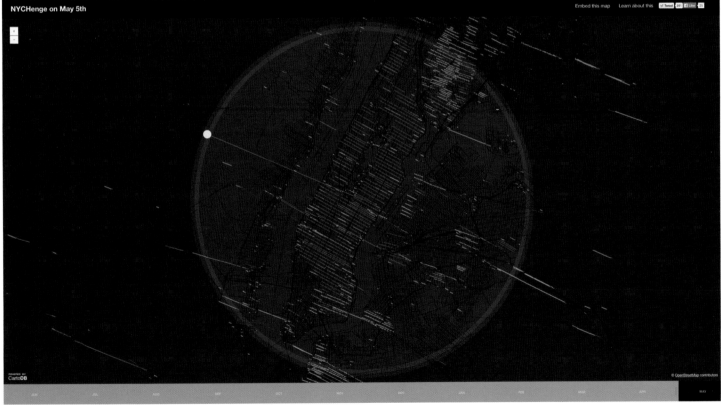

ARTISTS The map was designed and created by Andrew Hill. The interface was designed by Sergio Alvarez and Javier Arce. The data was created by the contributors to OpenStreetMap.

STATEMENT Manhattanhenge is a twice-yearly event where the setting sun directly aligns with the street grid of midtown Manhattan, allowing for memorable views through the urban canyons. But other New York streets run at other angles and have their own "henges." NYCHenge is an interactive map that allows the viewer to explore the angle of the setting sun for any evening of the year and see what streets in New York City align with that sunset.

PUBLICATION *nychenge.com* (June 2014)

Best American Infographics Brain Trust

THOMAS ALBERTY became the design director at *New York Magazine* in 2012, after eight years on staff at *GQ*. His work has been recognized by the Society of Publication Designers and the Type Directors Club, and *New York* has won the American Society of Magazine Editors' award for Design twice since his arrival, in 2014 and 2015. He lives in Brooklyn.

SAMUEL ARBESMAN is a complex systems scientist and writer. He is a senior adjunct fellow of the Silicon Flatirons Center for Law, Technology, and Entrepreneurship at the University of Colorado and an associate of the Institute for Quantitative Social Science at Harvard University. He is the author of *The Half-Life of Facts*.

ALBERTO CAIRO teaches infographics and data visualization at the University of Miami, where he is Knight Chair in Visual Journalism and director of the visualization program at the Center for Computational Science. He is the author of the book *The Functional Art: An Introduction to Information Graphics and Visualization*.

JEN CHRISTIANSEN is the art director of information graphics at *Scientific American*. Previously she was an assistant art director and then a designer at *National Geographic*. She completed her undergraduate studies in geology and art at Smith College, and her graduate studies in science illustration at the University of California, Santa Cruz.

AMANDA COX joined the *New York Times* graphics desk in 2005. She holds a master's degree in statistics from the University of Washington.

CARL DE TORRES is a multi-disciplinary graphic designer operating at the intersection of design, illustration, and information graphics. He is a longtime contributor to publications such as *Nature*, *WIRED*, *Fortune*, *Time*, and the *New York Times* and regularly partners with corporations and institutions like IBM, Visa, Facebook, and the Gates Foundation. He has recently partnered with Jeffrey O'Brien to create StoryTK, a hybrid design and storytelling agency.

MARIETTE DICHRISTINA is editor in chief and senior vice president of *Scientific American*, which includes oversight of the magazine as well as ScientificAmerican.com, *Scientific American Mind*, and all newsstand special editions. Under her leadership, the magazine received a 2011 National Magazine Award for General Excellence.

JOHN GRIMWADE has his own information graphics business. He has produced infographics for over 40 magazines. Before moving to the United States, he worked for 14 years in newspapers in London, including 6 years as head of graphics at the *Times*. He cohosts the annual Malofiej "Show, Don't Tell!" infographics workshop in Pamplona, Spain, and teaches information graphics at the School of Visual Arts in Manhattan.

KARL GUDE is the former director of information graphics at *Newsweek* and the Associated Press. Karl left *Newsweek* after a decade to spearhead the first information graphics program at Michigan State University's School of Journalism. Karl also teaches a class on creative problem-solving and the creative process.

NIGEL HOLMES is the founder of Explanation Graphics, a design company that helps people to understand complex processes and statistics. He was graphics director for *Time* from 1978 to 1994. The Society for News Design gave him a Lifetime Achievement Award in 2009, and a retrospective exhibition of his work was shown at Stevenson University in Baltimore in 2011. His most recent book, *Instant Expert*, was published by Lonely Planet in 2014. With his son, Rowland, he makes short animated films.

ANDY KIRK is a UK-based data visualization specialist, published author, and editor of the blog *Visualising Data* (visualisingdata.com). He is a globe-trotting freelance design consultant, researcher, and provider of training workshops, as well as a visiting lecturer at Maryland Institute College of Art, teaching in the Information Visualization master's program. Andy is on Twitter as @visualisingdata.

GEOFF MCGHEE develops interactive media at the Bill Lane Center for the American West at Stanford University. Previously, he spent a decade doing infographics, multimedia, and video at the *New York Times*, ABC News, and France's *Le Monde*. In 2009–2010, he was a John S. Knight Journalism Fellow at Stanford University studying data visualization, which resulted in the Web documentary *Journalism in the Age of Data*.

JOHN NELSON is a friendly cartographer and information designer who works with social and natural data to create stirring illustrations of Earth's systems, including us. He is the director of visualization for IDV Solutions, where he manages software user experience and the effective presentation of information. He researches, creates, and lectures on the intersection of aesthetics, usability, and mapping, and then writes about it at *UX Blog* (uxblog.idvsolutions.com).

HANSPETER PFISTER is An Wang Professor of Computer Science and director of the Institute for Applied Computational Science at the Harvard School of Engineering and Applied Sciences. His research in visual computing lies at the intersection of visualization, computer graphics, and computer vision. He has a PhD in computer science from the State University of New York at Stony Brook and an MS in electrical engineering from ETH Zürich, Switzerland. Before joining Harvard, he worked at Mitsubishi Electric Research Laboratories, where he was associate director and senior research scientist.

MARIA POPOVA is the founder and editor of *Brain Pickings* (brainpickings.org), an inventory of cross-disciplinary interestingness. She has written for *Wired UK*, *The Atlantic*, *Nieman Journalism Lab*, the *New York Times*, *Smithsonian*, and *Design Observer*, among others, and is an MIT Futures of Entertainment Fellow. She is on Twitter as @brainpicker.

KIM REES is cofounder of Periscopic, a socially conscious data visualization and strategy firm.

ERIC RODENBECK came to San Francisco from New York City in 1994. Twenty years later, Eric's passion for cities, design, and technology has made him both a local and international leader at the intersection of all three. In 2001 he founded the data visualization design studio Stamen, where he is creative director and CEO. The company's high bar for elegant, data-driven design has brought many brilliant data artists, designers, and technologists through its doors. In 2007, Eric joined the board of the Kenneth Rainin Foundation (KRF), an organization whose mission is to bring innovative thinking to medicine, education, and the arts. Through this work, Eric fulfills his mission of connecting design with civic duty, people with place, and passion with data, with delight.

SIMON ROGERS is data editor at Twitter and former editor of the *Guardian*'s *Datablog and Data store*. In 2012, he won the Royal Statistical Society award for statistical excellence in journalism.

DREW SKAU is a visualization architect at Visually, an on-demand creative services platform connecting marketing professionals with premium creative talent. He is pursuing a PhD in computer science at the University of North Carolina at Charlotte with a focus on evaluating creativity in visualization design.

JOHN TOMANIO joined *National Geographic* in 2009 and is currently senior editor for art and graphics. Before that he spent ten years at *Fortune* as a graphics editor. His work has been recognized by the Society for News Design (SND), its Spanish chapter (SNDe), the Cartography and Geographic Information Society (CaGIS), and the Society of Publication Designers (SPD).

ANDREW VANDE MOERE is an associate professor at KU Leuven University in Belgium. He is also the author behind the blog *Information Aesthetics* (infosthetics.com), on which he showcases a collection of compelling data visualization examples, ranging from data art to scientific data analytics.

FERNANDA B. VIÉGAS is a computational designer whose work focuses on the social, collaborative, and artistic aspects of information visualization. She is a co-leader, with Martin Wattenberg, of Google's "Big Picture" data visualization group in Cambridge, MA.

MARTIN WATTENBERG is a computer scientist and artist whose work focuses on visual explorations of culturally significant data. With Fernanda Viégas, he leads Google's "Big Picture" visualization research group. A particular interest is using visual tools to foster collaboration and collective discovery.

BANG WONG is the creative director of the Broad Institute of MIT and Harvard and an adjunct assistant professor in the Department of Art as Applied to Medicine at the Johns Hopkins University School of Medicine. His work focuses on developing visual strategies to meet the analytical challenges posed by the unprecedented scale, resolution, and variety of data in biomedical research.

NATHAN YAU has a PhD in statistics from the University of California, Los Angeles, and is the author of *Visualize This* and *Data Points*. He writes about visualization and statistics at FlowingData.com.

DAN ZEDEK is the assistant managing editor for design at the *Boston Globe*, where he leads the design and infographics teams in print and online. In 2012, BostonGlobe.com was named the world's best-designed website by the Society for News Design.